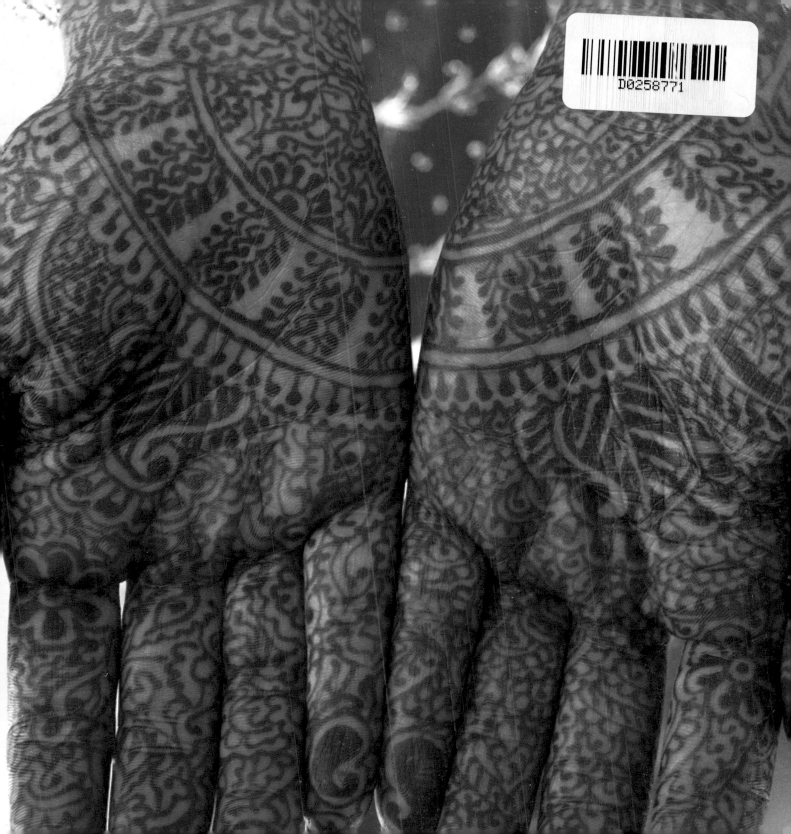

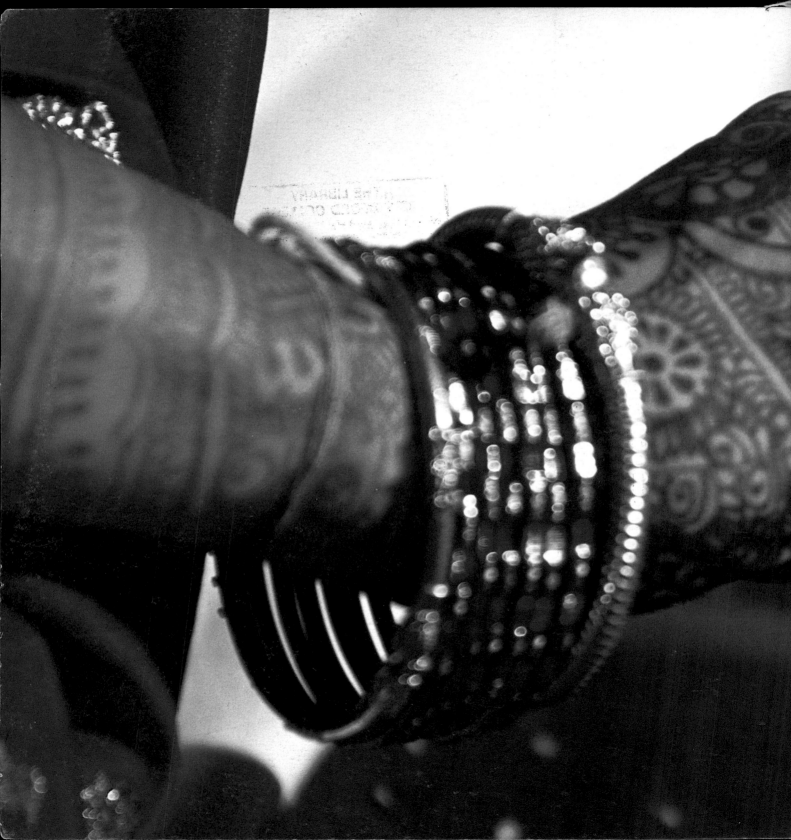

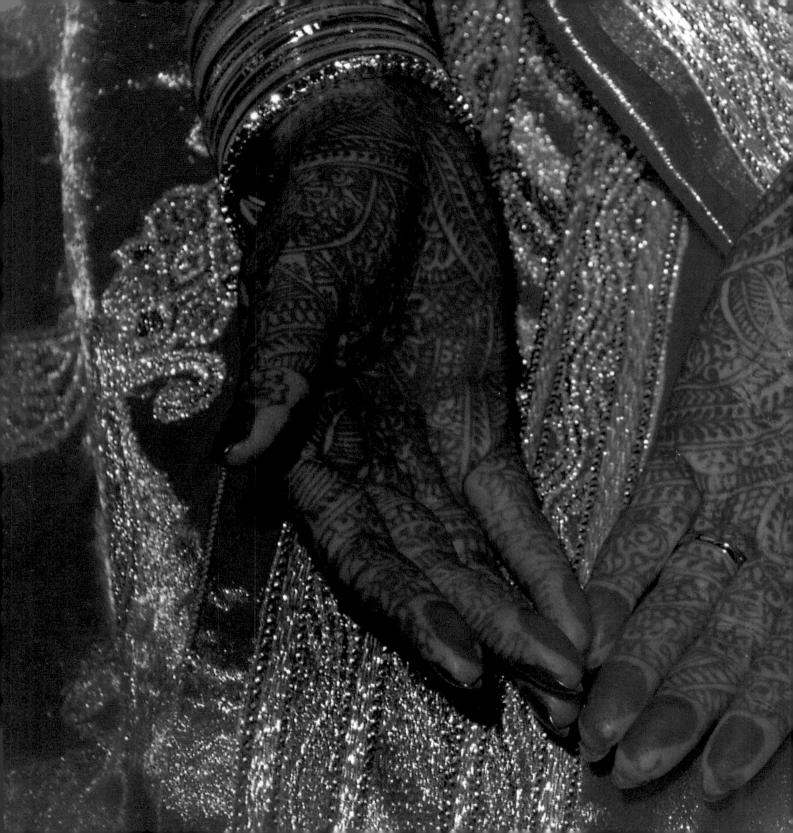

TRADITIONAL
HENNA DESIGNS

Traditionelle Henna-Designs
Motifs traditionnels au henné
Diseños tradicionales con henna
Disegni tradizionali all'henné
ヘンナの伝統デザイン

THE PEPIN PRESS
AMSTERDAM AND SINGAPORE

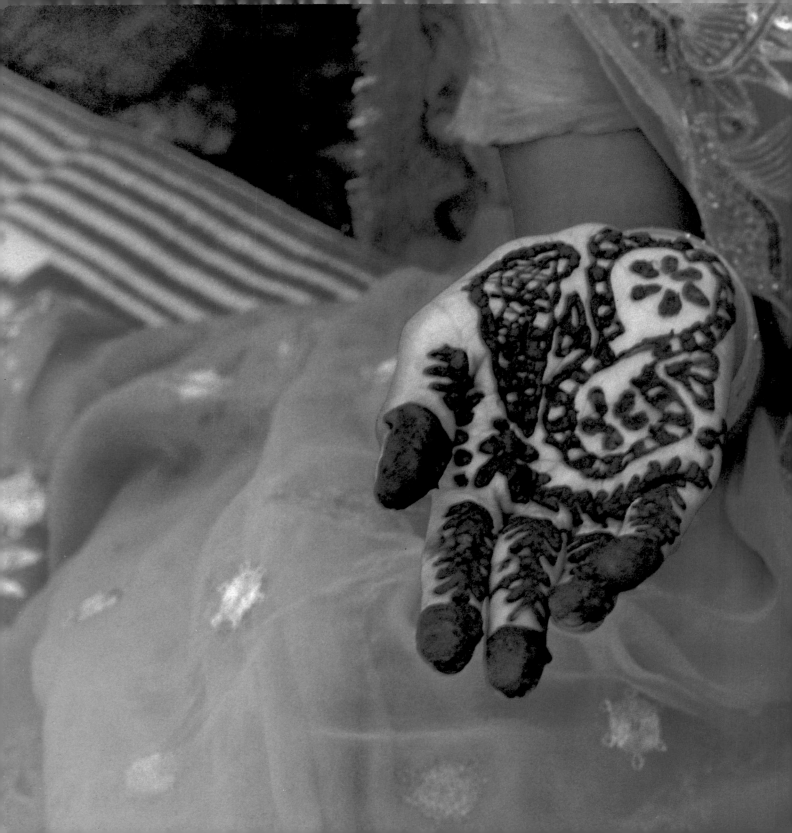

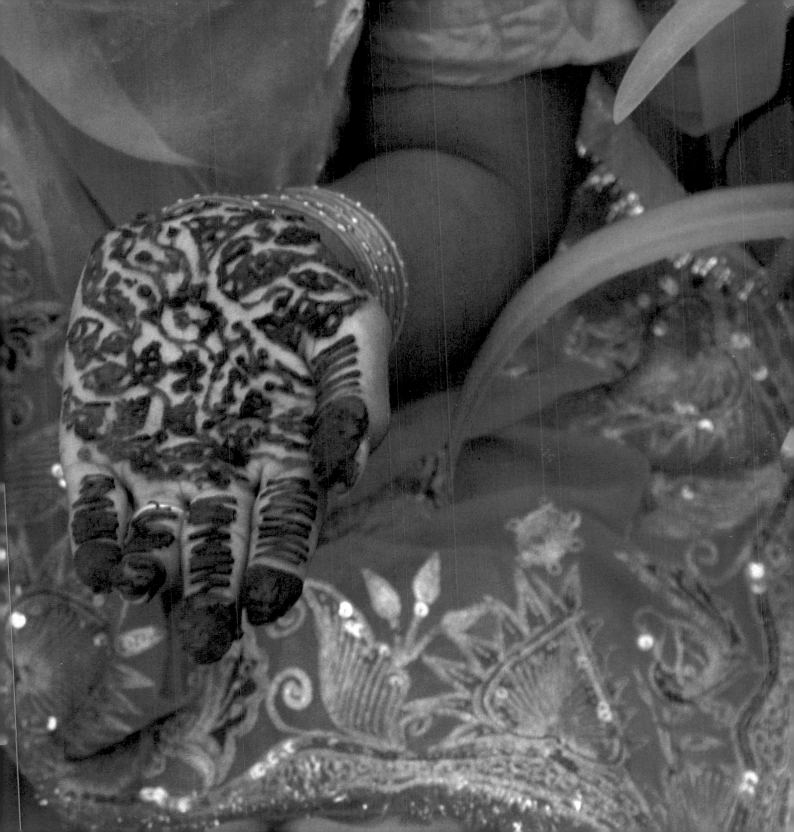

Photo credits:
cover: Ravi Shekhar / Dinodia
page 1: Viren Desai / Dinodia
page 2-3: Hari Mahidhar / Dinodia
page 4-5: Suraj N. Sharma / Dinodia
page 6-7: Dhiraj Chawda / Dinodia
page 10: Victoria & Albert Museum, London
page 11: The Pepin Press
page 12-3: Dinodia Picture Agency
page 14 left: M.M. Navalkar / Dinodia
page 14 right: Viren Desai / Dinodia
page 16-7: Ravi Shekhar / Dinodia
page 20: Suraj N. Sharma / Dinodia
page 22-3: N.M. Jain / Dinodia
page 24: Anil Dave / Dinodia
page 25: J. S. Sharma / Dinodia
page 26: Nadirsh Naoroji / Dinodia
page 27: Nadirsh Naoroji / Dinodia
page 28: Raju Shukla / Dinodia

ISBN 90 5496 068 x

A catalogue record for this book is available from the publishers and from the Royal Dutch Library, The Hague

Published in cooperation with Navneet Publications Ltd, India

This book is edited, designed and produced by The Pepin Press in Amsterdam and Singapore
Design: Dorine van den Beukel
English copy-editing: Debra Sellman
Translations: Sebastian Viebahn (German); Neus Soto Martínez / LocTeam (Spanish); Laurent Trigon (French);
Luciano Borrelli (Italian); Mitaka (Japanese)

The Pepin Press
P.O. Box 10349
1001 EH Amsterdam
The Netherlands
Tel (+) 31 204202021
Fax (+) 31 204201152
Email: mail@pepinpress.com
www.pepinpress.com

Printed in the European Union

Contents

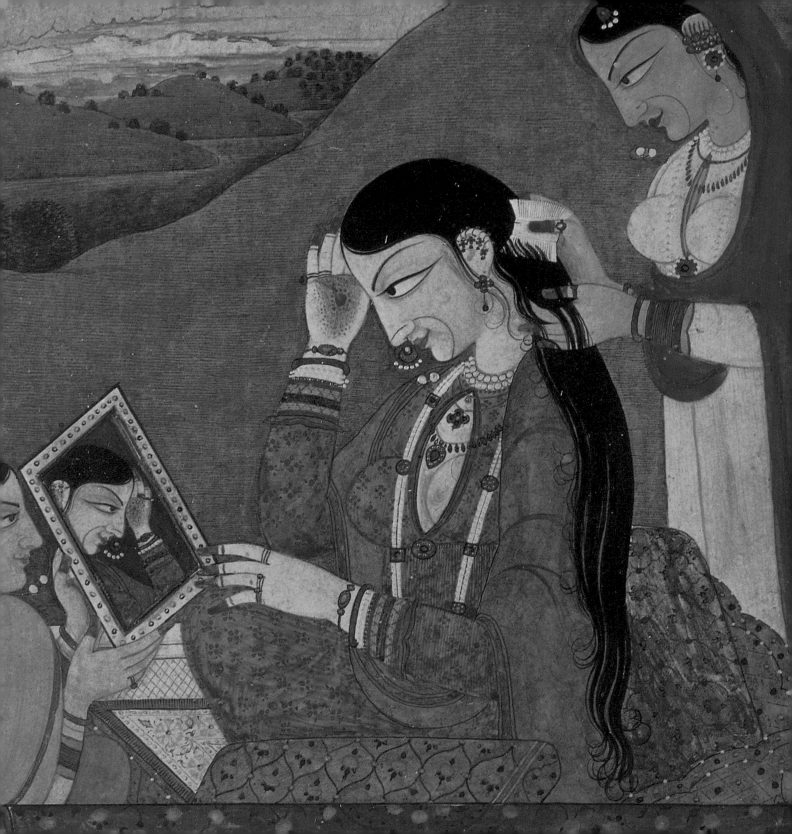

Introduction

Lawsonia inermis, hina, and *mehndi* are the Latin, Arabic and Hindi names for a fairly large plant with white flowers that grows in North Africa, the Middle East, India and Southeast Asia. Several medicinal properties are attributed to this plant, including its powers against bruises, headaches, sore throats and skin diseases such as ring-worm. The leaves have a cooling effect on the skin and have long been added as an ingredient to perfumed oils and ointments. However, its most familiar role is as the source of a reddish-brown natural dye. For centuries this plant has been used as a colourant for cotton, wool and silk and it continues to be very popular as hair dye and body paint, mostly on the hands and feet. Today this plant is best known by its Arabic name, *henna*.

It is not known for certain when and where the use of henna for skin decoration originated, but there is ample evidence that it is an ancient practice. In Egypt, traces of henna have been found on five-thousand-year-old mummies and in India cave paintings have been discovered depicting a princess with henna designs on her hands and feet. The prevailing theory is that the decorative application of henna began in Egypt. From there the custom is thought to have spread to the West as far as Morocco, and to the East as far as the Middle East, India and Southeast Asia.

Henna body decoration is generally practised on festive occasions, religious cere-monies and, most notably, weddings. In all cultures that practise henna painting it is the hands and feet that are commonly decorated; for weddings the designs can extend onto the arms and legs. For Islamic, Sephardic Jewish and Hindu marriages, brides, and sometimes also grooms, are adorned with patterns which are thought to bring good fortune. In some places it is believed that the deeper the hue of the henna, the happier the newly married couple will be.

Design motifs vary from culture to culture. For instance, in line with general Islamic doctrine, which excludes the depiction of people and animals, North African henna designs tend to be geometric or composed from highly stylized flowers. In the Middle East floral compositions also prevail. In some parts of Saudi Arabia large areas of the hands and feet are simply coloured with henna without any decorative motif.

Above: Indian wedding card, showing a bride's hands decorated with henna designs.
Page 10: Indian painting, Kangra, Punjab Hills, c. 1815.

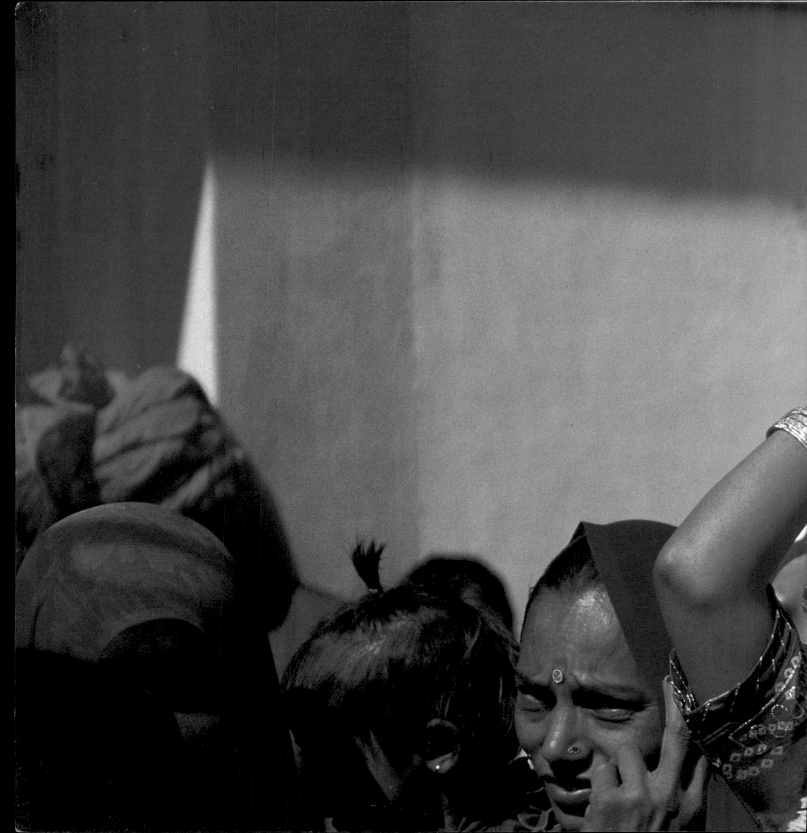

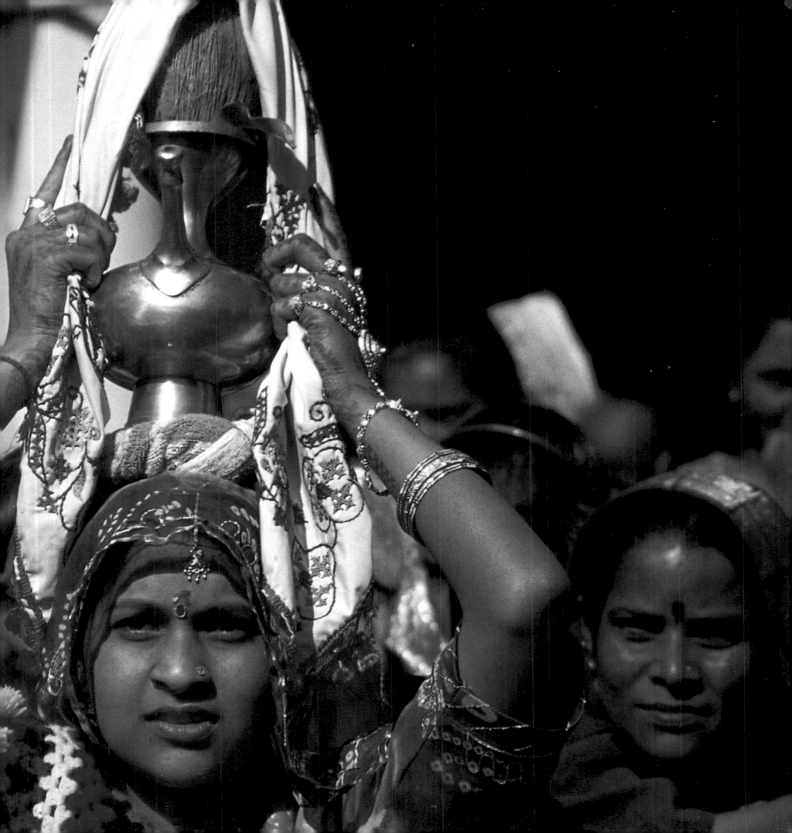

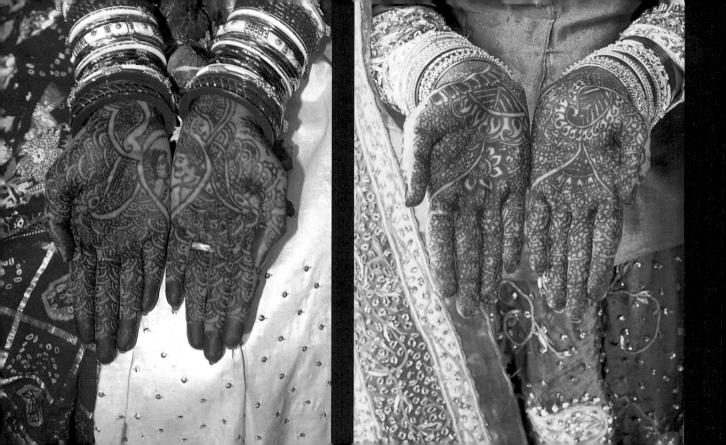

Indian designs tend to have a central theme. Usually they are drawn within a square, rectangle or circle which is then surrounded by a myriad of smaller patterns that cover the hands and lower arms, the feet and ankles. Motifs are taken from a vast Indian decorative vocabulary: Moghul flowers, Paisley patterns, complicated tendril designs, stars, vines, spirals, leaves, checkerboards, water drops and waves. Often the intricate decoration can give the impression of delicate lace gloves.

As well as these small repeated patterns, larger, more figurative motifs are frequently used, such as lotus flowers, unripe mangoes, fans, elephants, butterflies, fish, parrots, peacocks sweets and traditional musical instruments. Even Indian jewellery and watches have been included in the designs.

The fingers are covered with special linear motifs (p 50-7, 179-83) and the fingertips may be dipped in henna, staining the fingernails. Border motifs (p. 58-9) are applied around the wrist, ankles and footsoles.

The designs on the left and right hands are sometimes complementary, in the sense that the hands together form one design (p. 24-5). In some cases they are mirrored, forming a bird or heart (p 119-25), in other cases, different patterns are used on the left and right hands (p. 14 right). Examples of matching hand and feet designs are given on pages 140-53, 197-201.

Specific illustrations are used for wedding ceremonies. They include traditional symbols, such as the sedan chair in which the bride is carried from her house to the house of her in-laws (p. 18, 132); a pitcher containing holy water used in the ceremony (p. 12-13, 133); images of the bride and bridegoom (p. 49, 134-9); the peacock – a symbol of love; or the swastika – the ancient Indian symbol of well-being in the future. Although most often it is only the bride's hands that are decorated with henna in some regions in Bangladesh and Kashmir the hands of the groom are also decorated with motifs reserved for men.

Above: henna designs depicting the pitcher with holy water which is used in wedding ceremonies.
Page 12-13: woman carrying pitcher with holy water at a marriage ceremony, Ahmedabad, Gujurat, India.
Page 14: bridal henna designs.
Page 16-17: marriage ceremony, India.

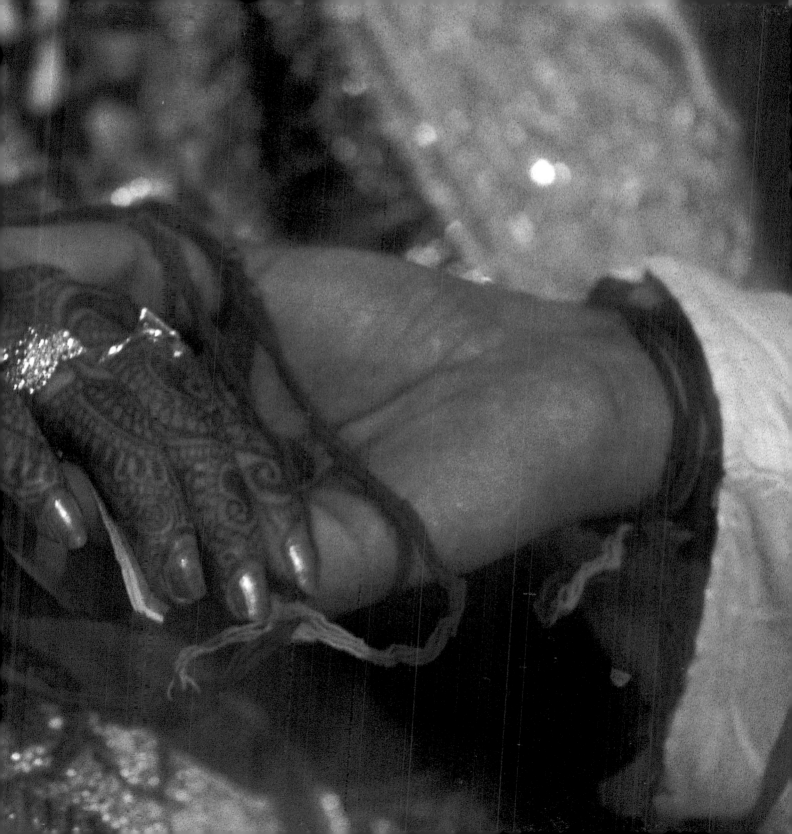

Applying henna designs

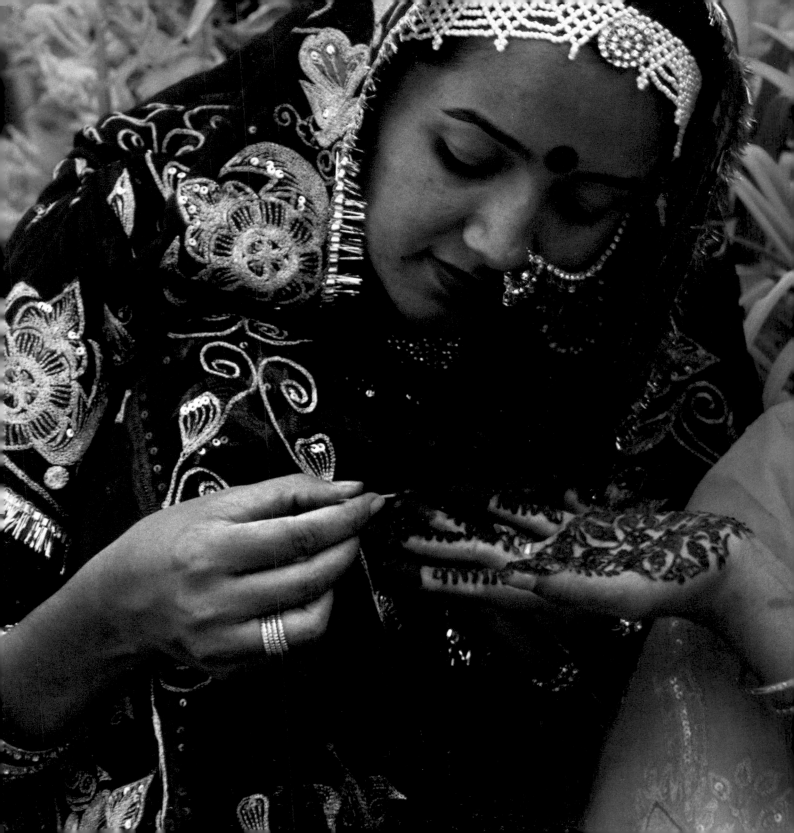

Applying henna designs

The traditional manner of applying henna is without the use of any tools. First, some paste is taken between the thumb and index finger. Next, a thread of henna is formed by moving the thumb and index finger back and forth several times. With this thread the design is drawn on the skin. This method requires a great deal of experience. Some cultures apply the henna with a stick, although the most practical method is to use a cone (see description on p. 29).

A completely different technique is to draw the designs with a paste made of sugar and lime juice. This paste is left to dry before the whole surface of the hand is covered with henna paste. When the lime is removed taking with it the henna paste, a white design remains on a red background.

Recipes for henna paste vary. For this reason only a general description is given here.

1
Sift the henna powder until it is very fine. It should not contain any twigs or lumps. Add a hot mixture of strong black tea or coffee, lemon juice (two spoonfuls of juice for one cup of coffee or tea) and mustard oil to the sifted henna. When the paste has a mud-like consistency, leave it to cool for at least one hour. If the mixture gets too dry, add some more of the tea/lemon/oil mixture. After forty-eight hours the paste is at its best.

Do not use henna which is meant to dye hair as this will not be powerful enough to dye the skin. Make sure that the henna powder you use is not too old because it loses strength over time. The ground henna leaves should be a bright green colour.

2
Clean the skin before applying the henna design by washing with rose water or mustard oil. Apply the henna paste with a small stick, a syringe without a needle, or a small cone (see drawing). Make sure that the tool you use does not touch the skin: only the thread of henna paste should make contact.

Instead of mustard oil, other types of vegetal oils can be used, such as eucalyptus, lavender, clove, or olive oil.

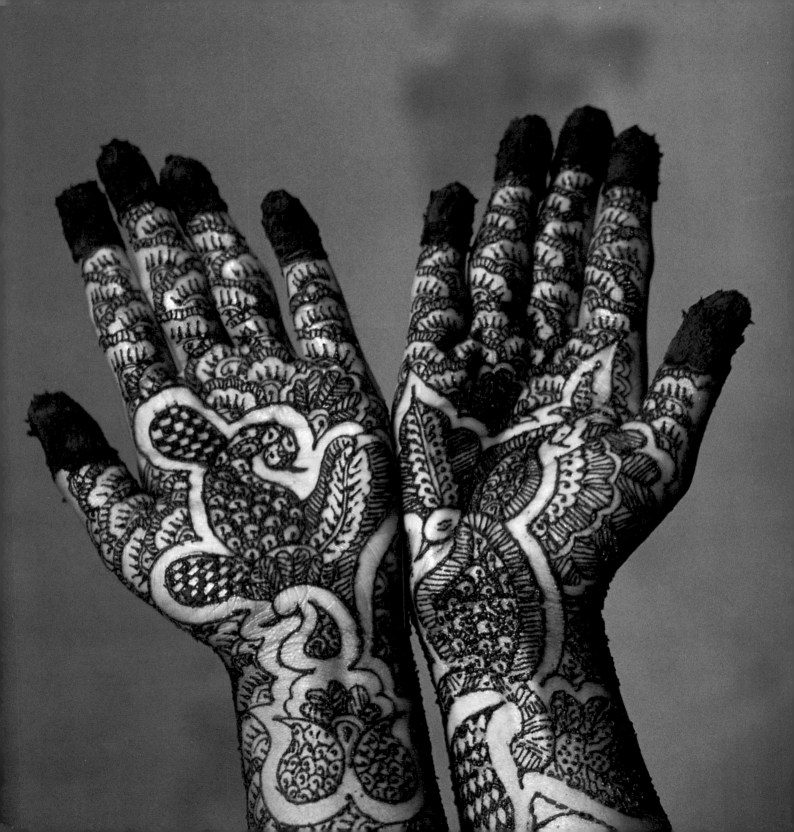

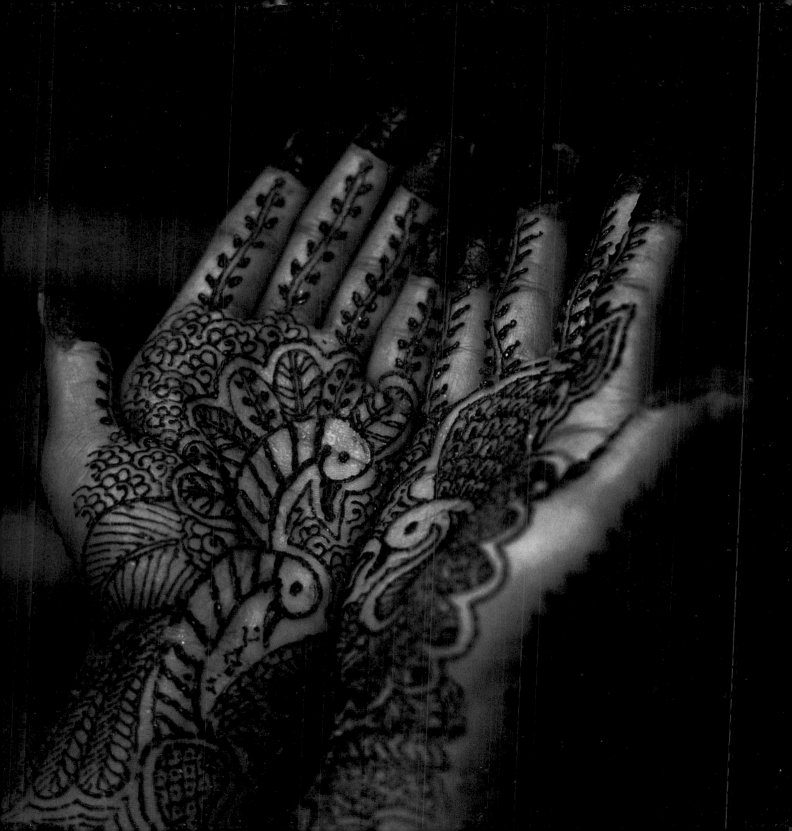

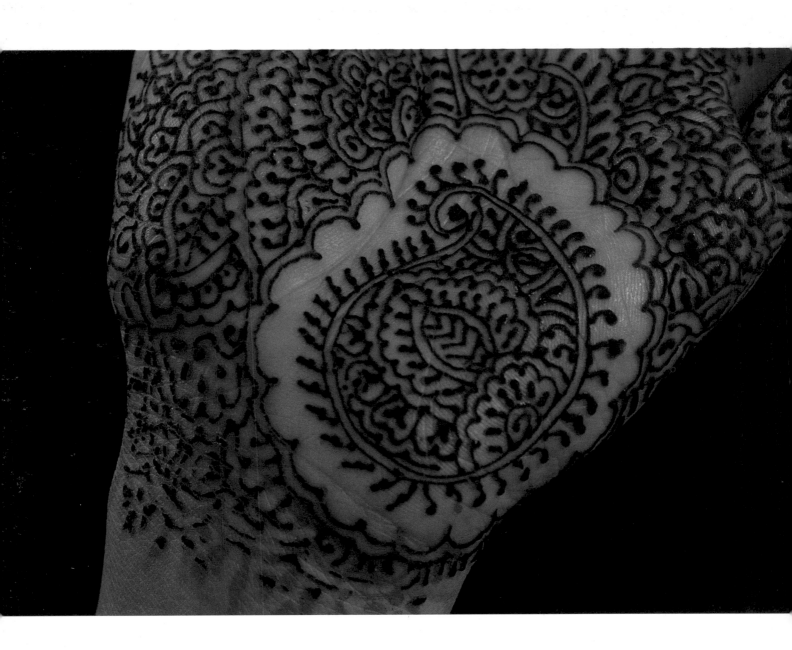

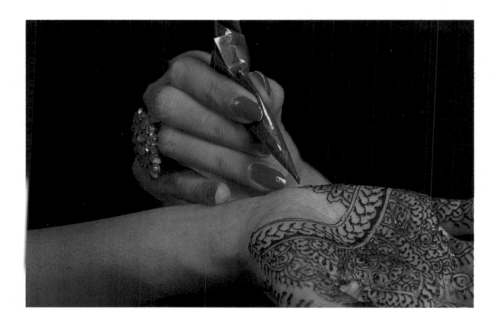

Left: applying henna designs with a cone
Page 26: hand decoration before the henna paste is scraped off. Underneath the dark paste the reddish design on the skin is visible.

3

After the design is completed it should be left for four or five hours at least, and preferably overnight. Be careful not to damage it and, if necessary, cover it with cotton balls. To prevent the henna from cracking and falling off, it should be moistened with a solution of lemon juice and sugar from time to time. This will also help it reach a deeper colour.

4

When the paste has turned a dark red, rub the skin with mustard oil, scrape off the paste, wash the skin with water and rub it with oil again.
To deepen the colour even further, leave the design unwashed for twelve hours. Then, to preserve it, wash the skin as little as possible and avoid the use of soap. The applied motif should stay in good condition for two to four weeks, depending on the degree of use of the hands, feet, or part of the body marked.

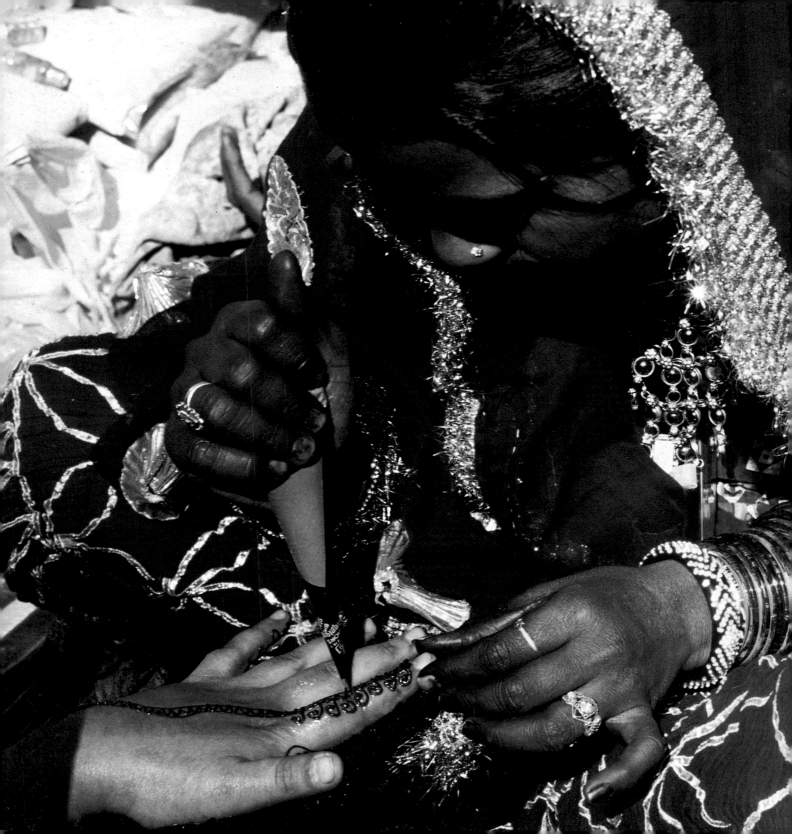

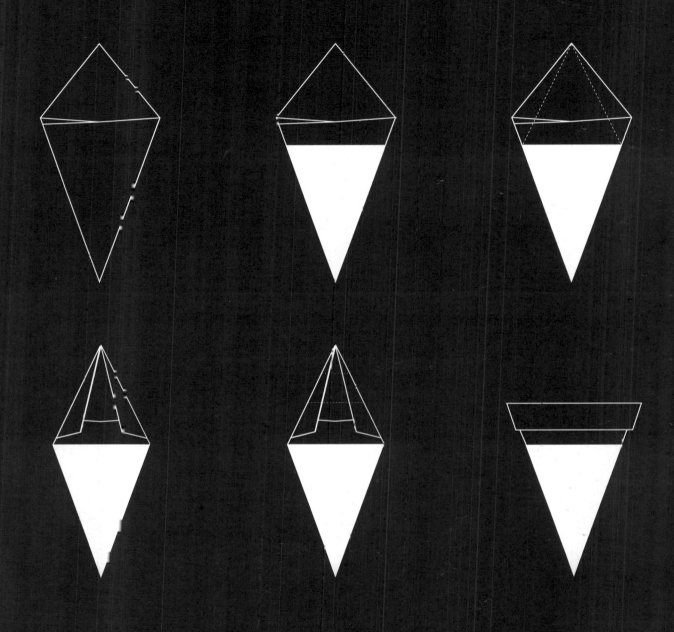

Cut a rectangle of approximately 15 x 20 cm from a strong plastic bag. Shape it into a cone and close the seams with some tape. Fill the cone with henna paste and it is ready to use.

Traditional henna designs

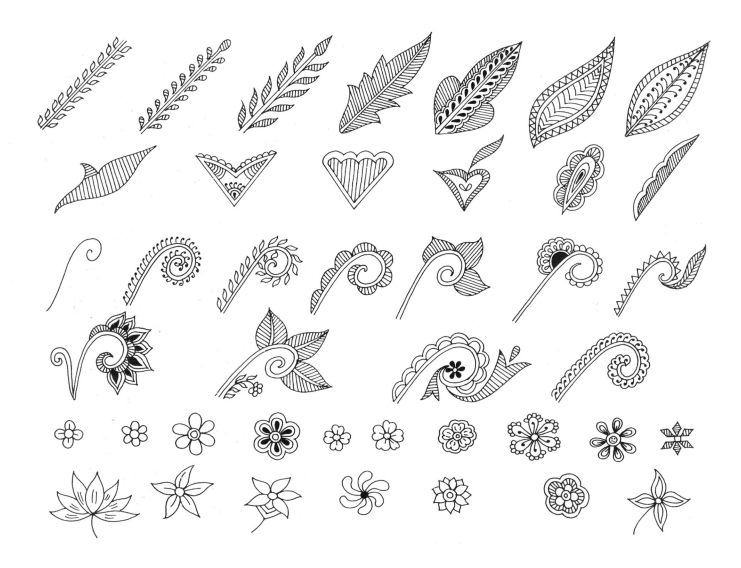

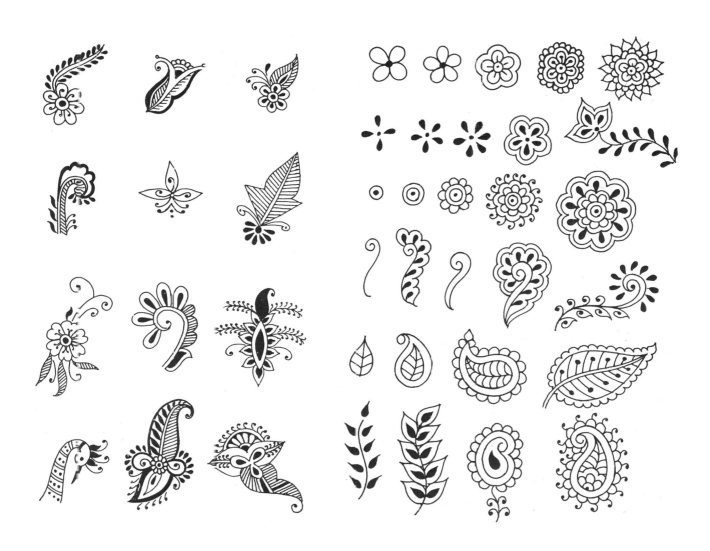

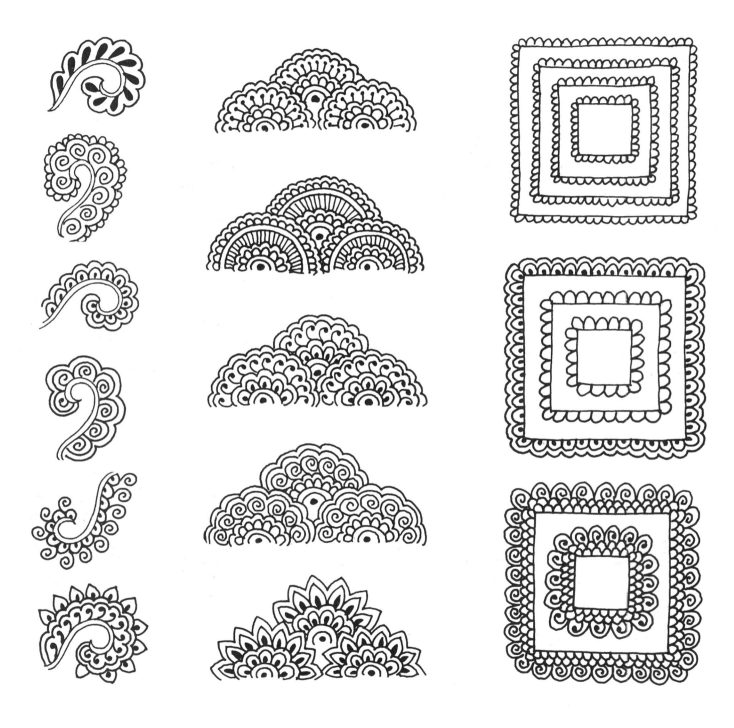

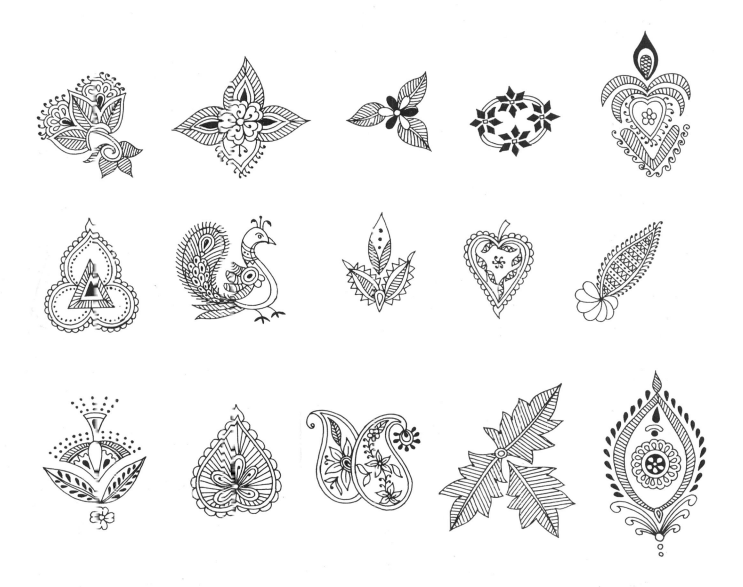

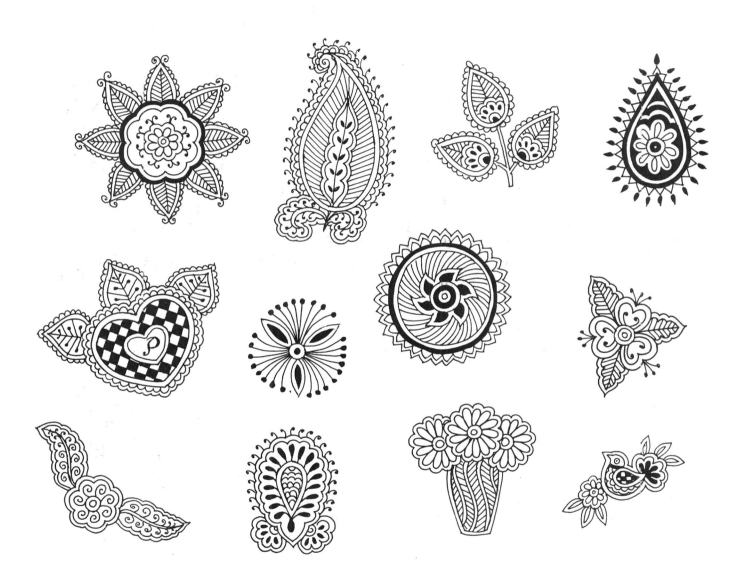

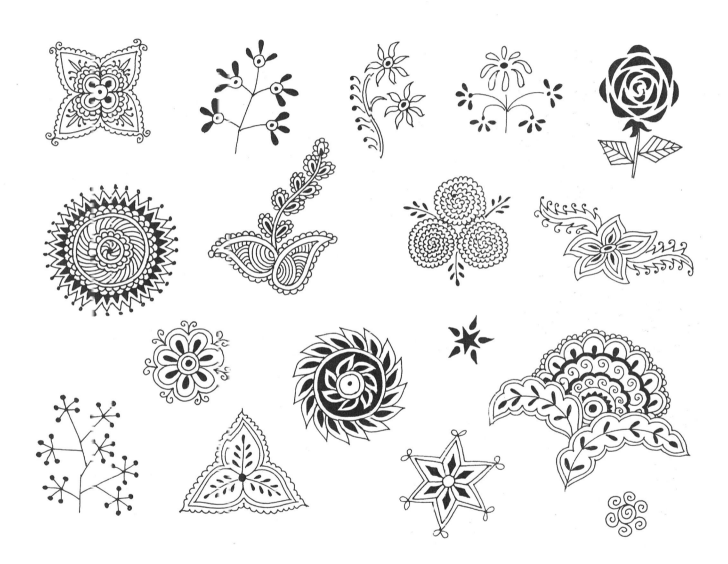

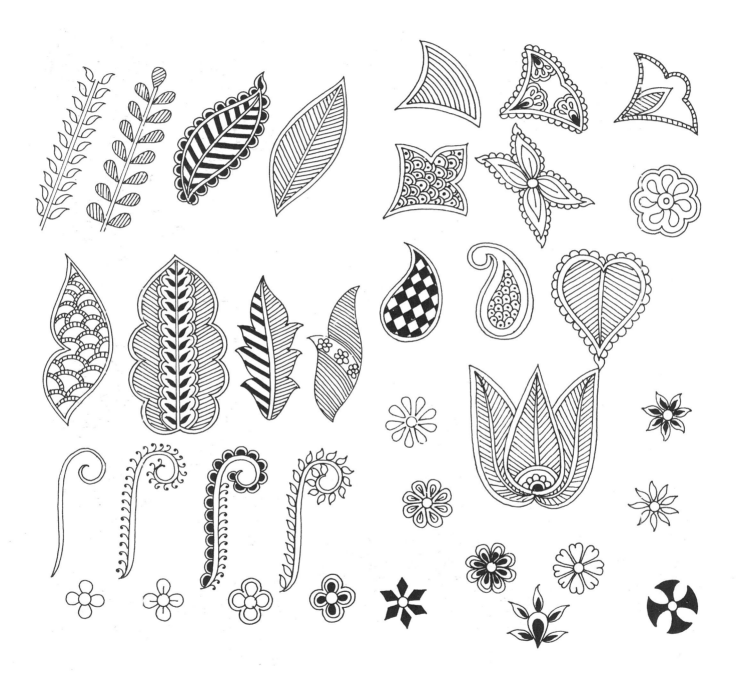

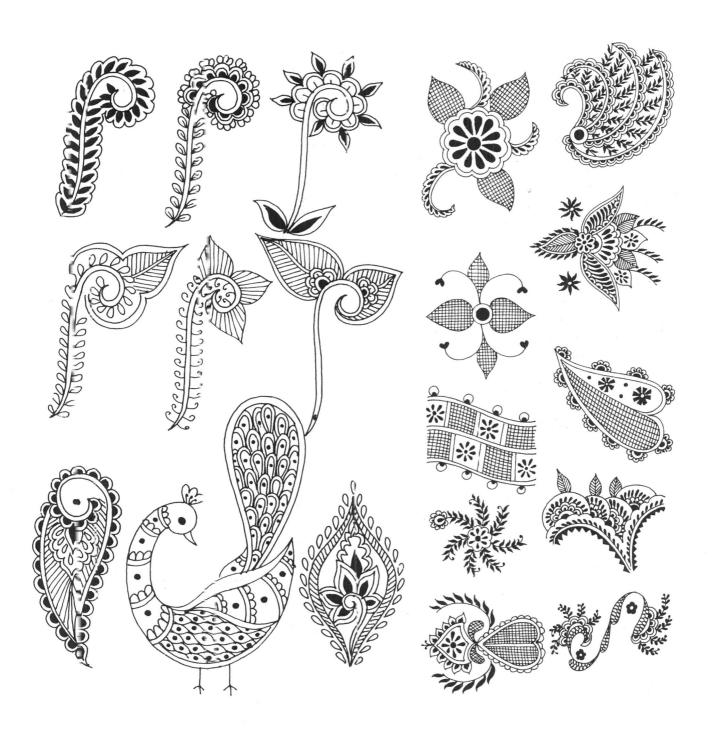

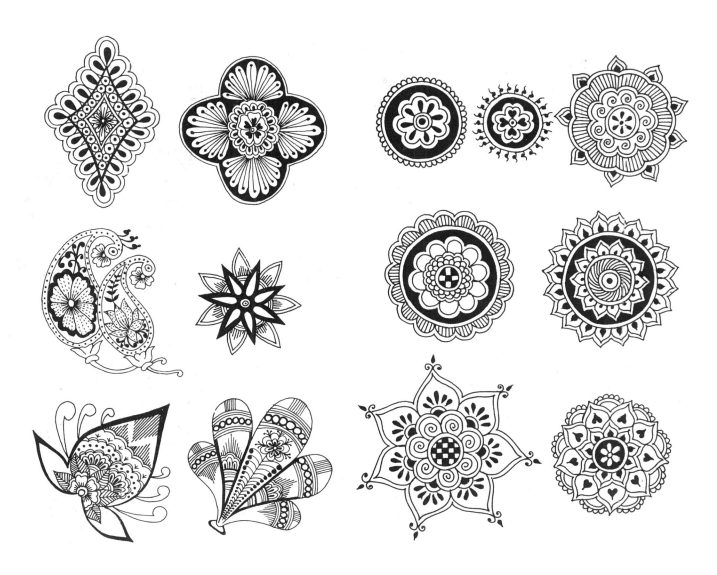

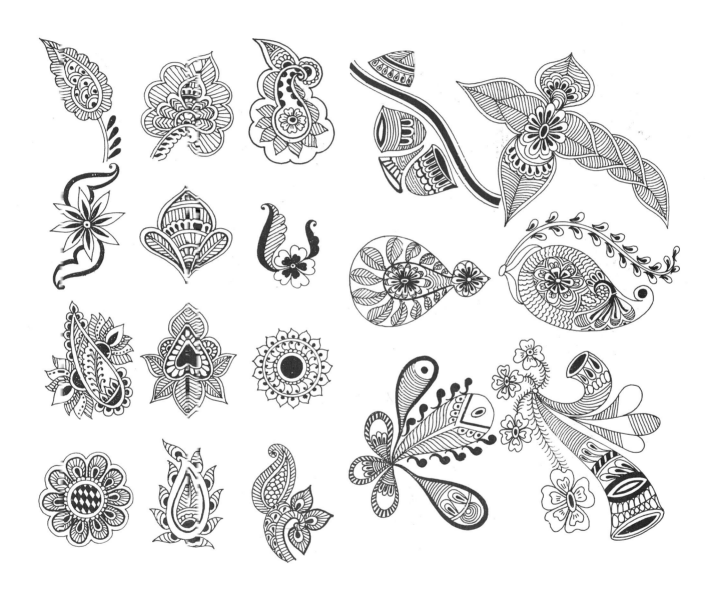

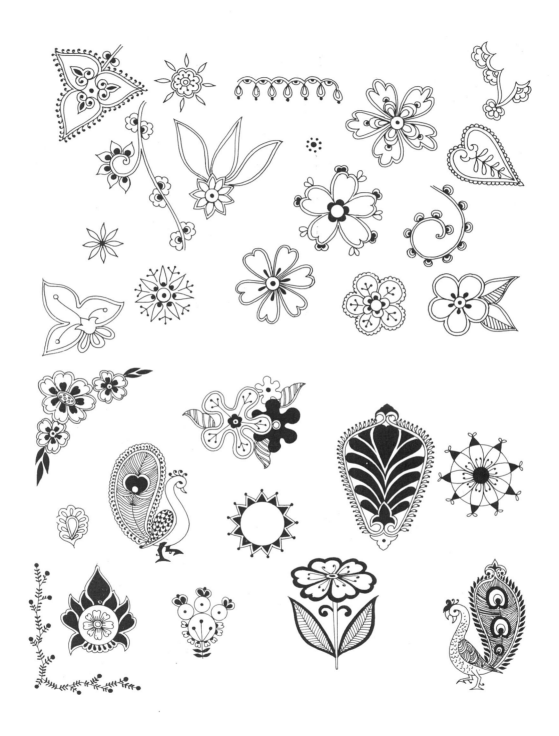

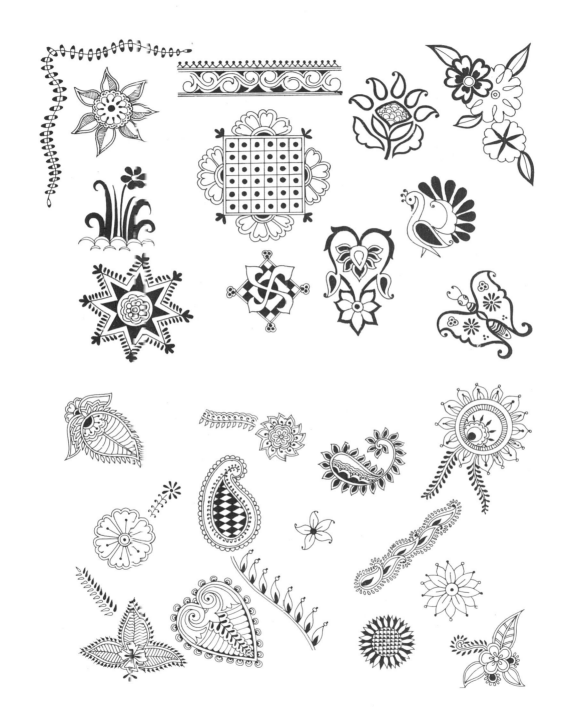

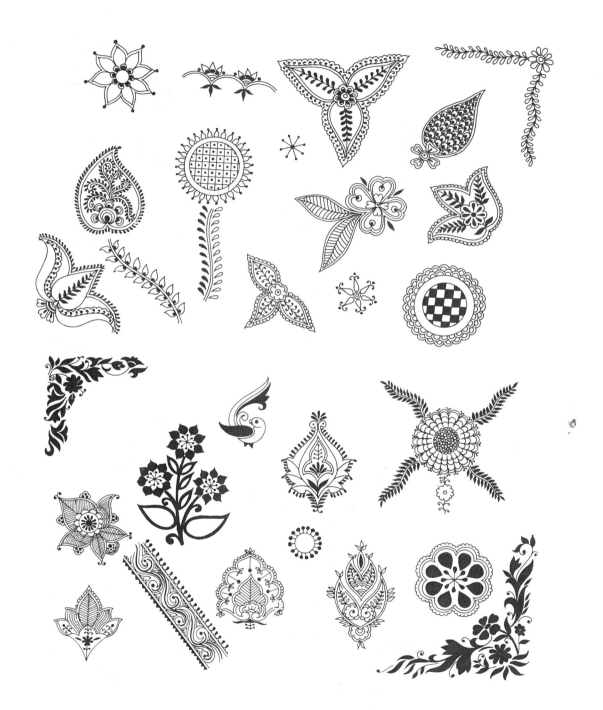

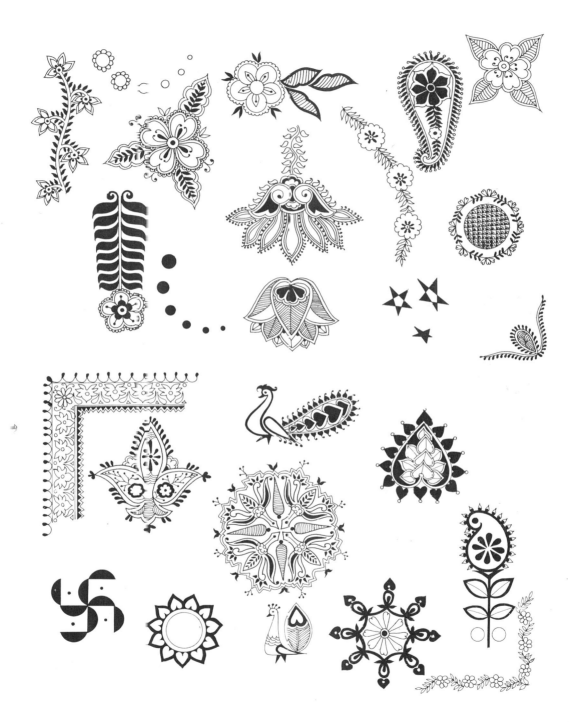

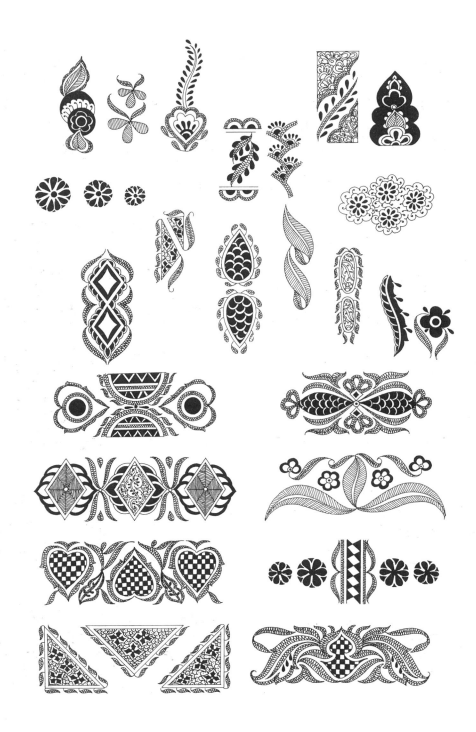

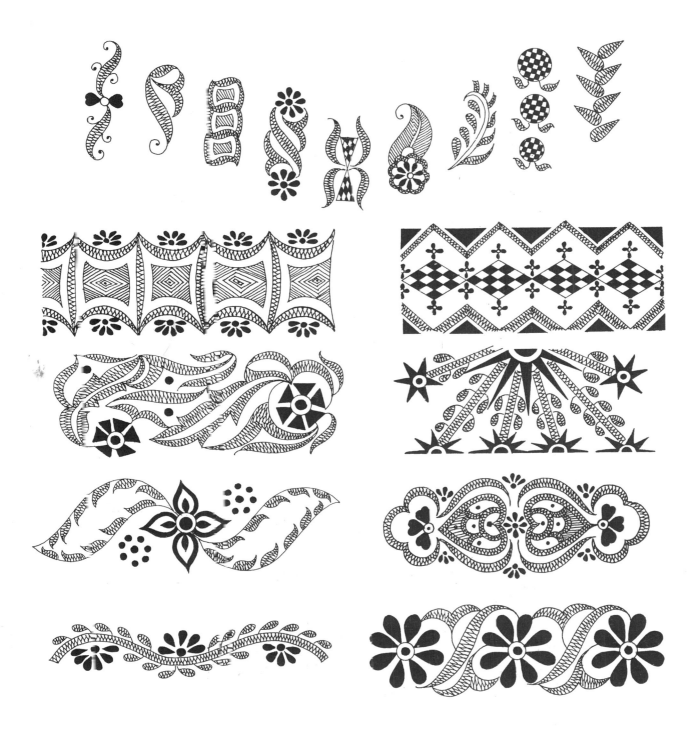

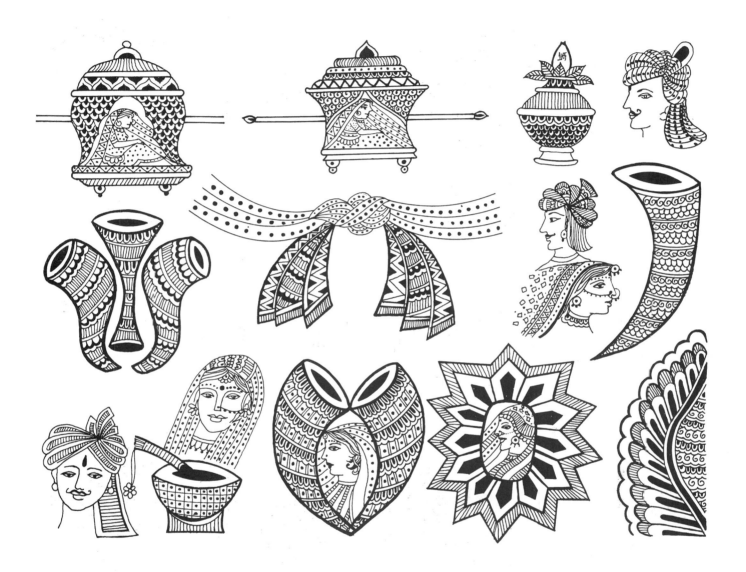

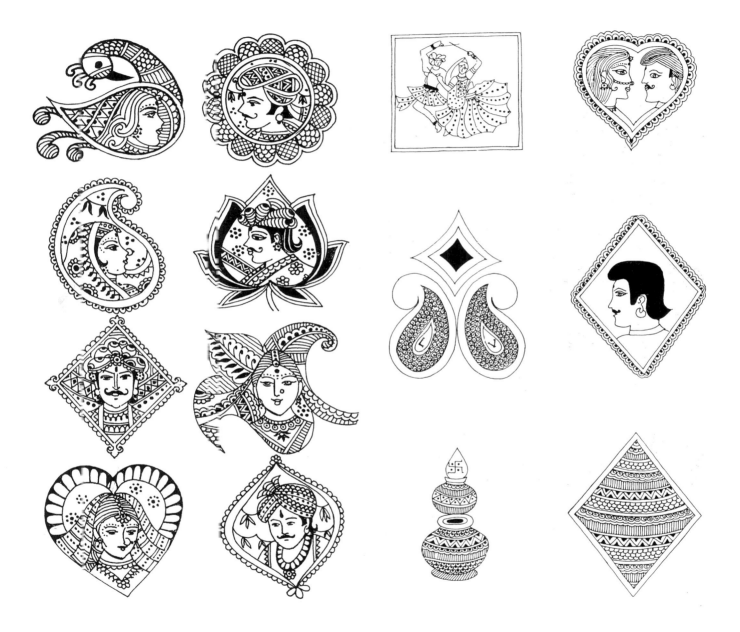

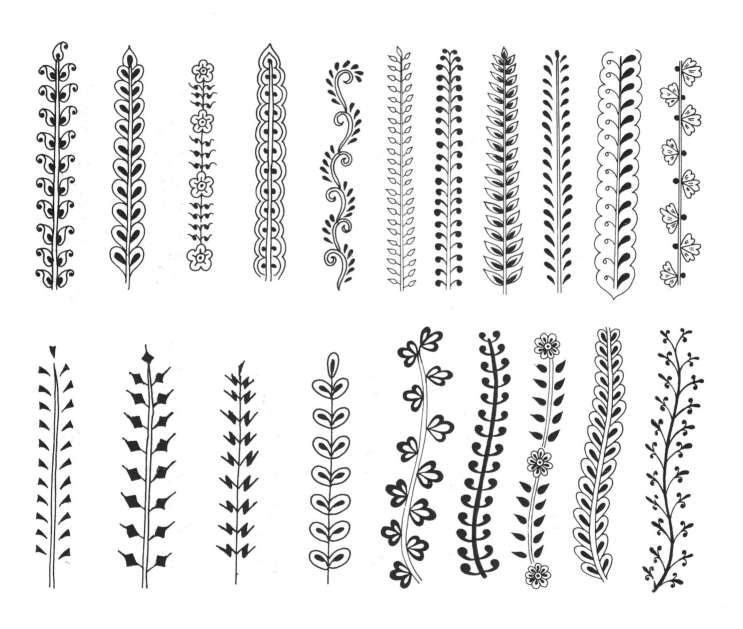

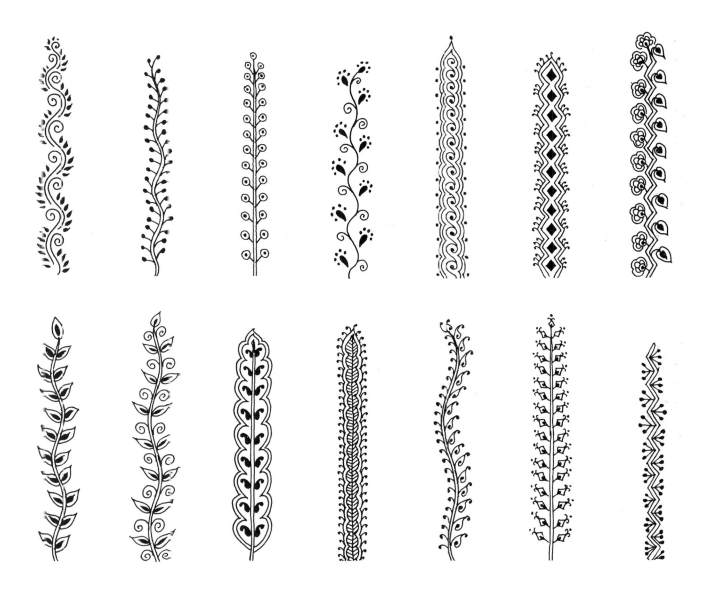

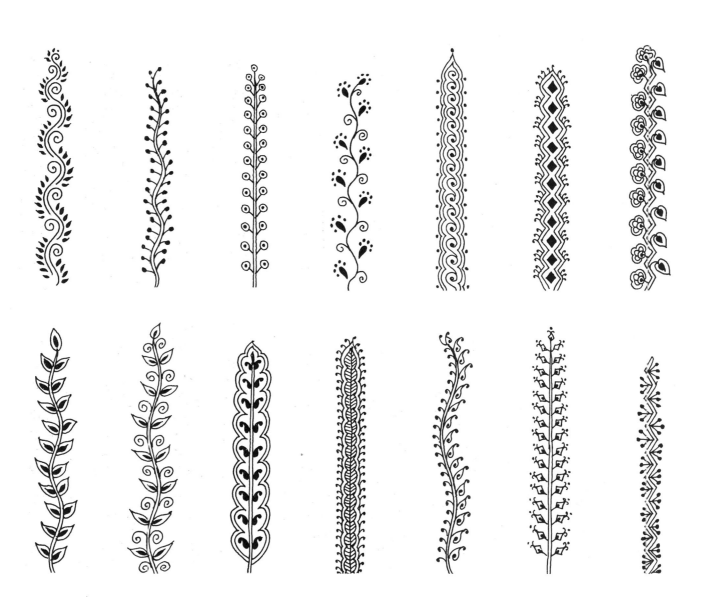

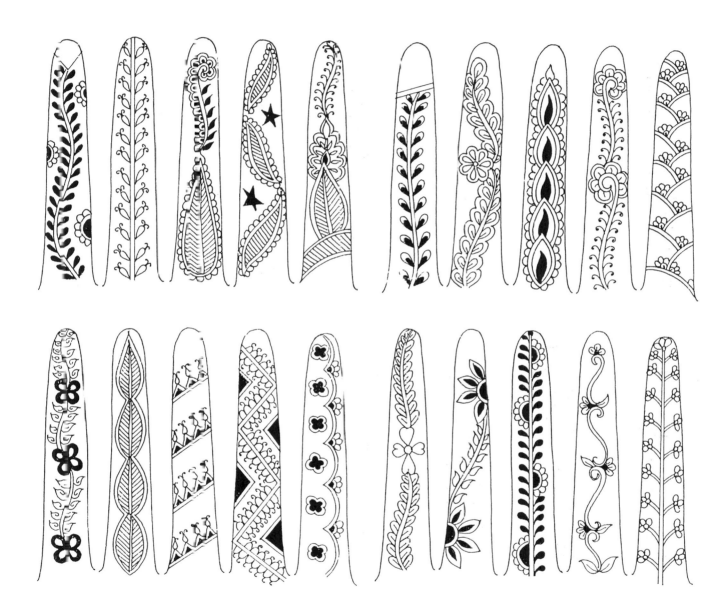

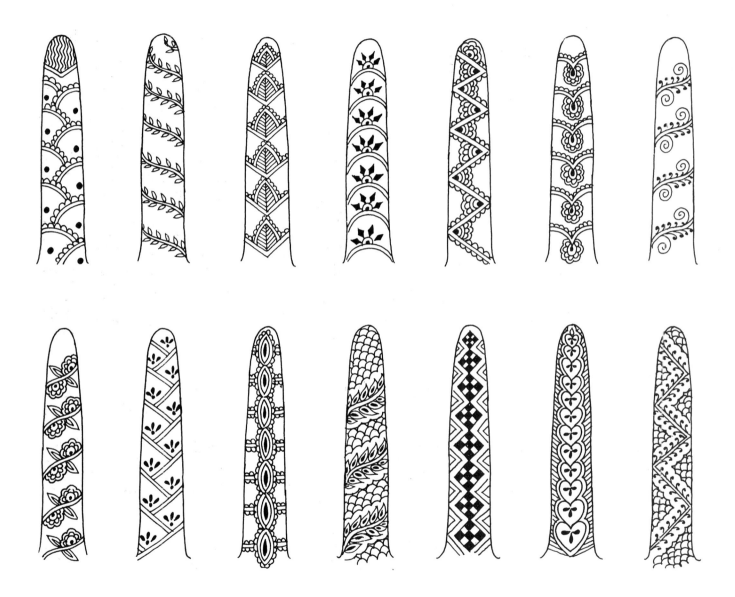

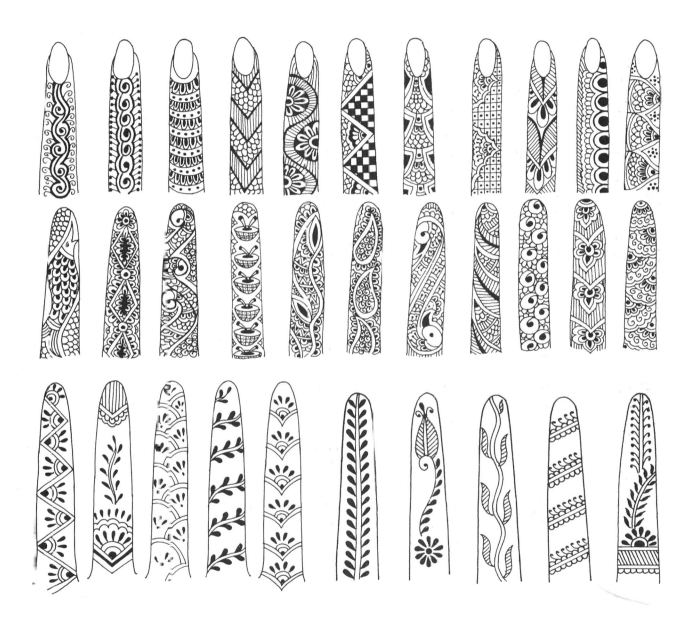

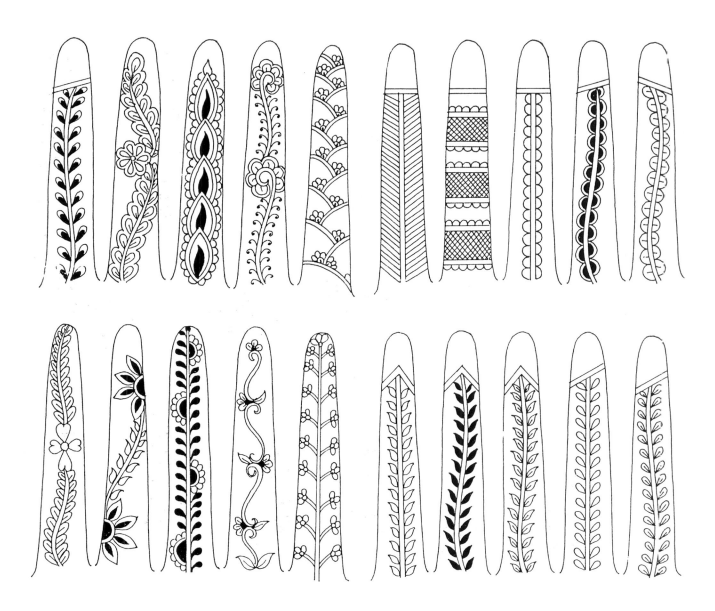

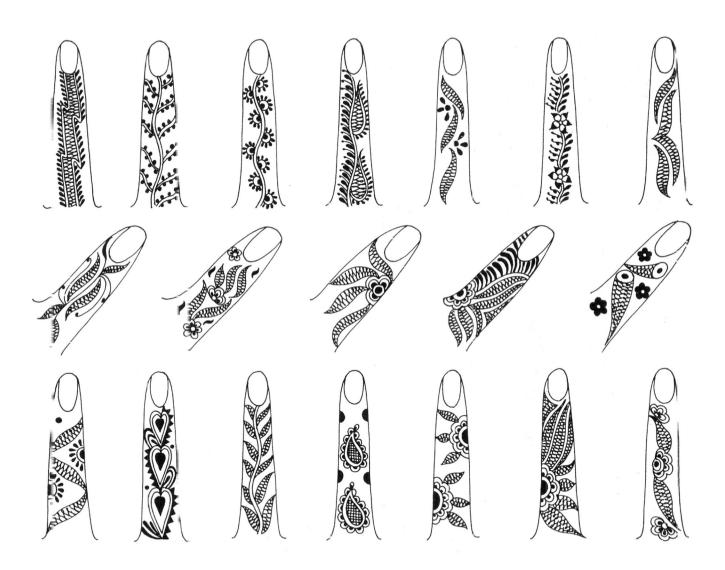

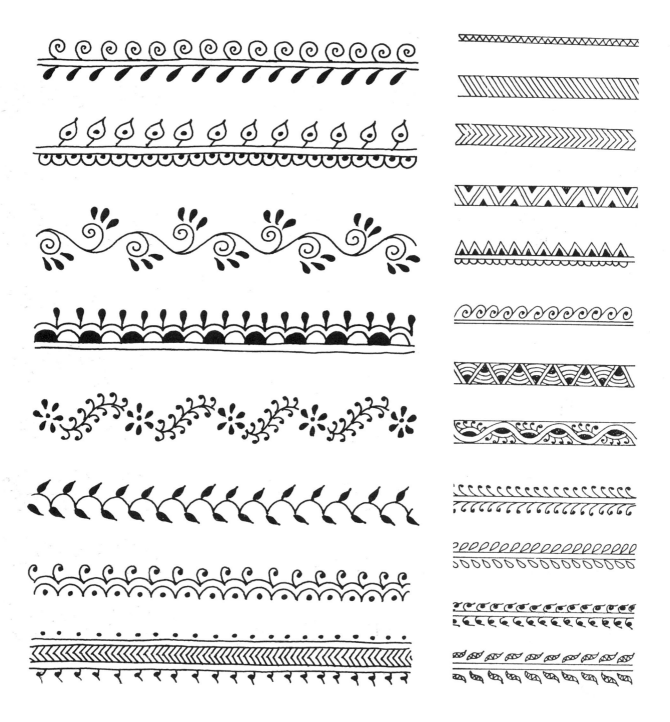

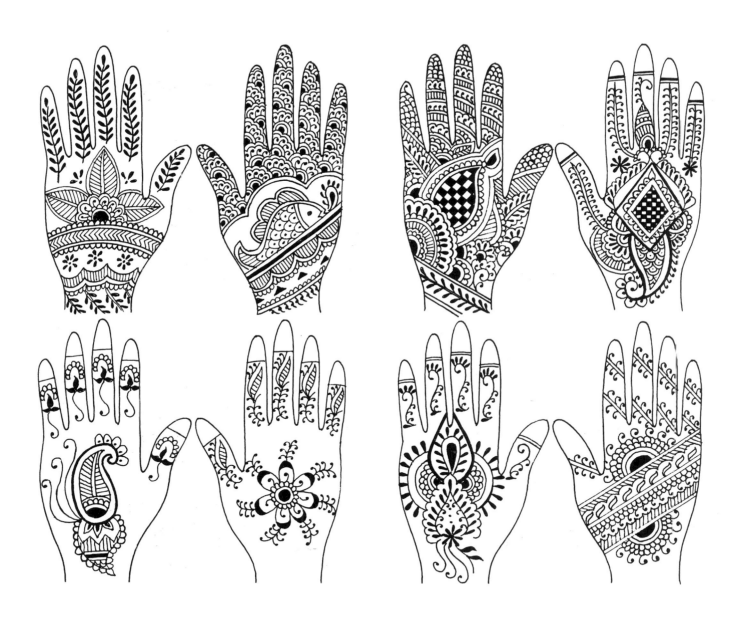

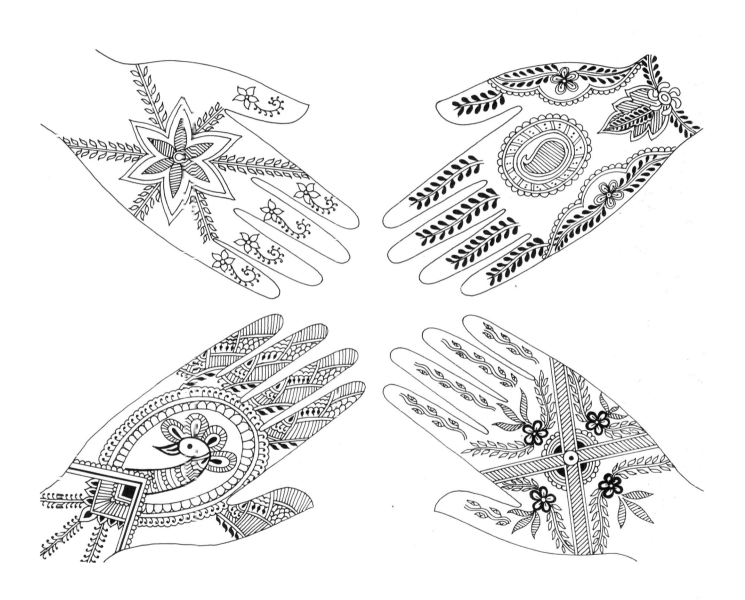

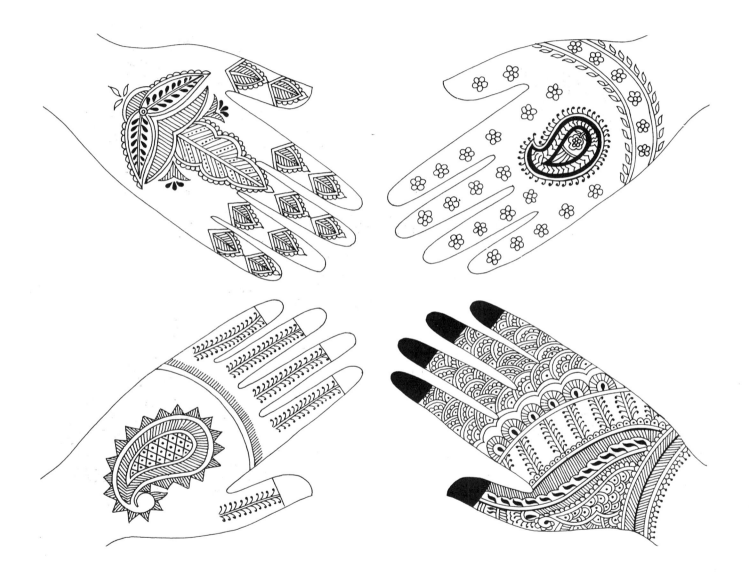

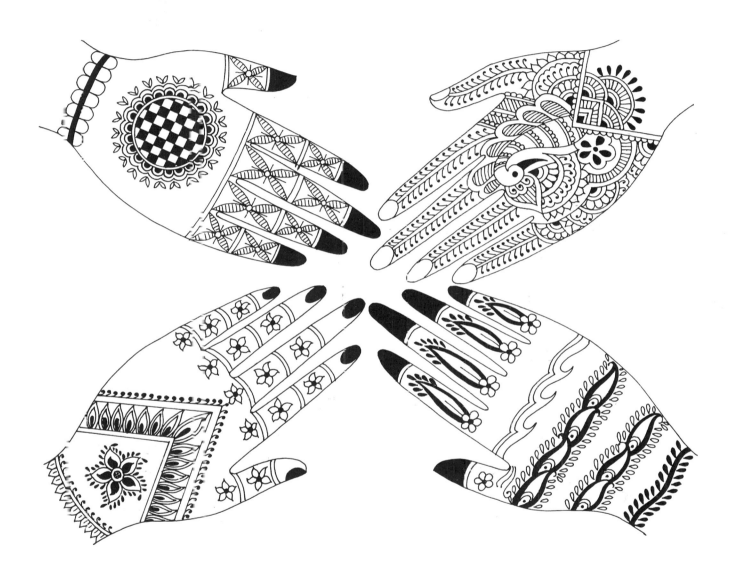

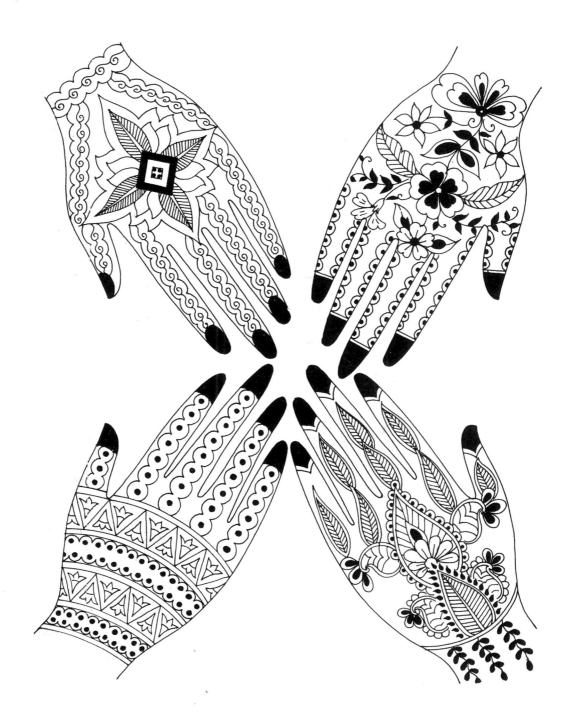

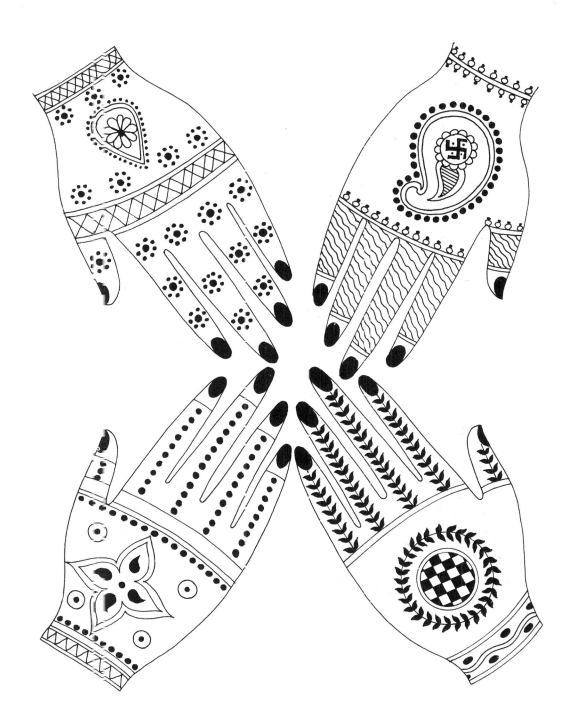

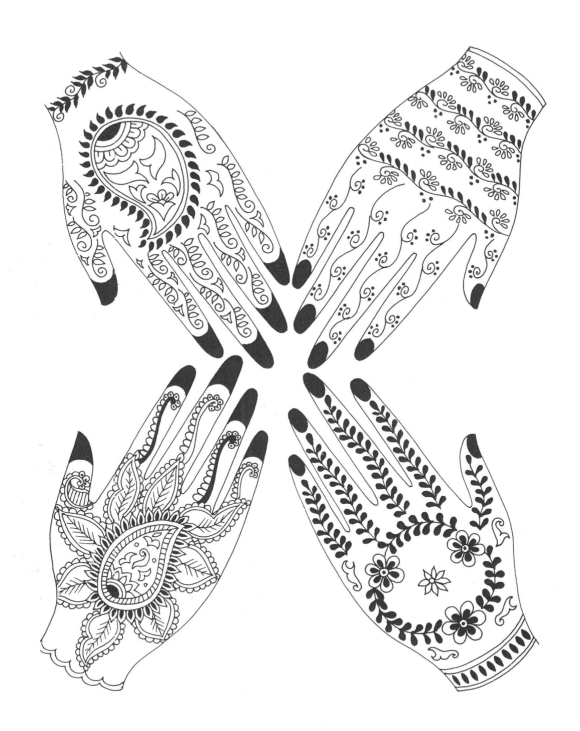

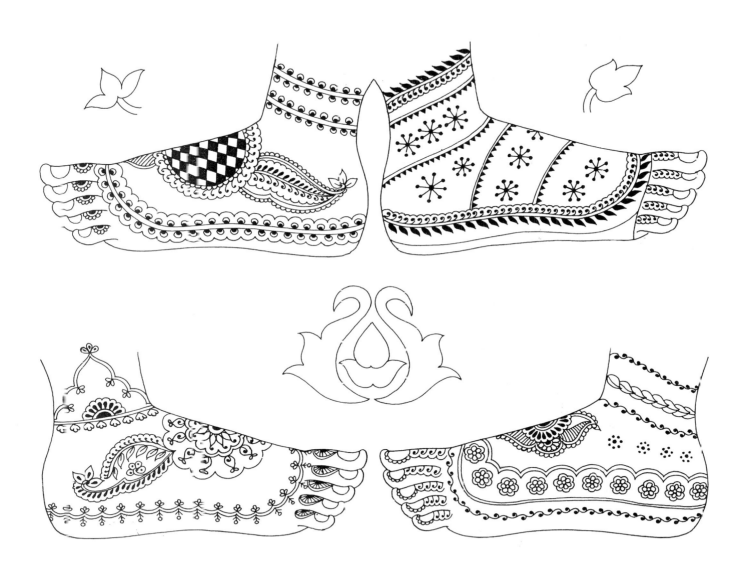

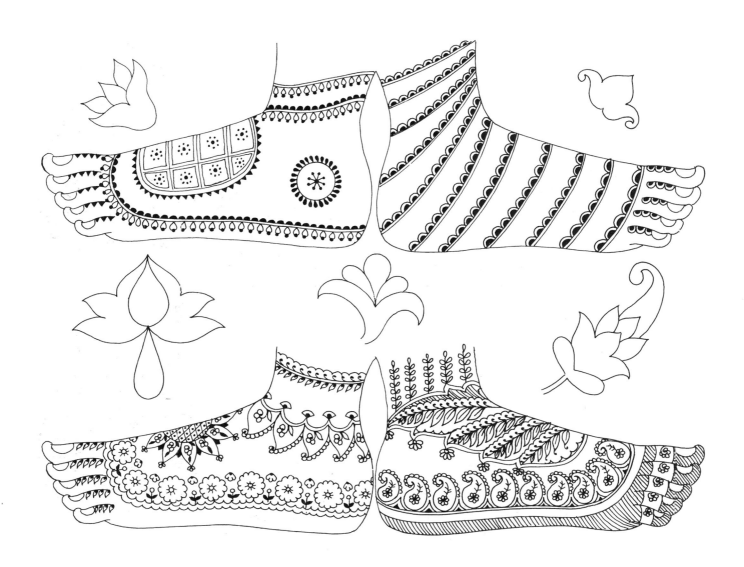

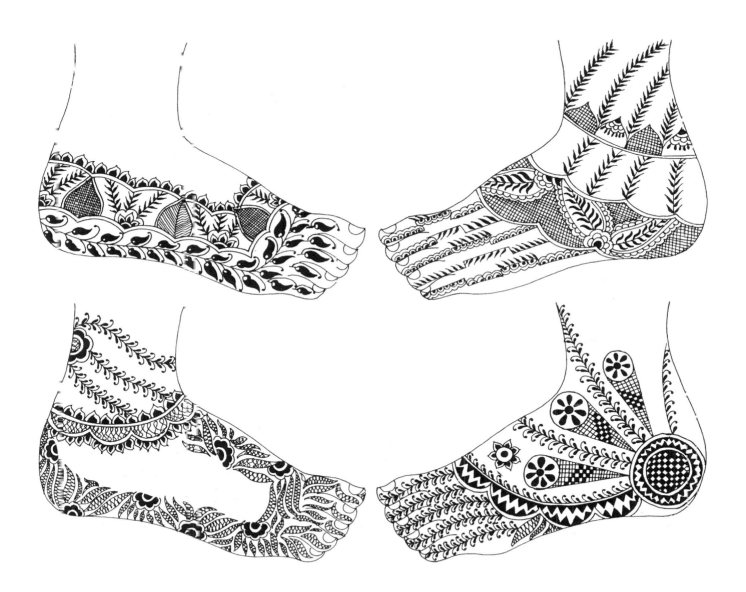

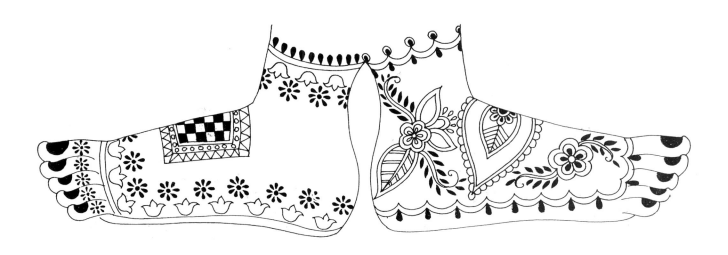

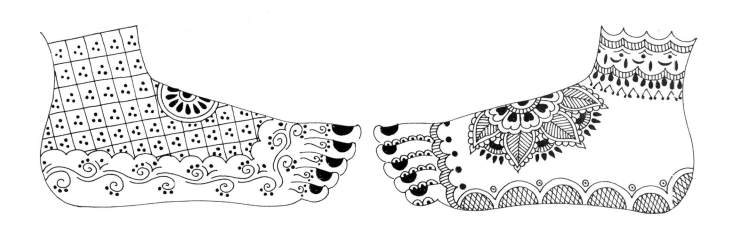

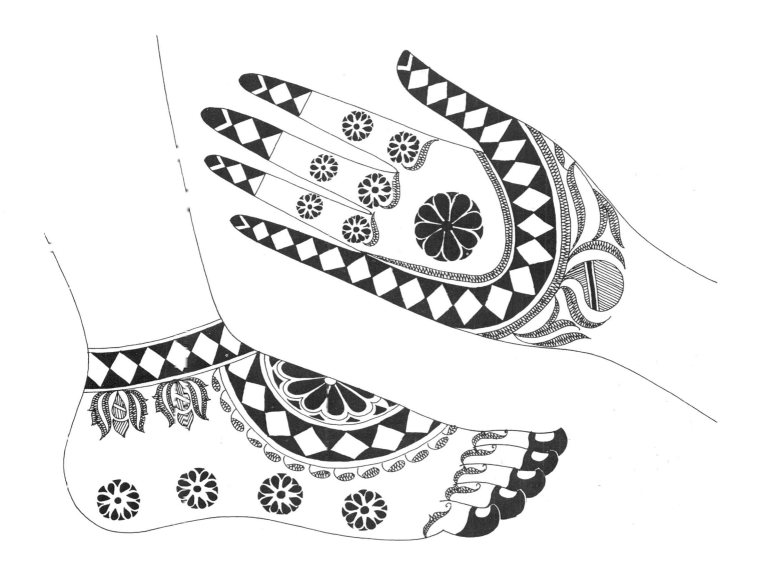

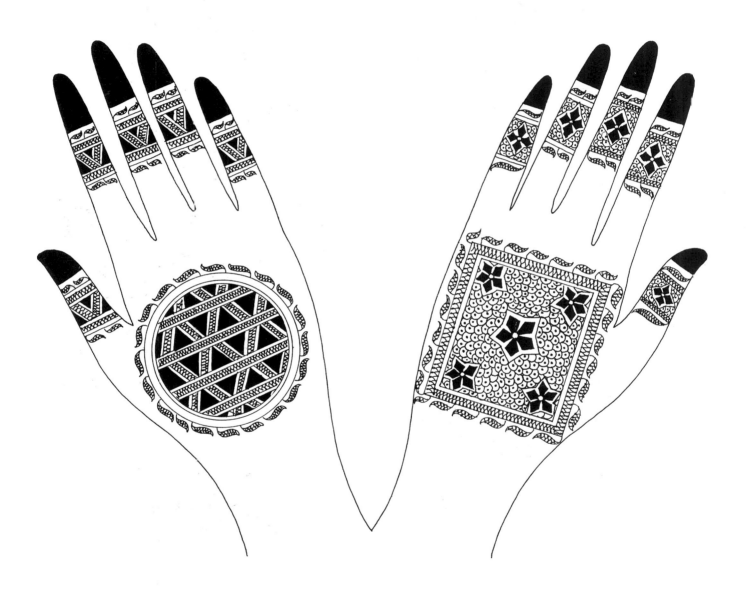

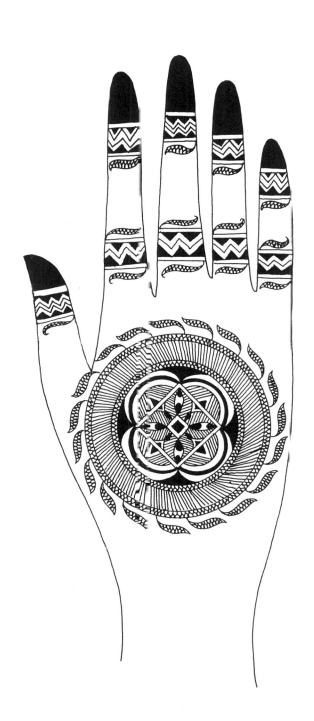
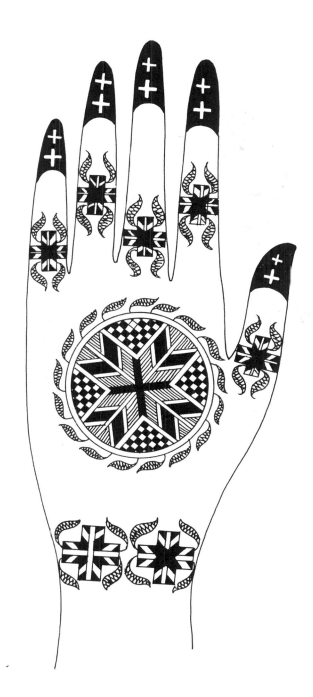

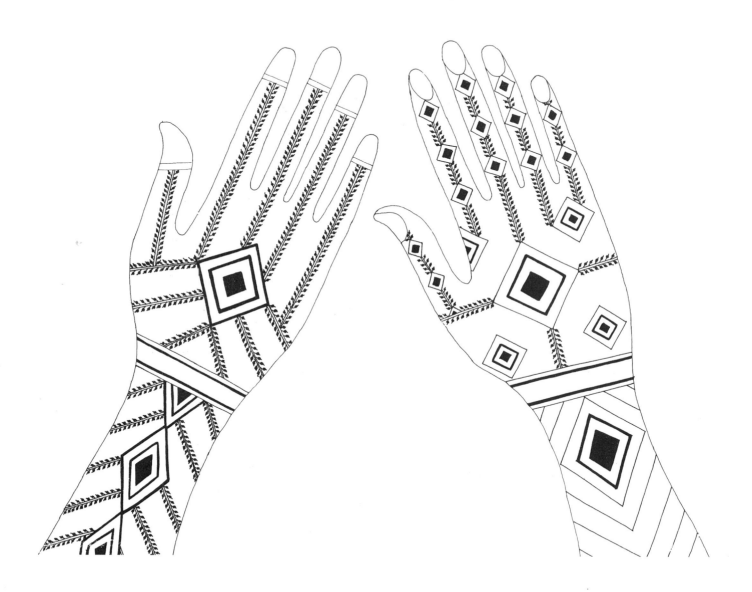

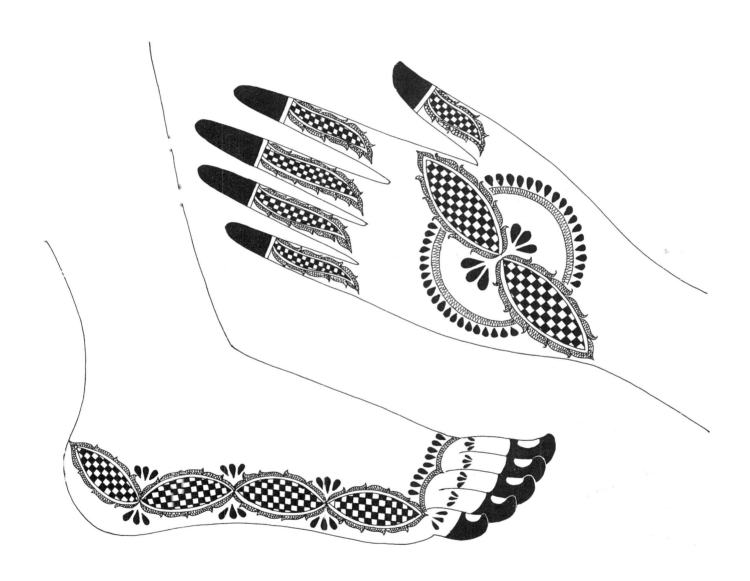

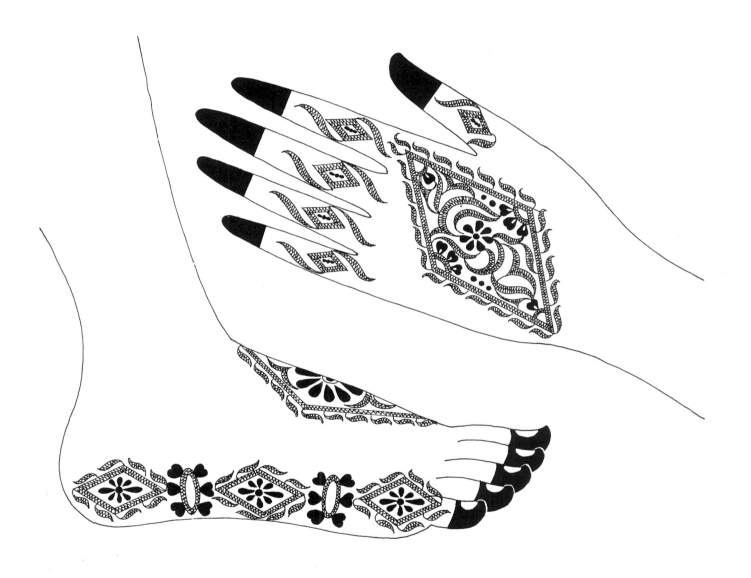

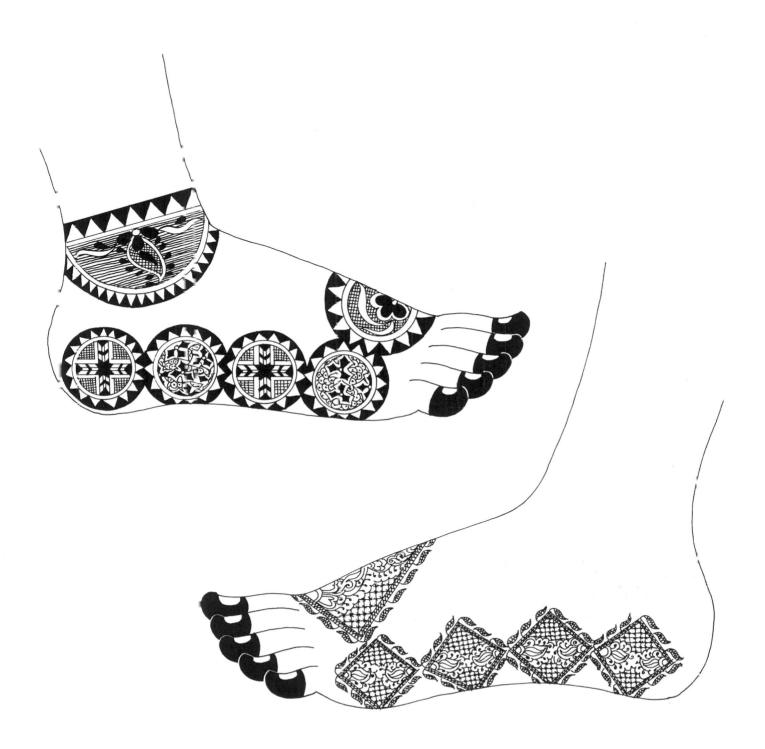

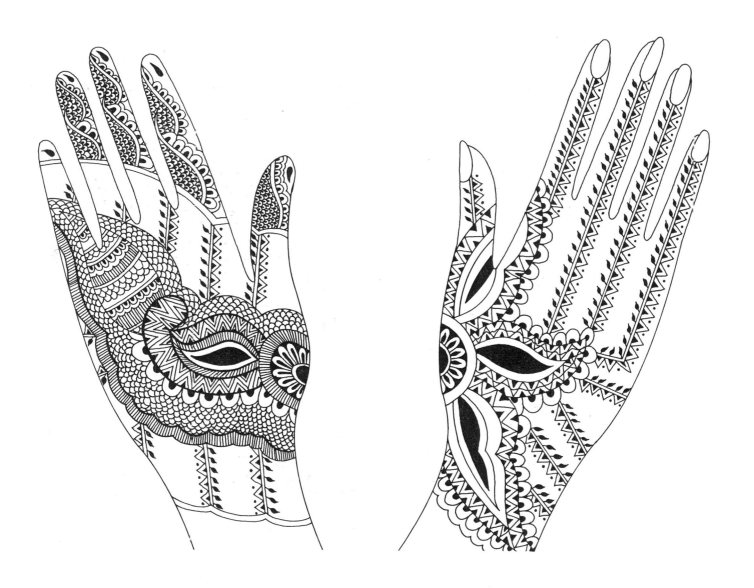

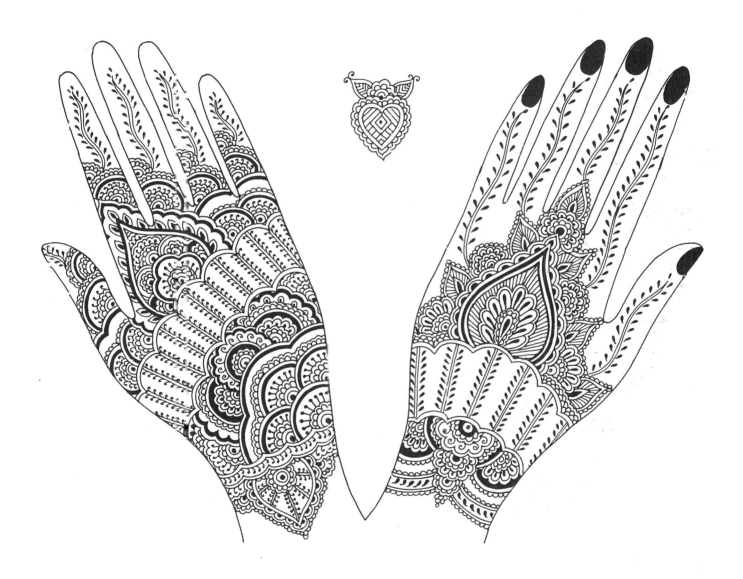

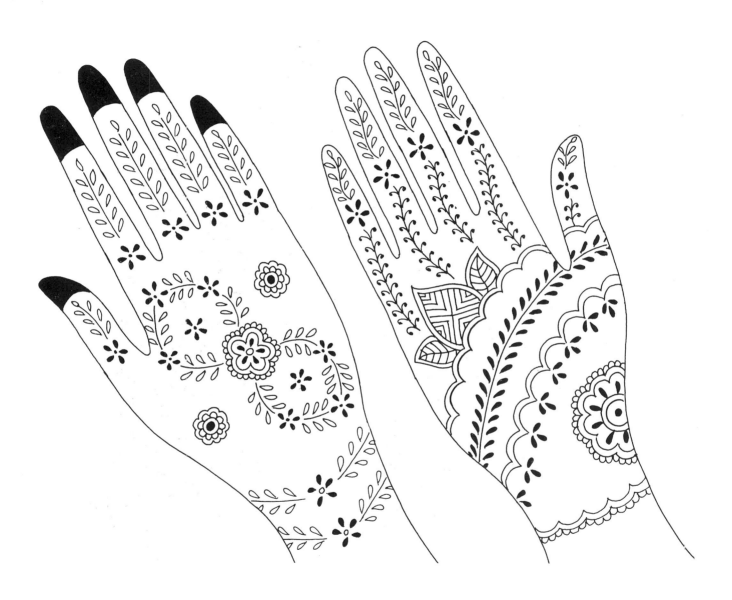

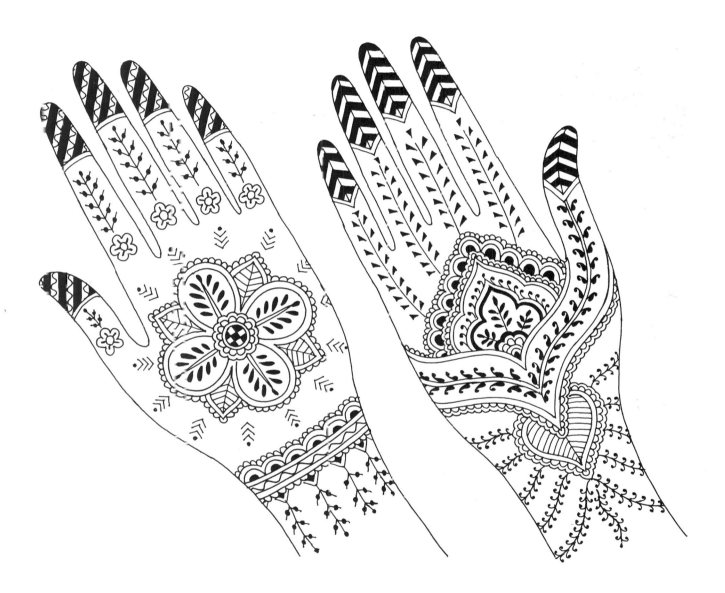

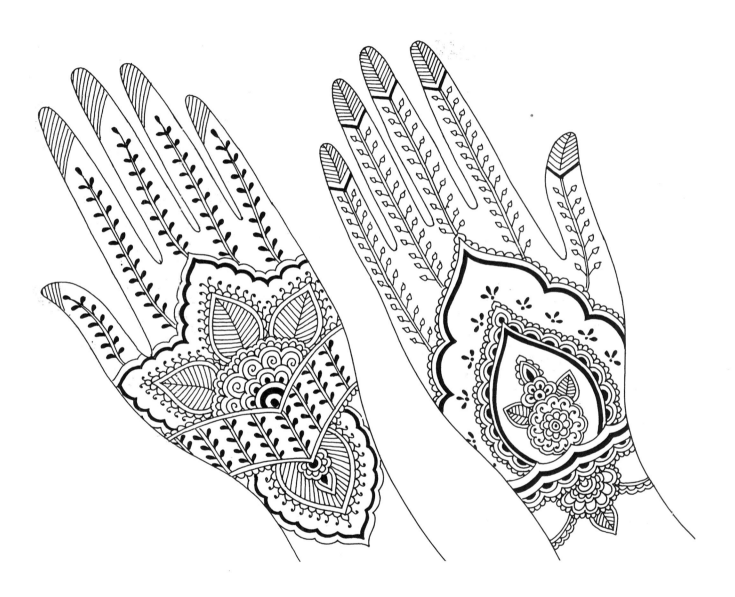

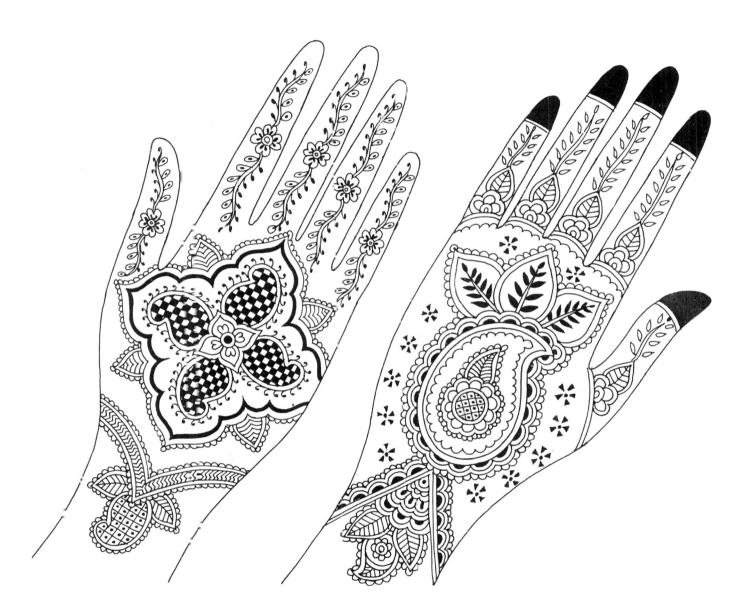

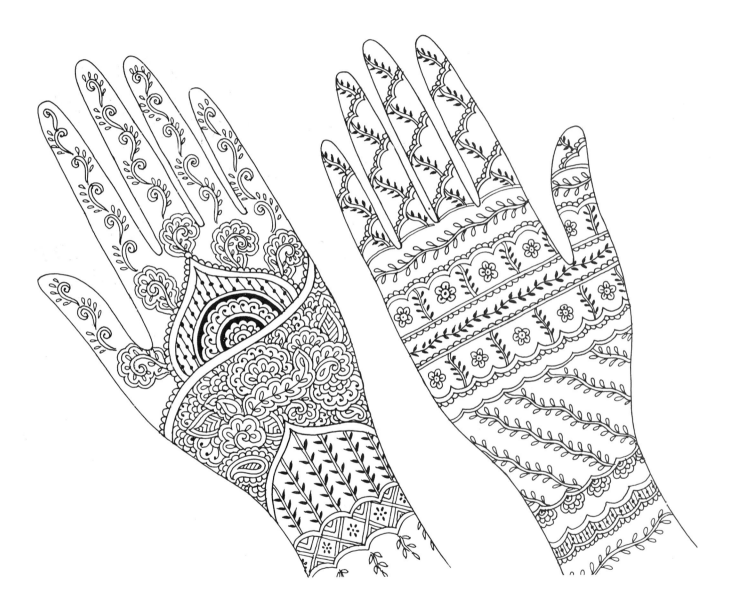

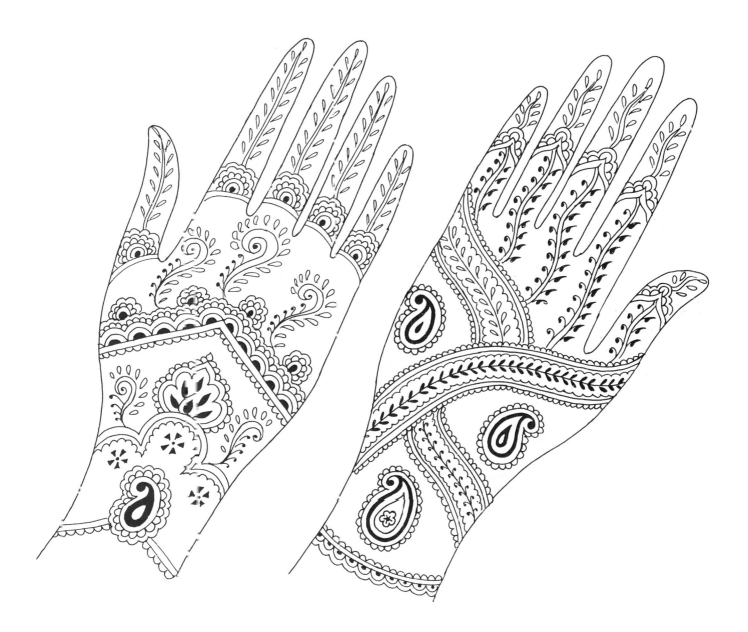

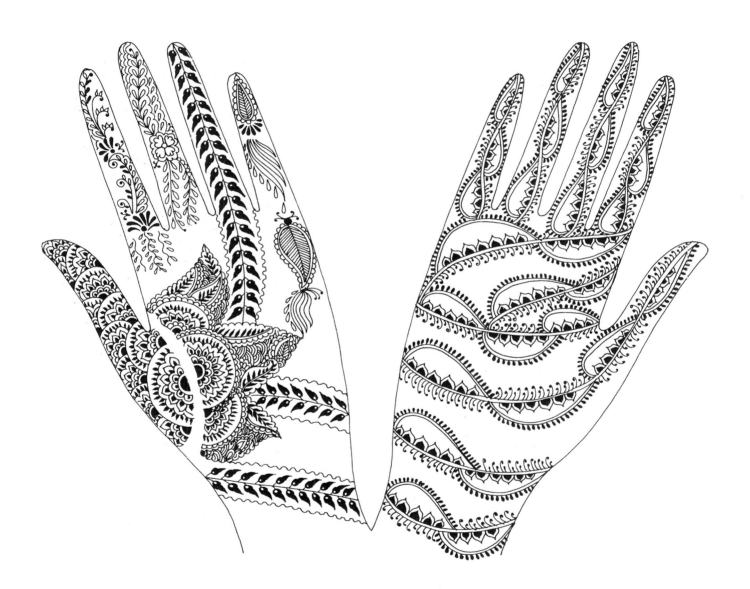

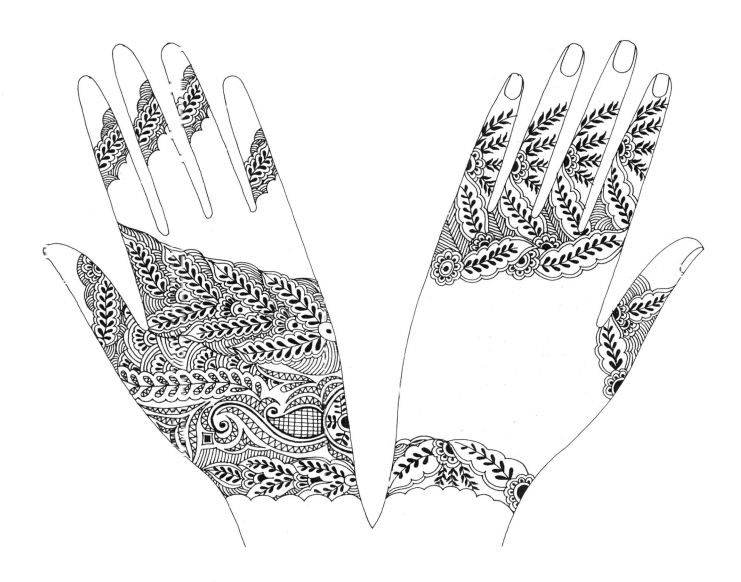

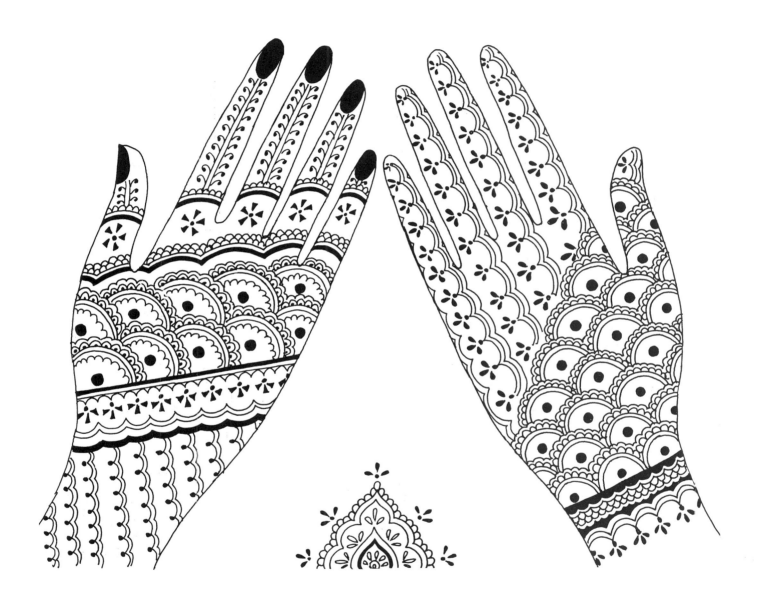

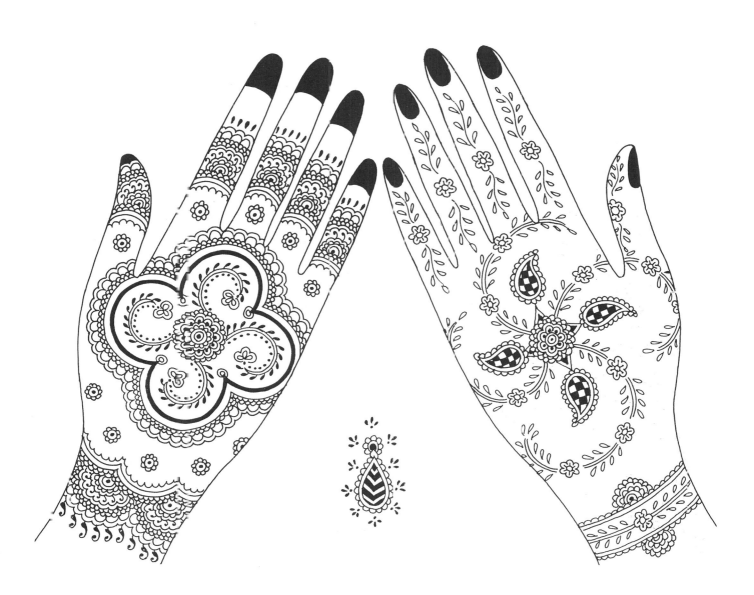

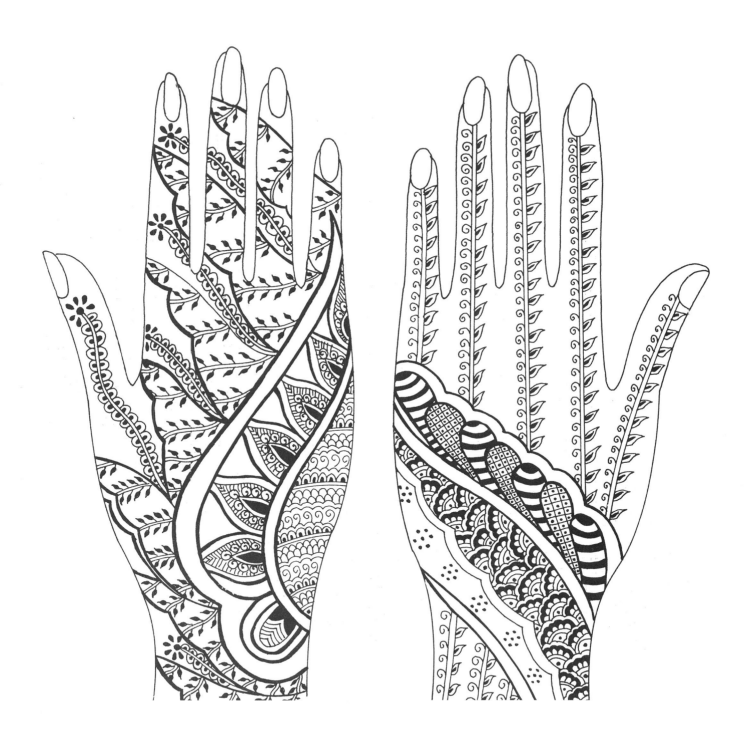

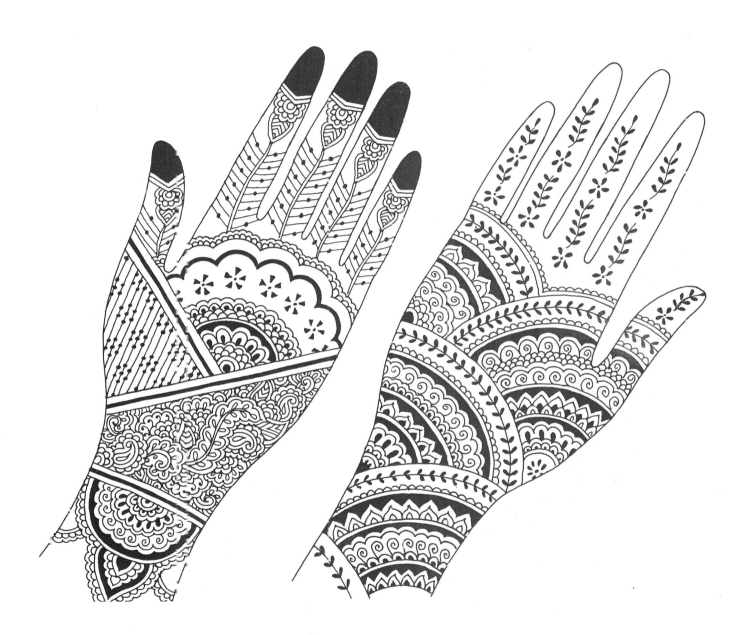

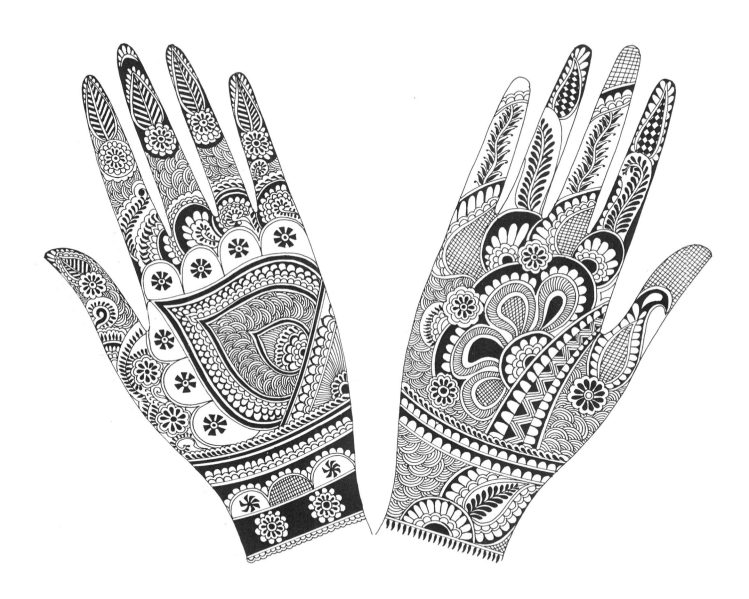

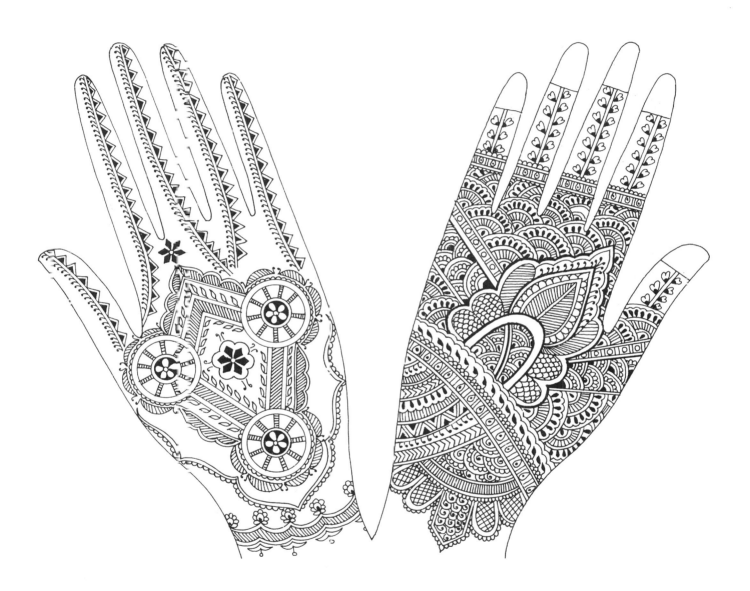

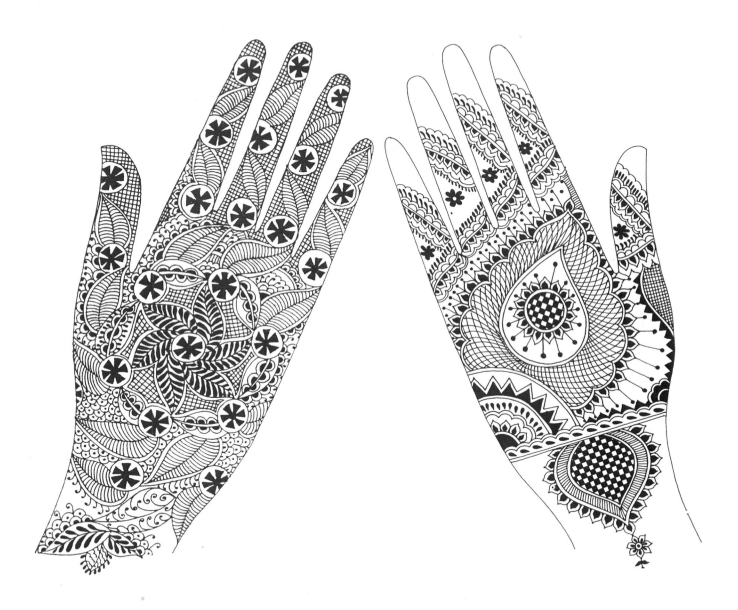

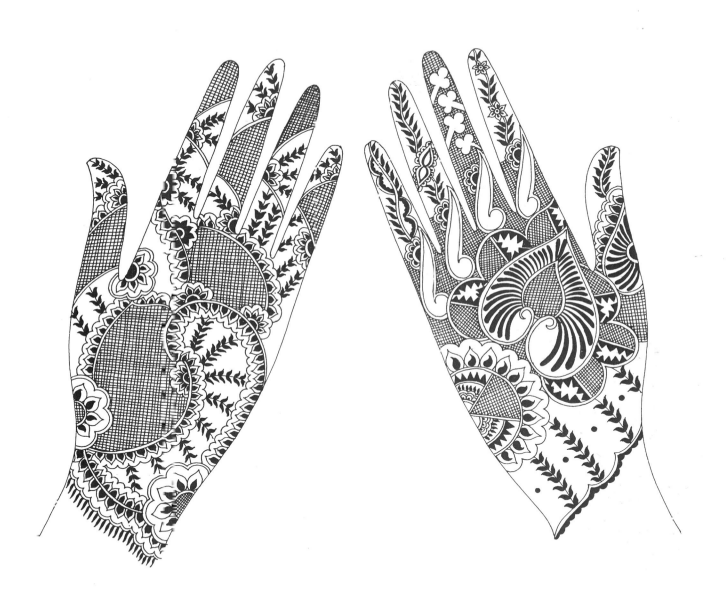

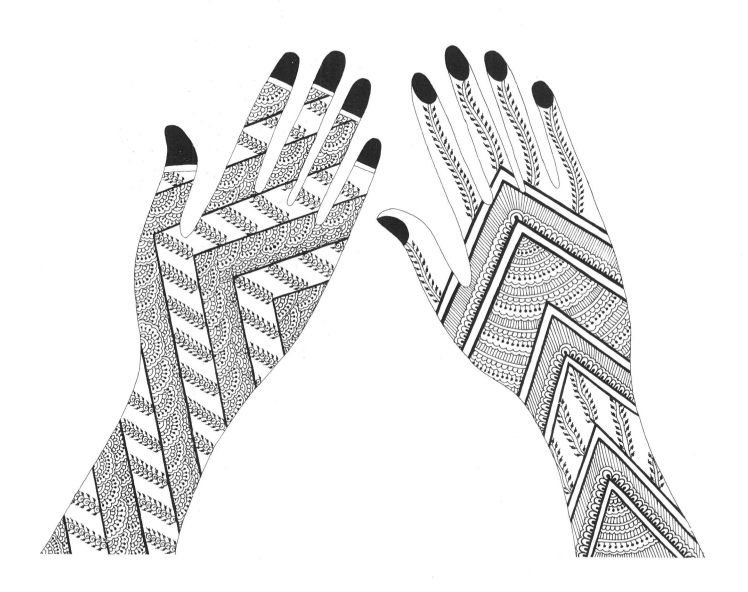

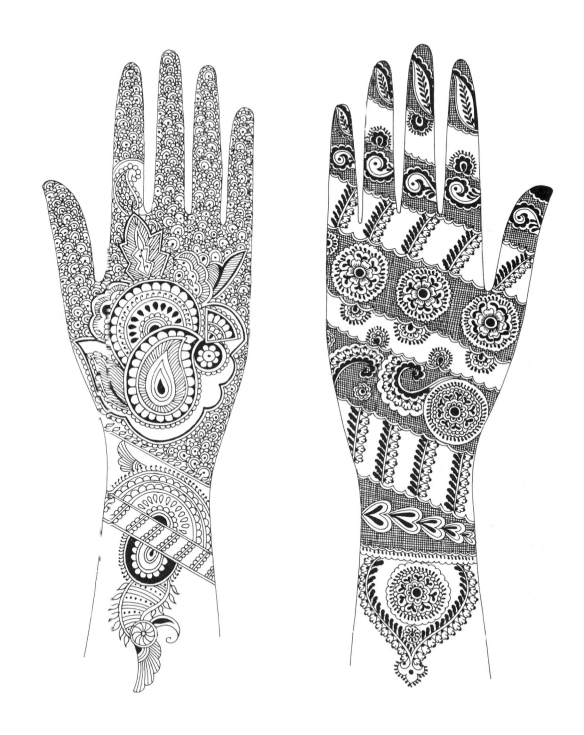

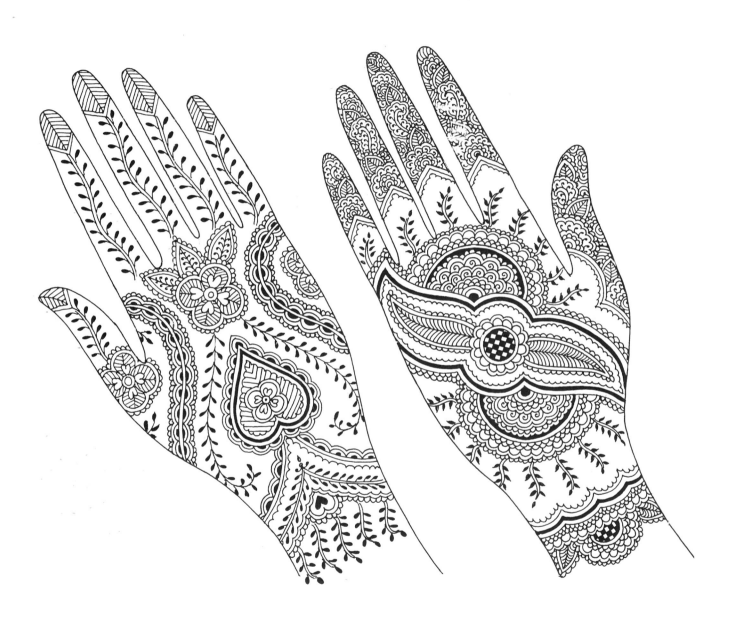

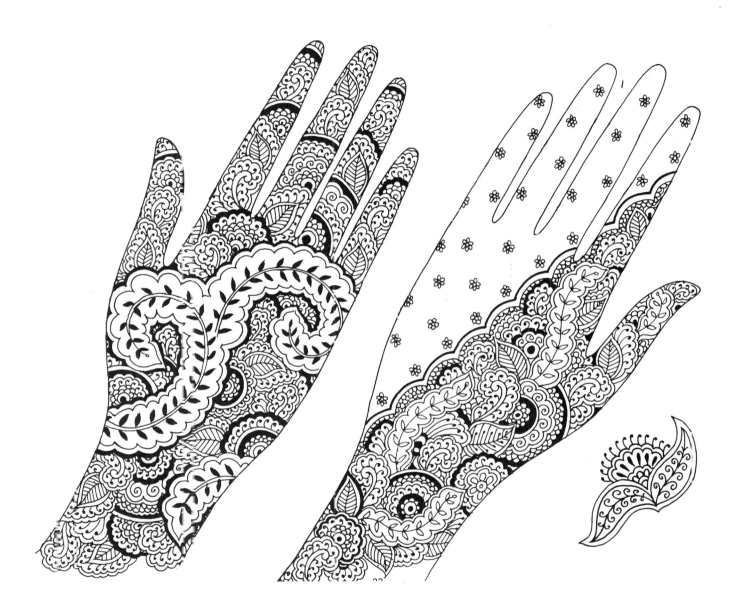

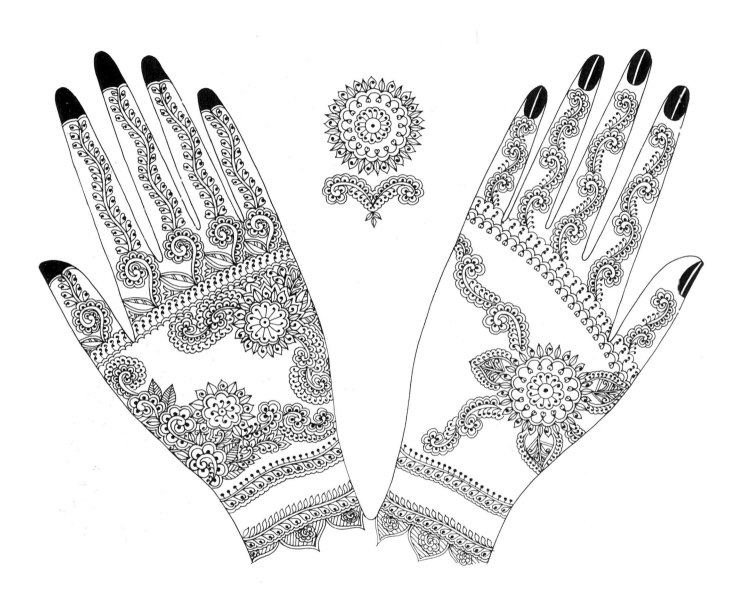

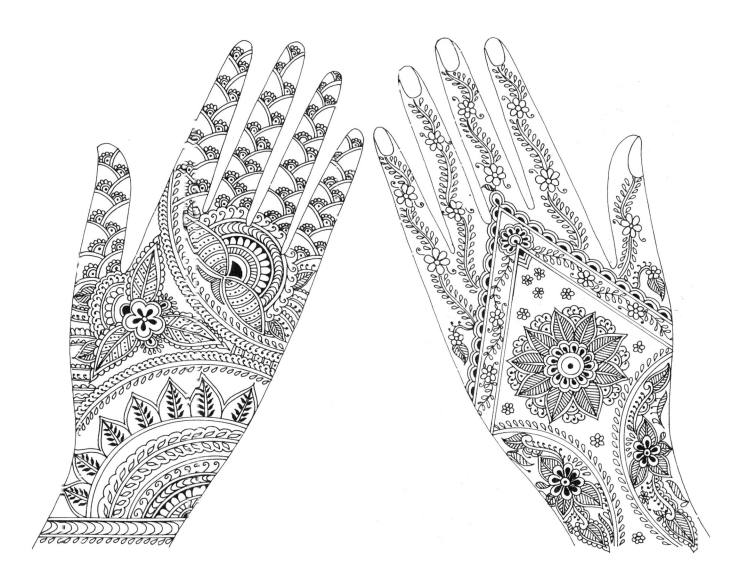

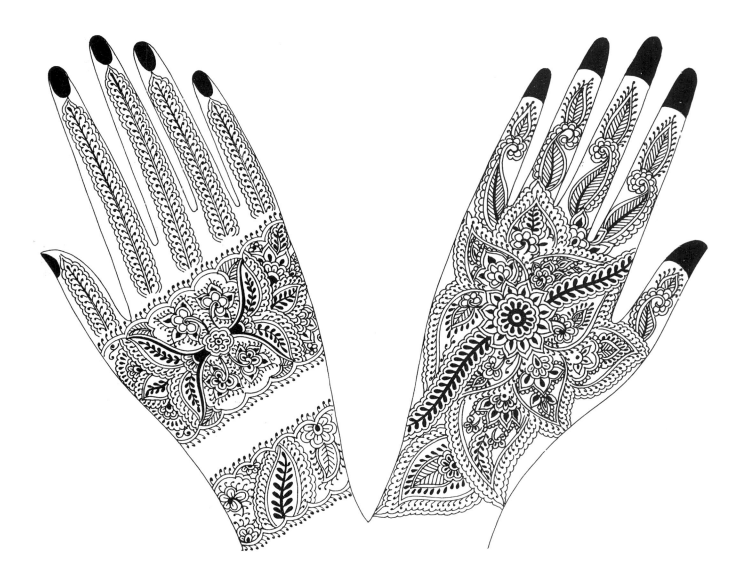

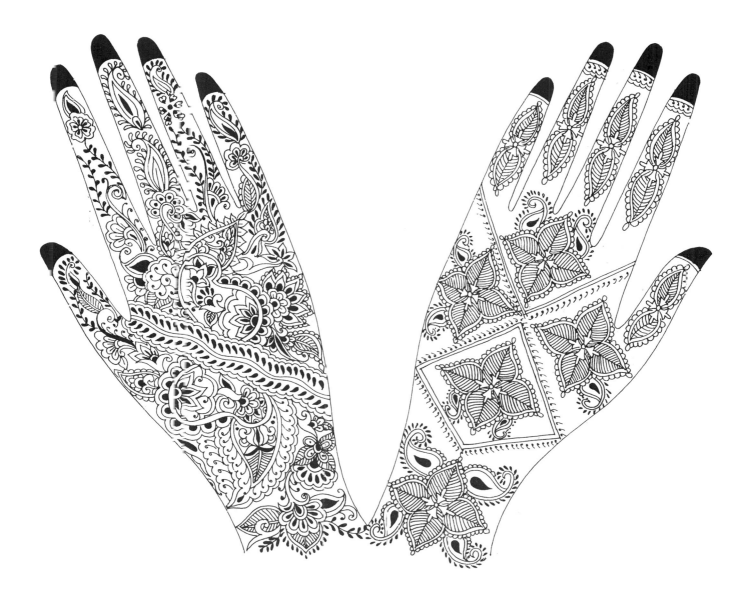

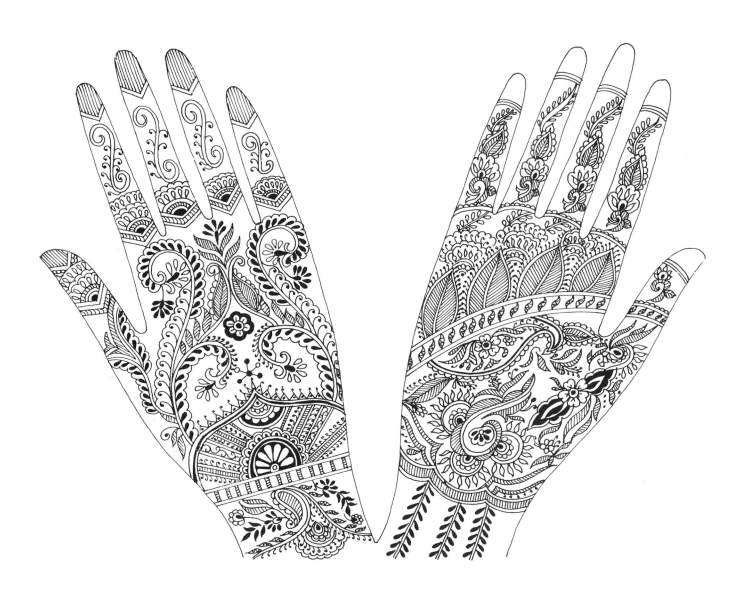

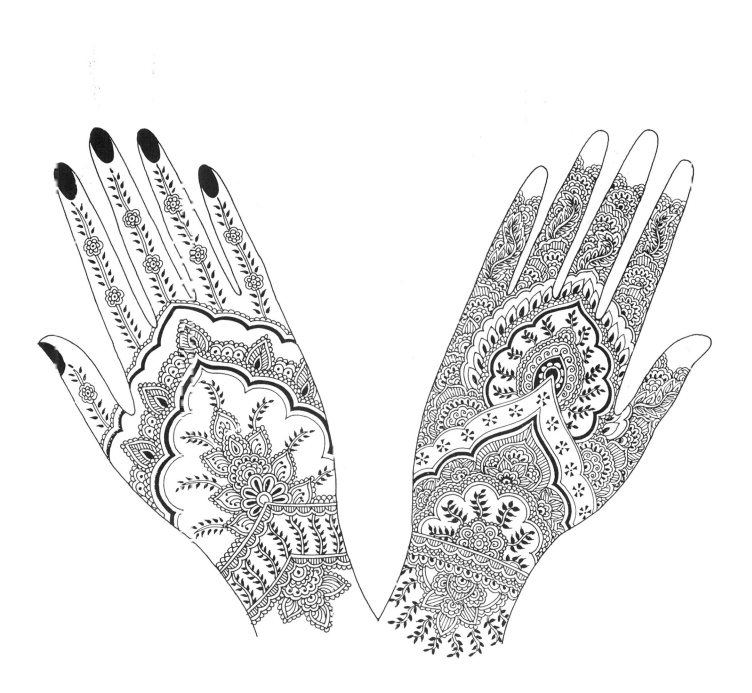

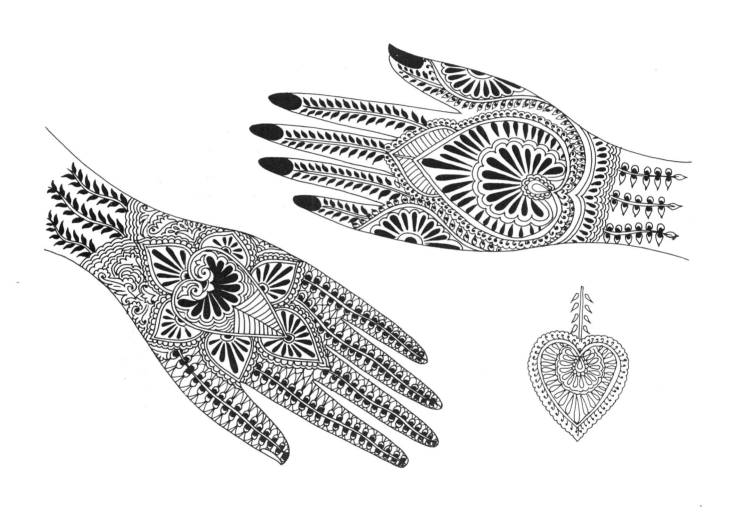

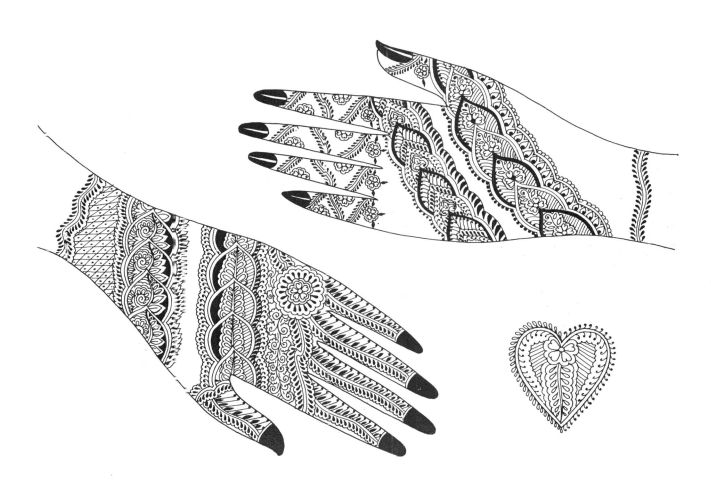

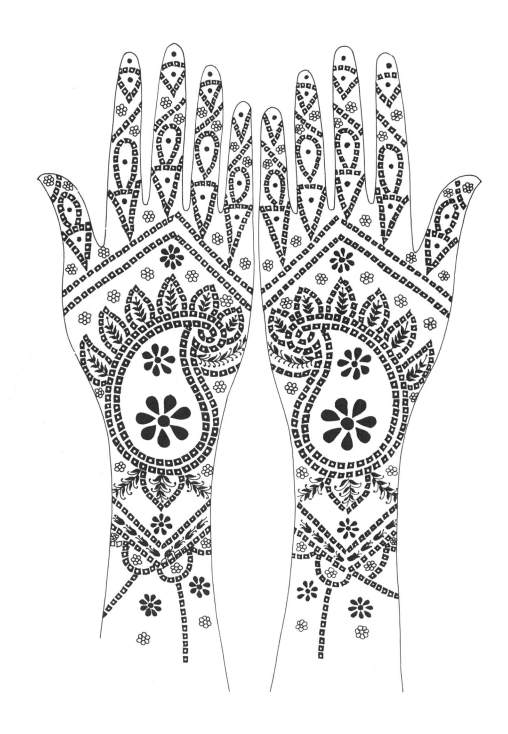

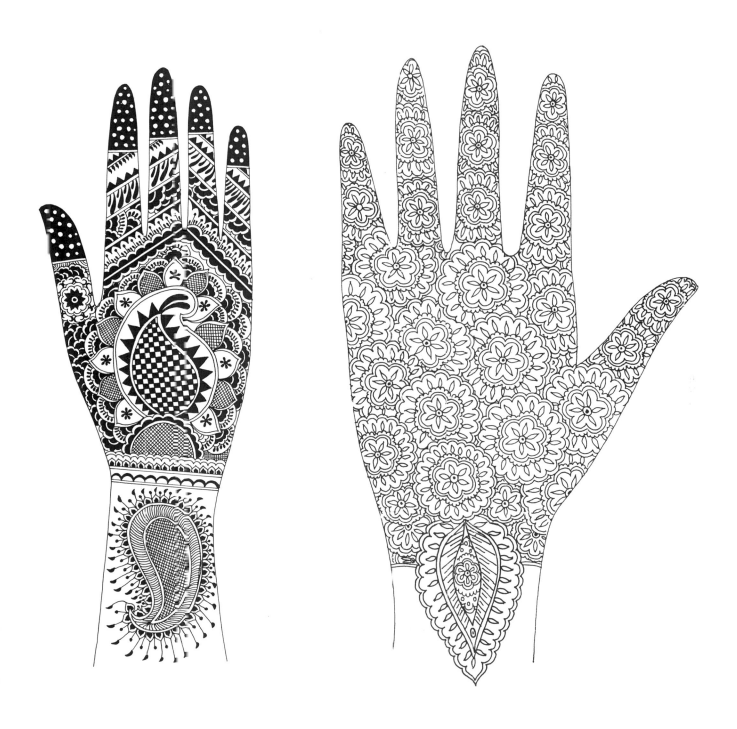

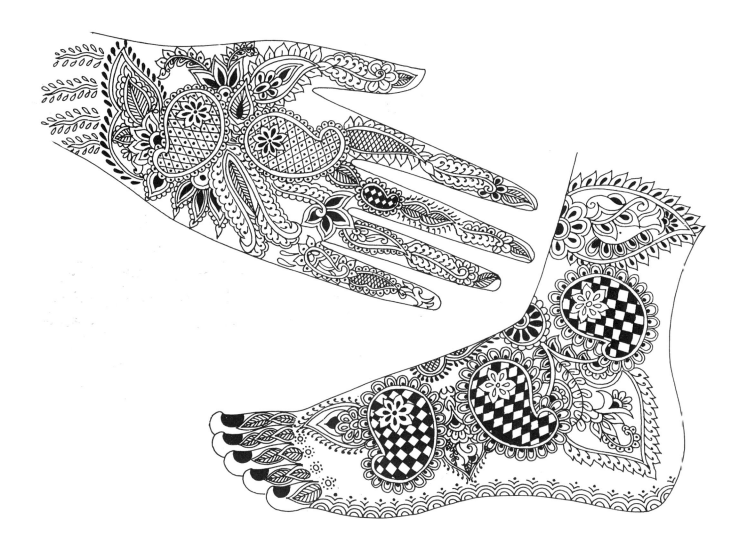

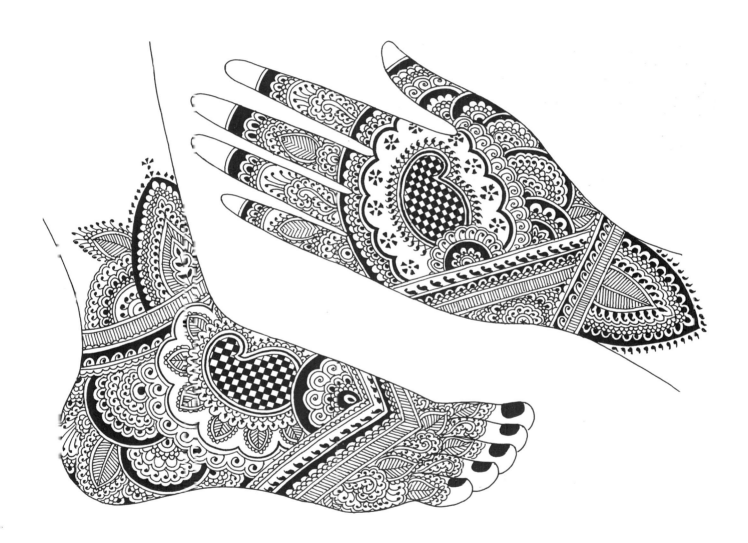

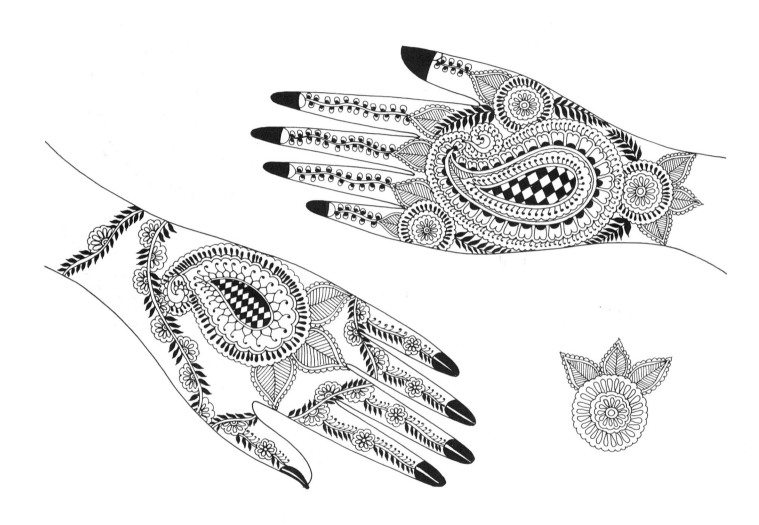

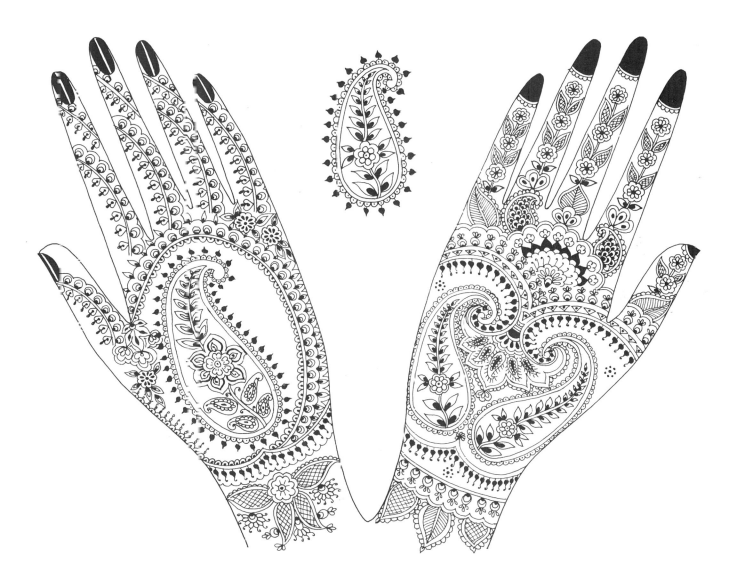

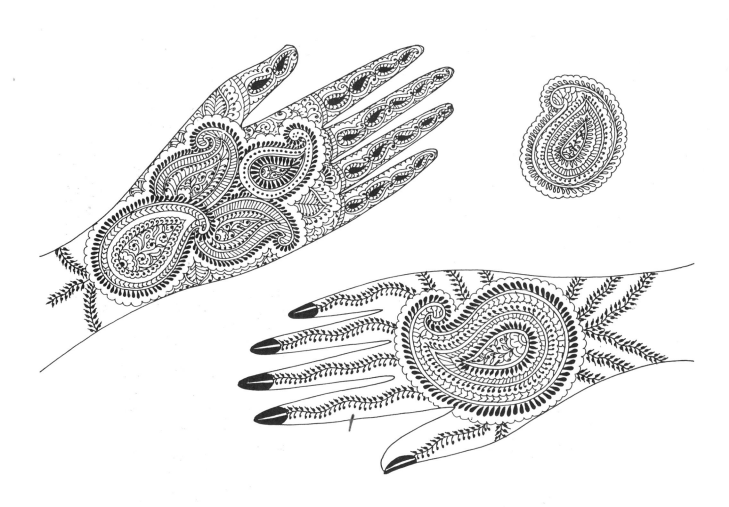

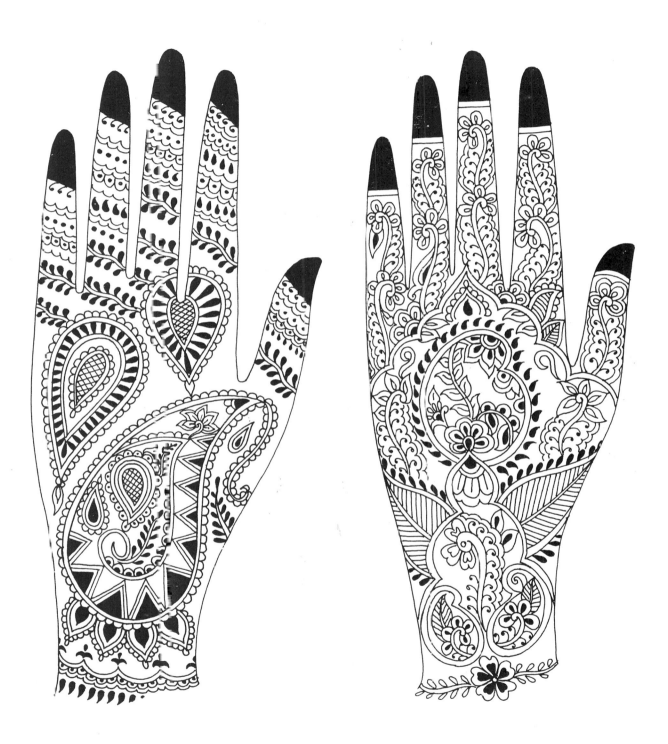

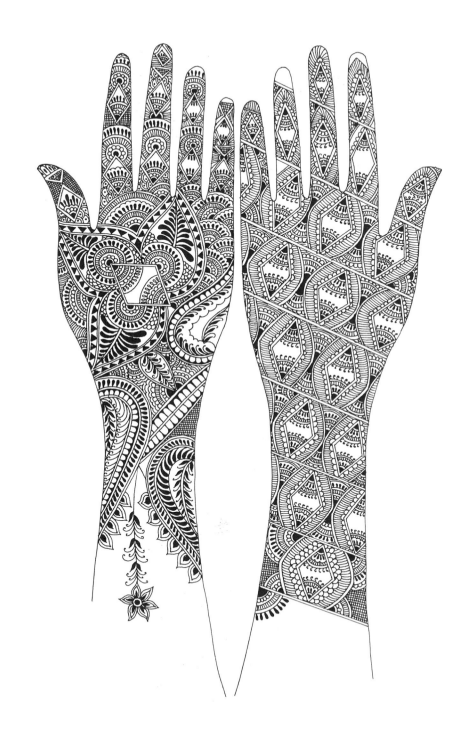

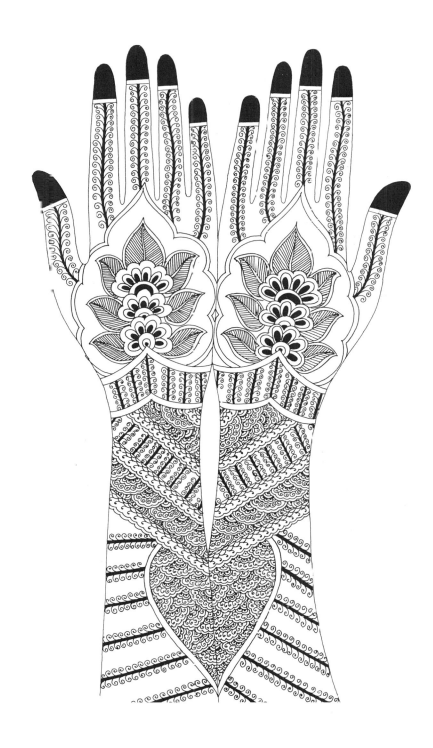

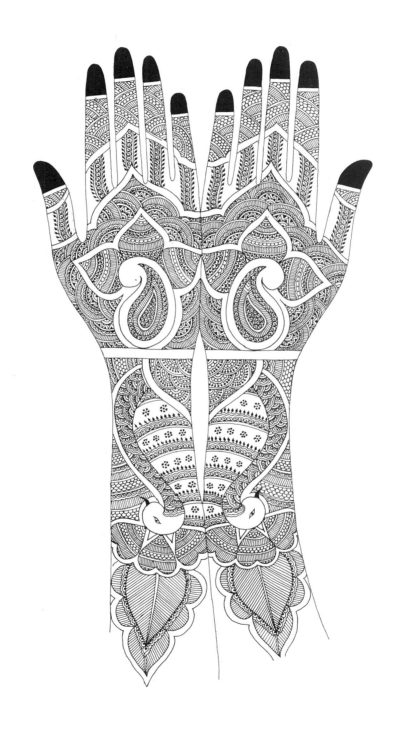

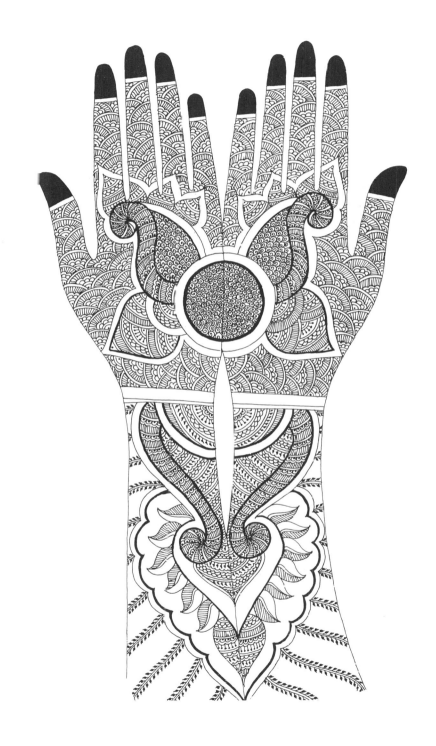

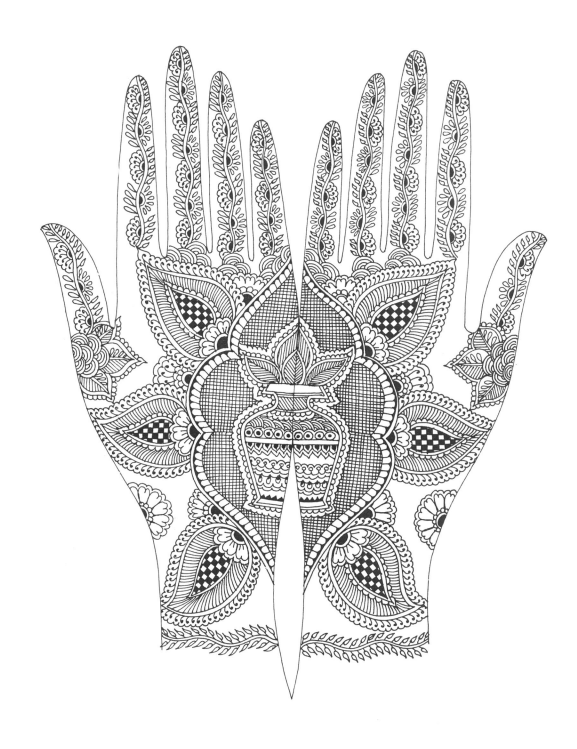

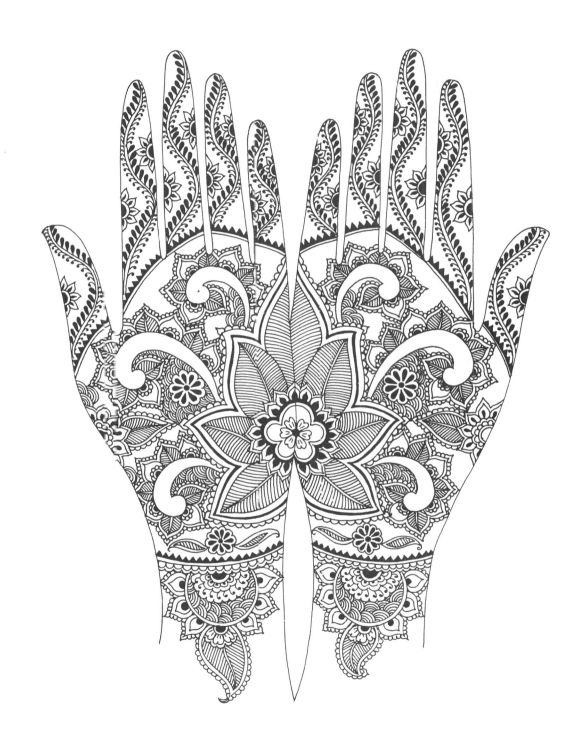

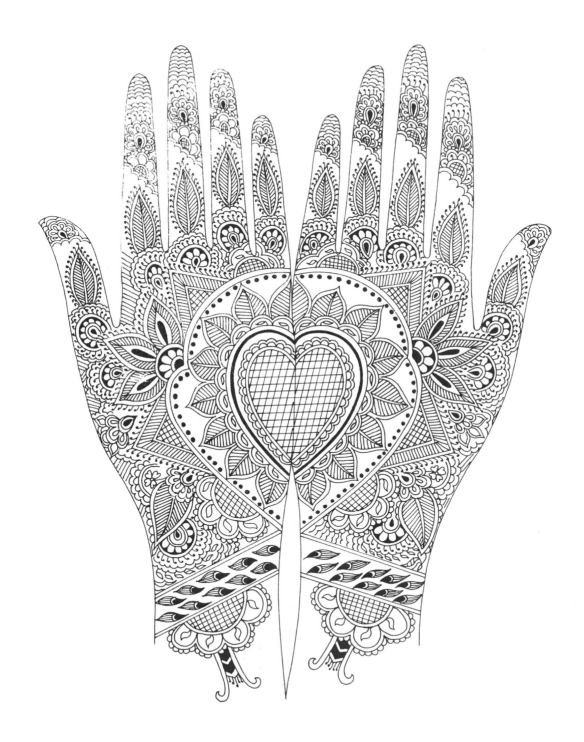

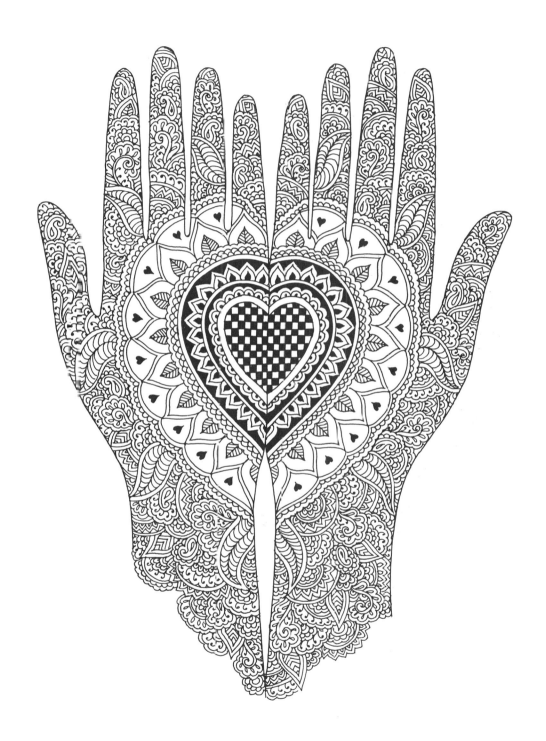

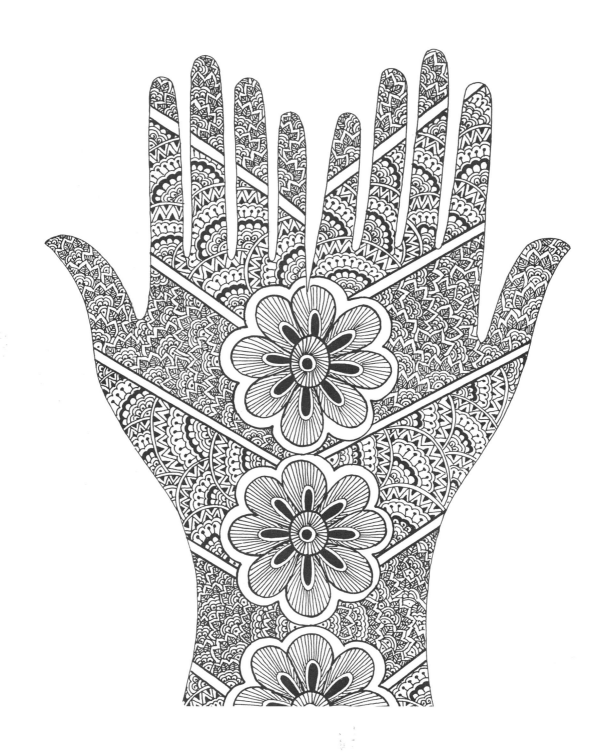

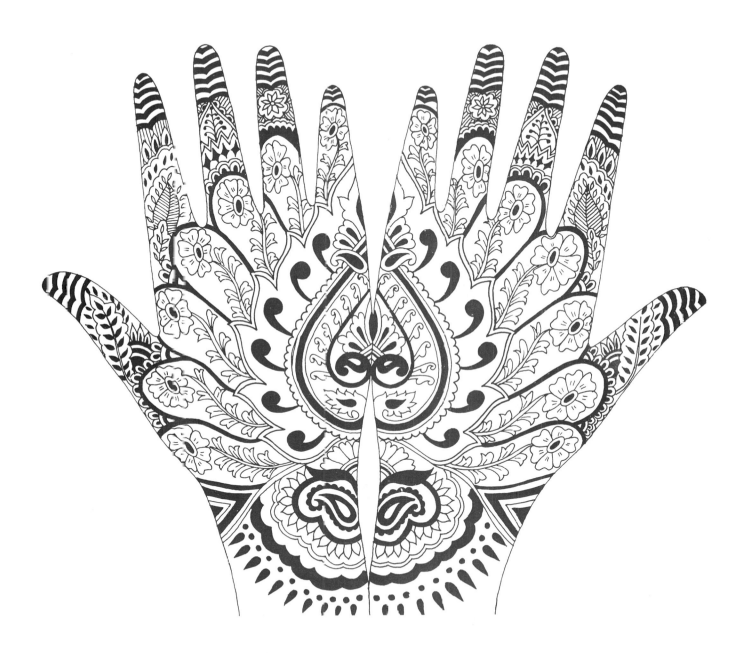

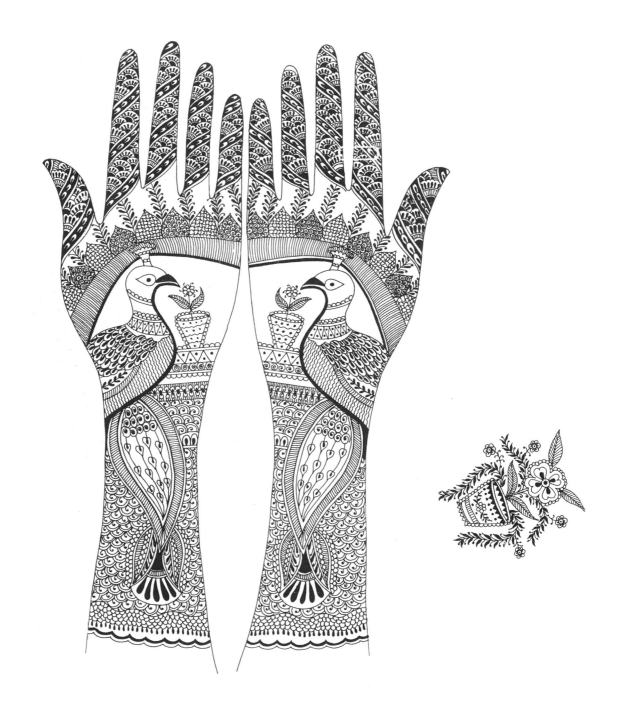

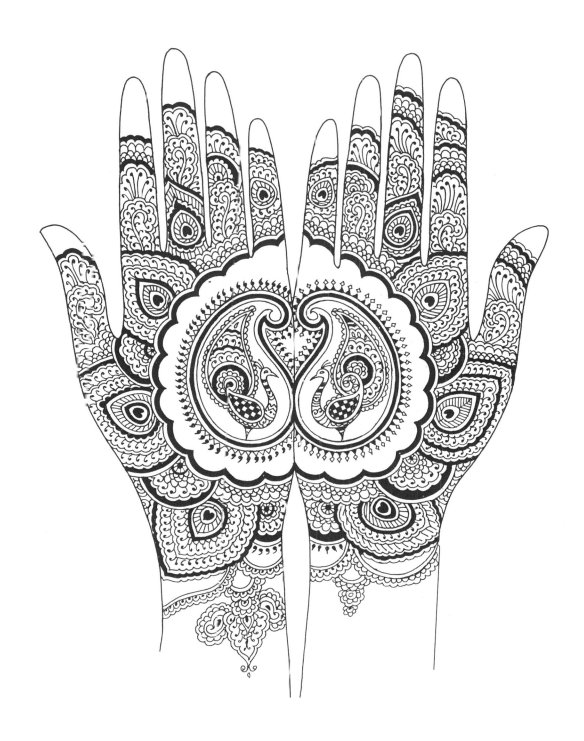

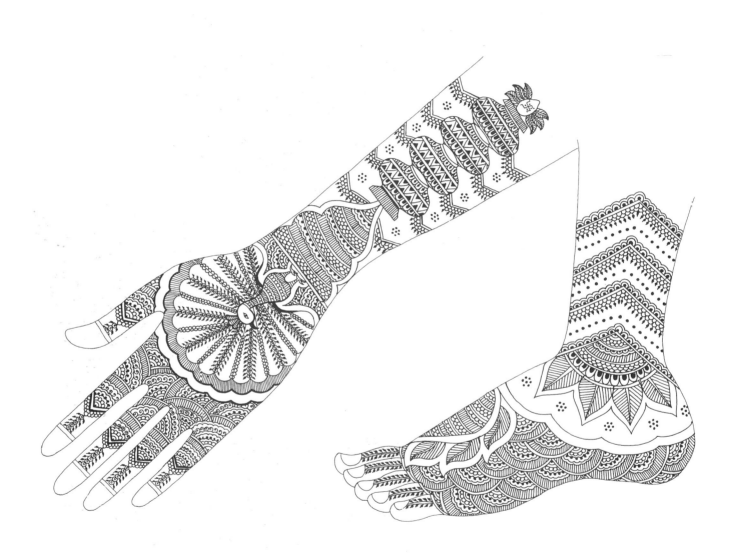

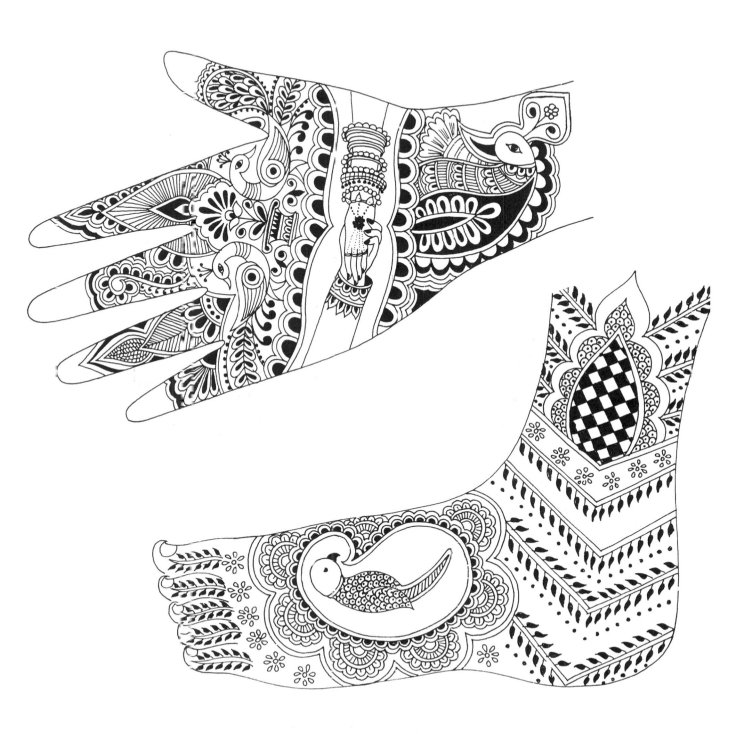

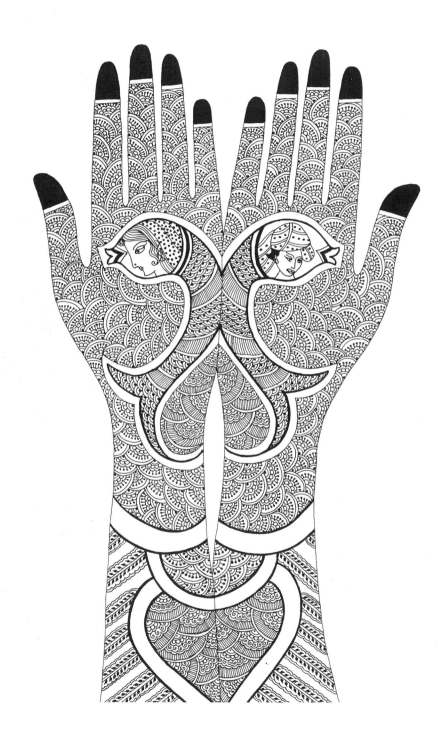

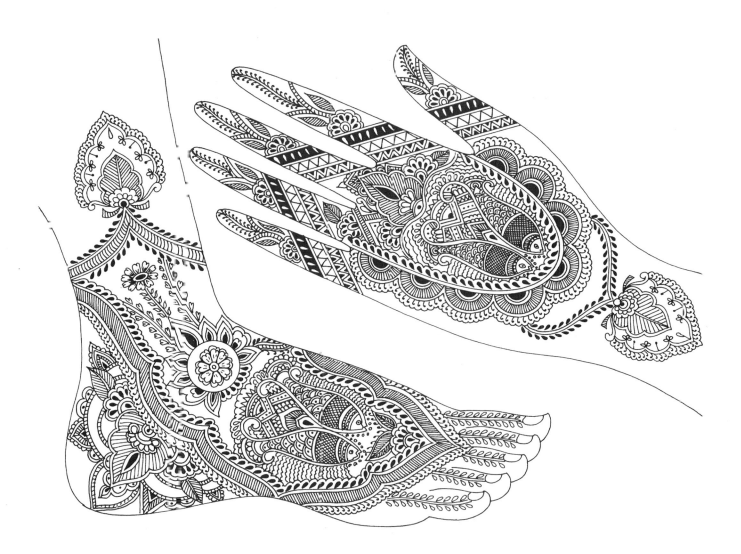

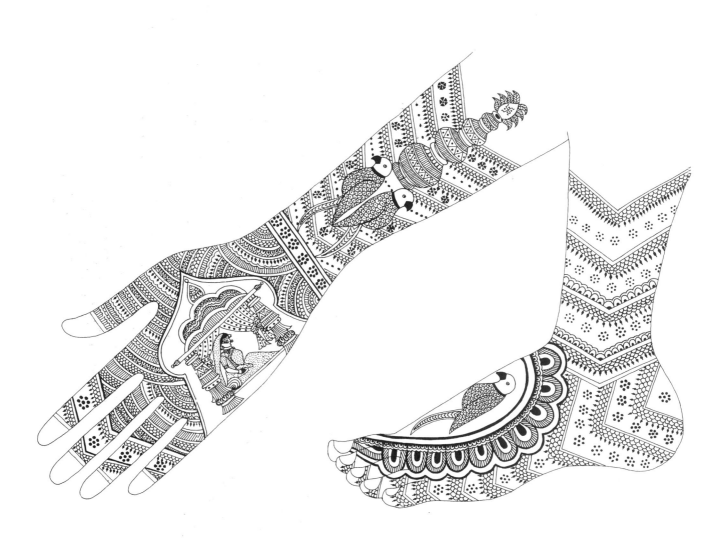

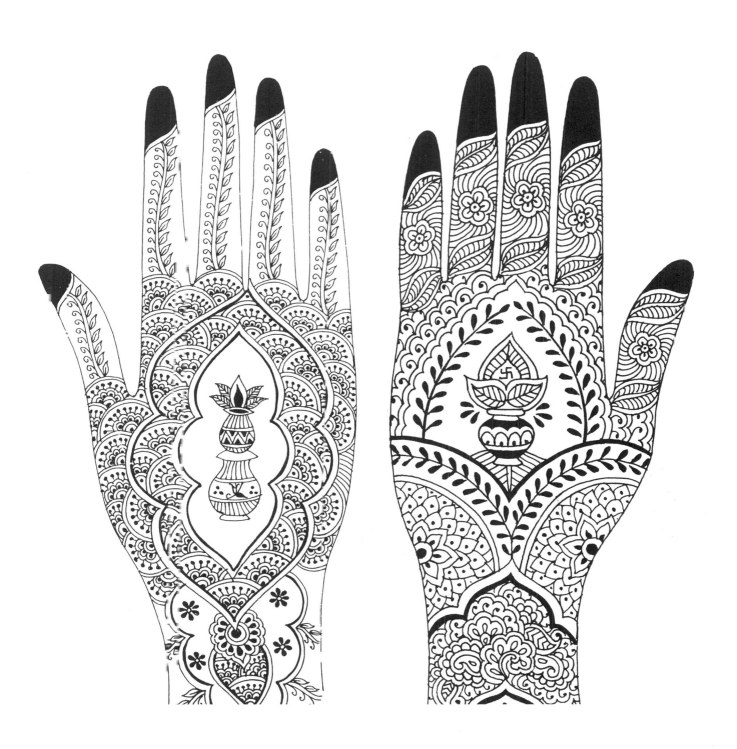

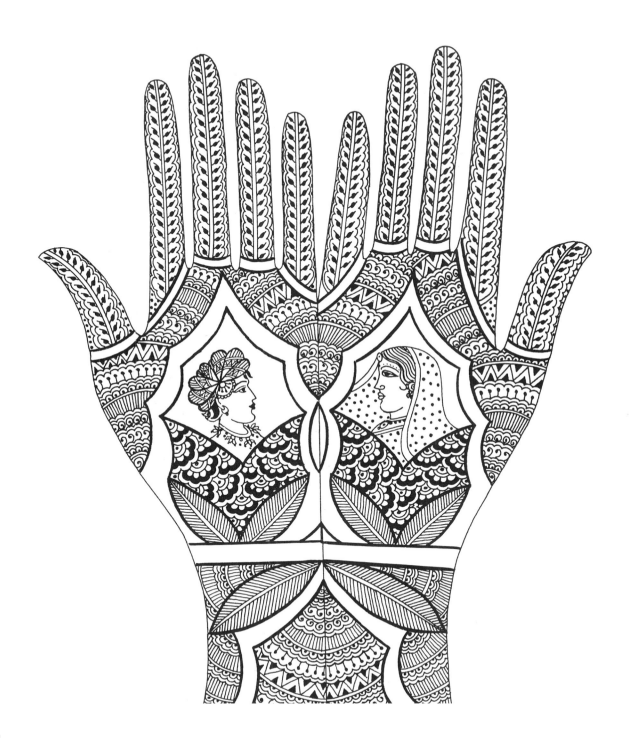

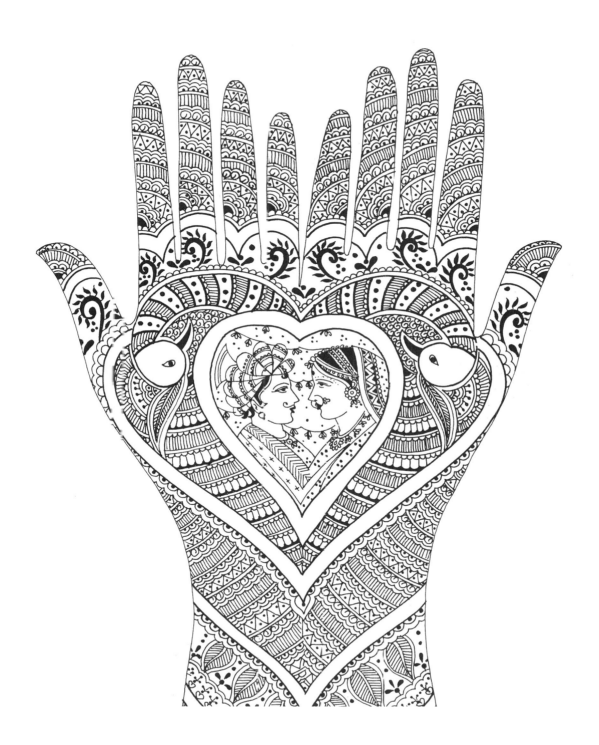

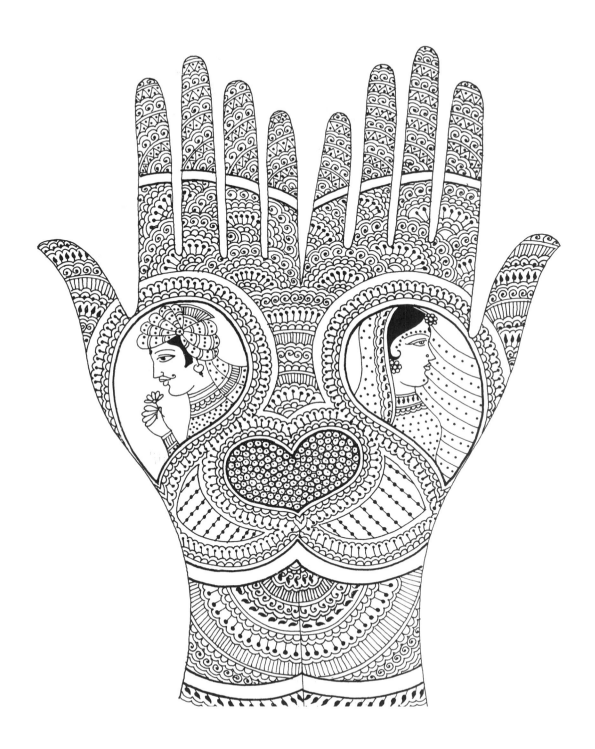

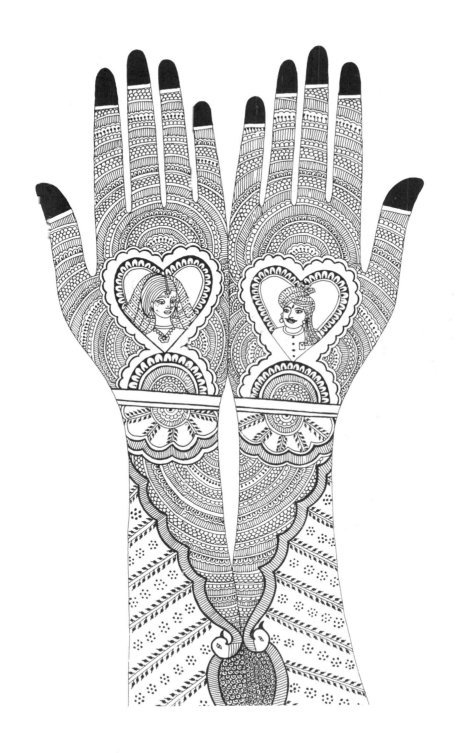

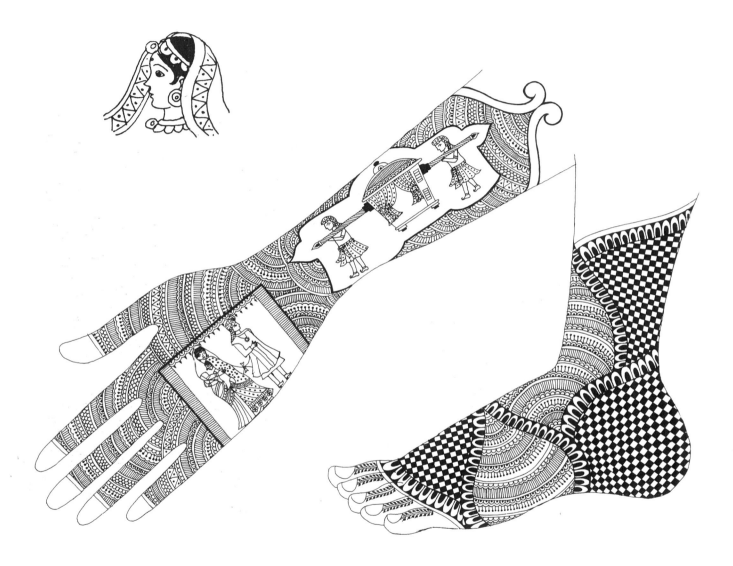

138

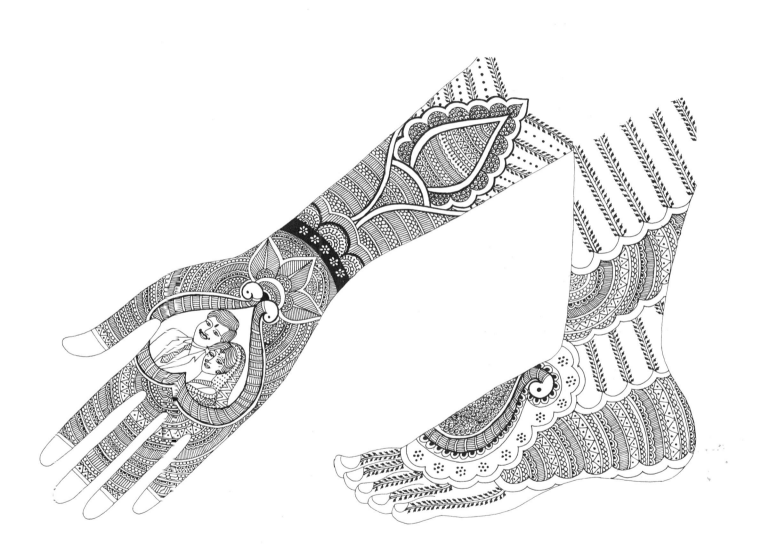

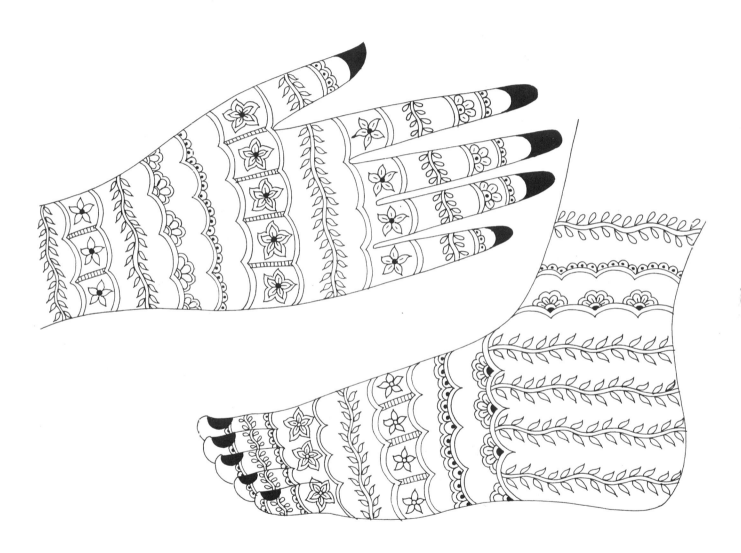

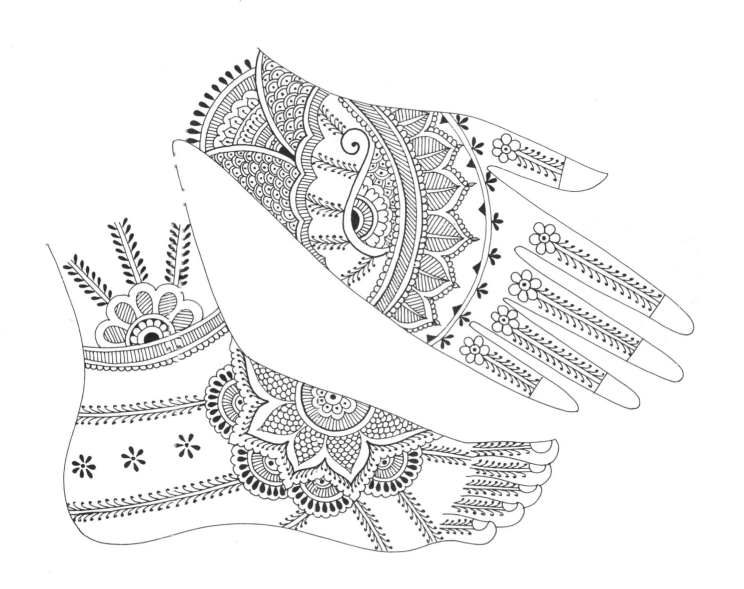

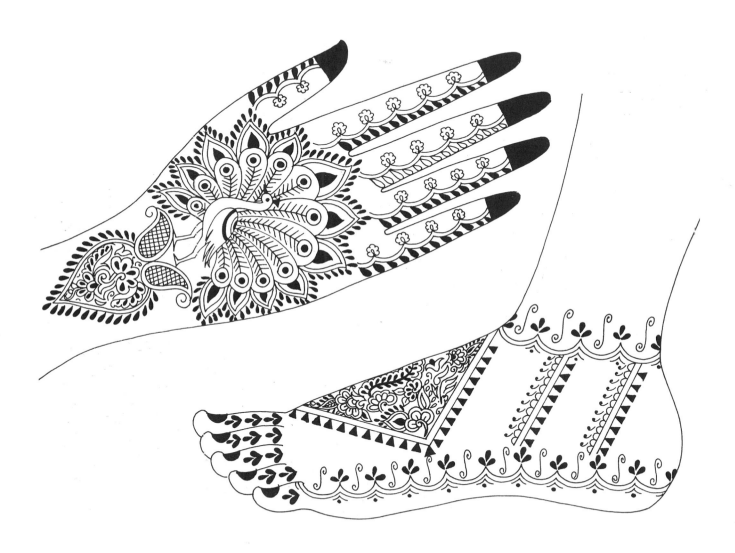

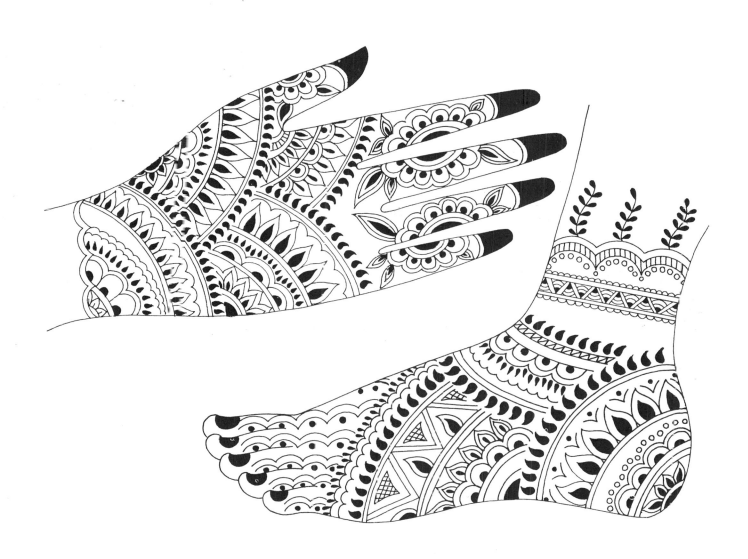

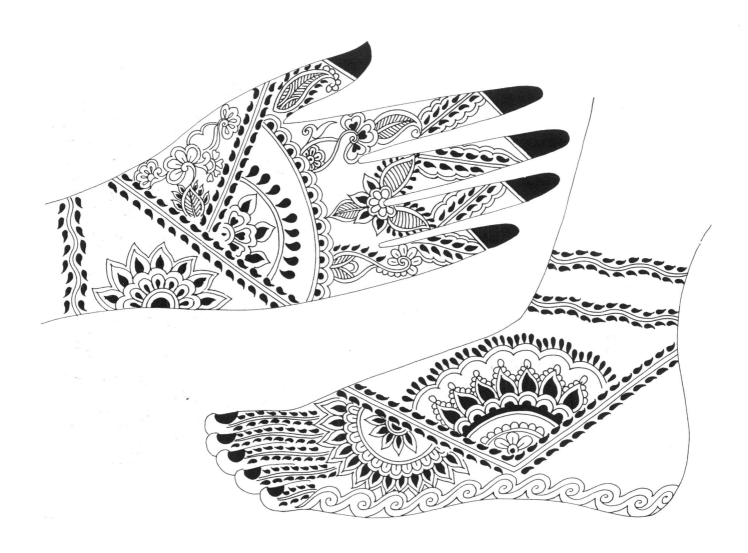

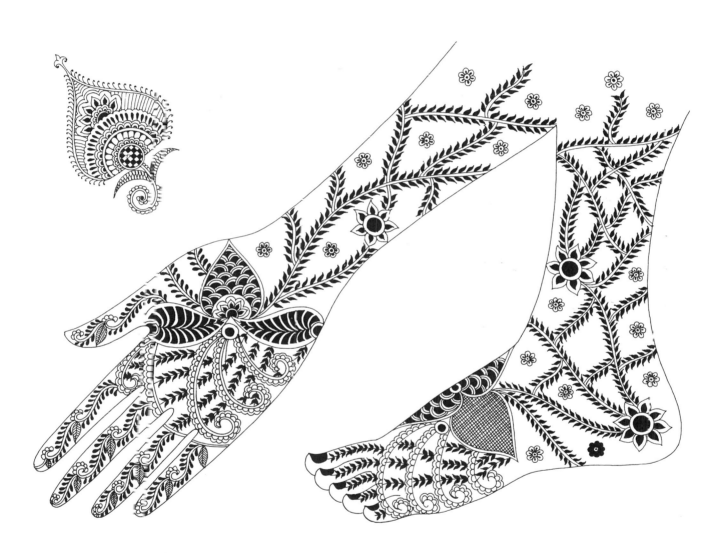

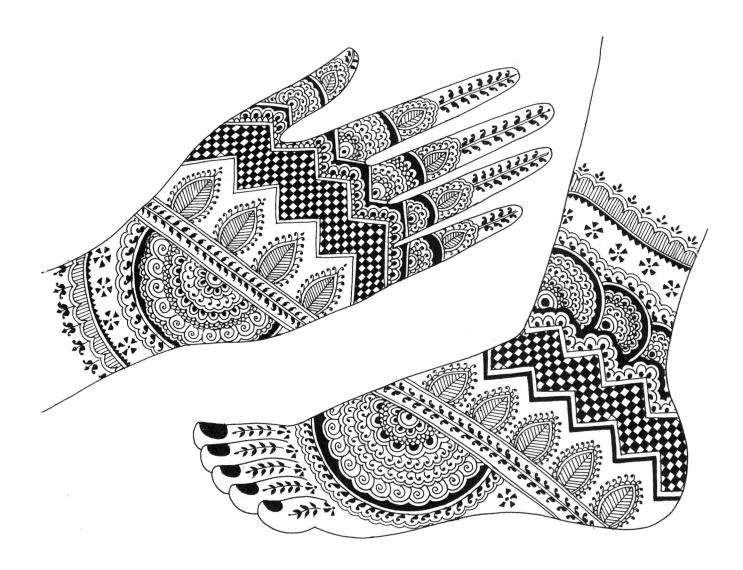

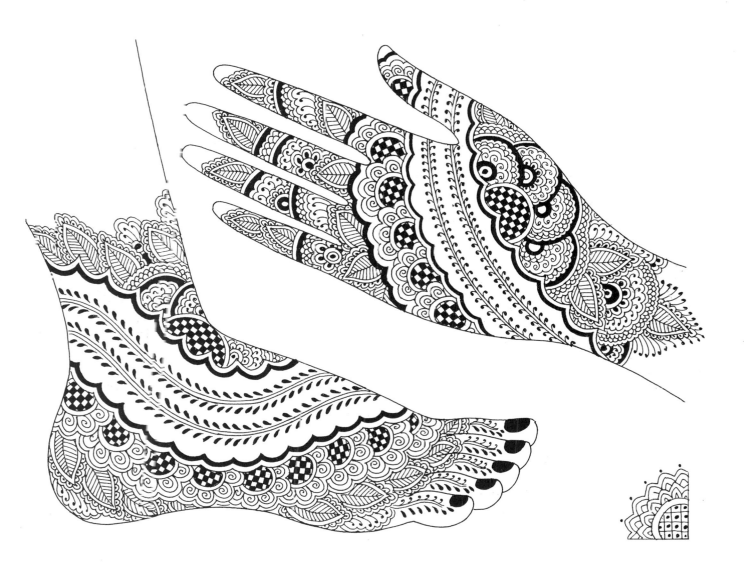

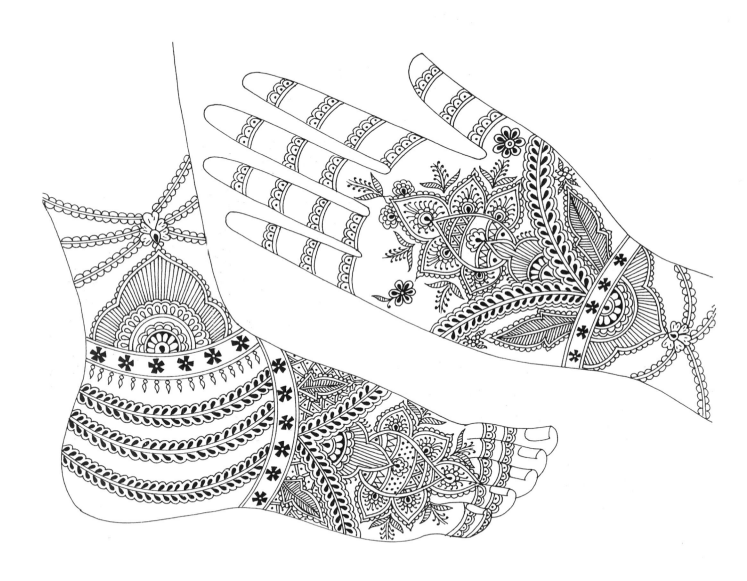

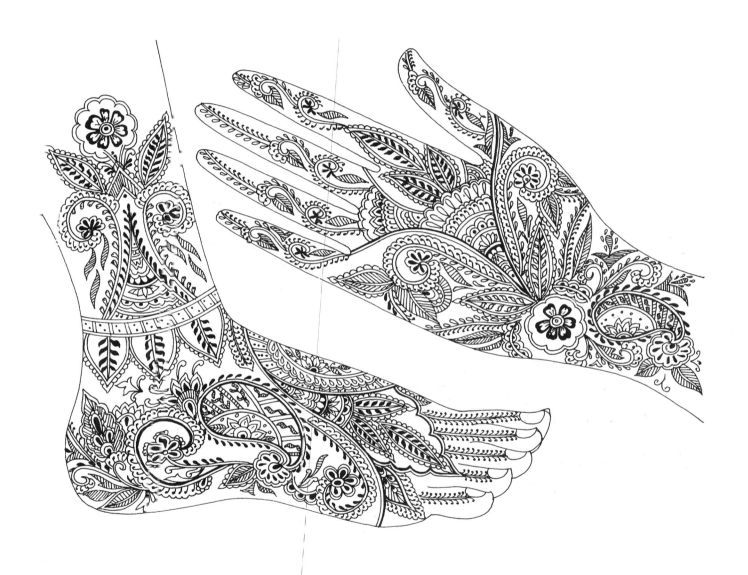

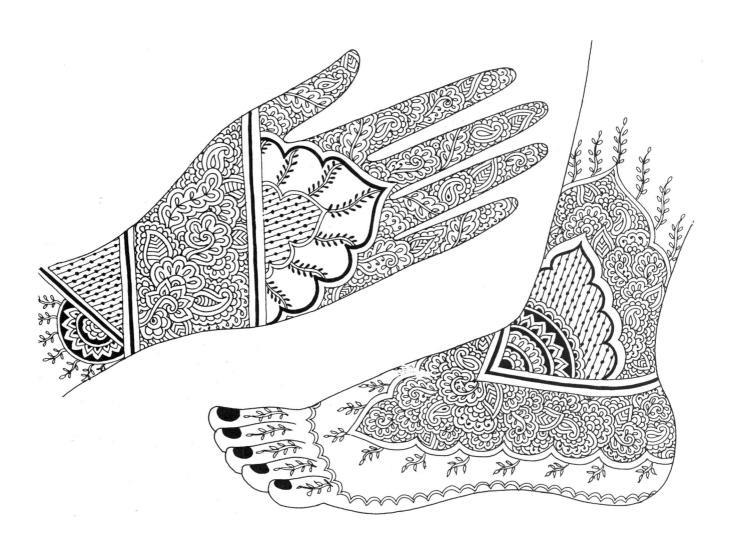

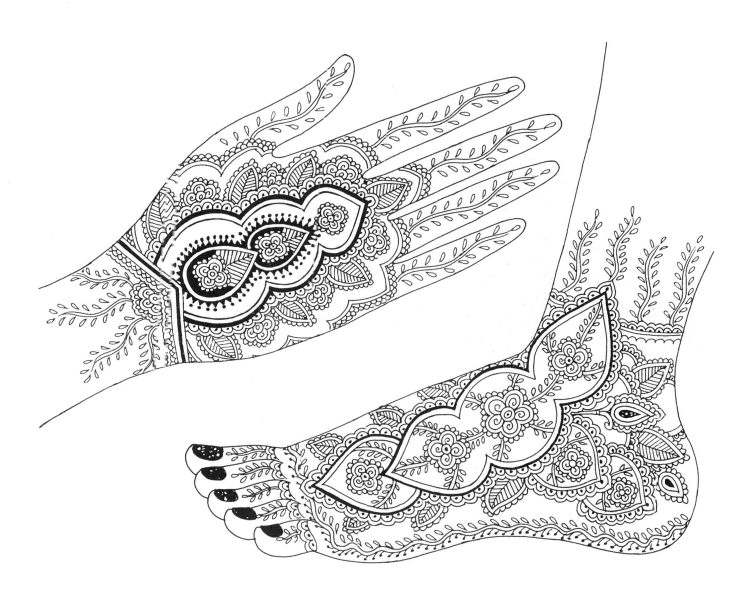

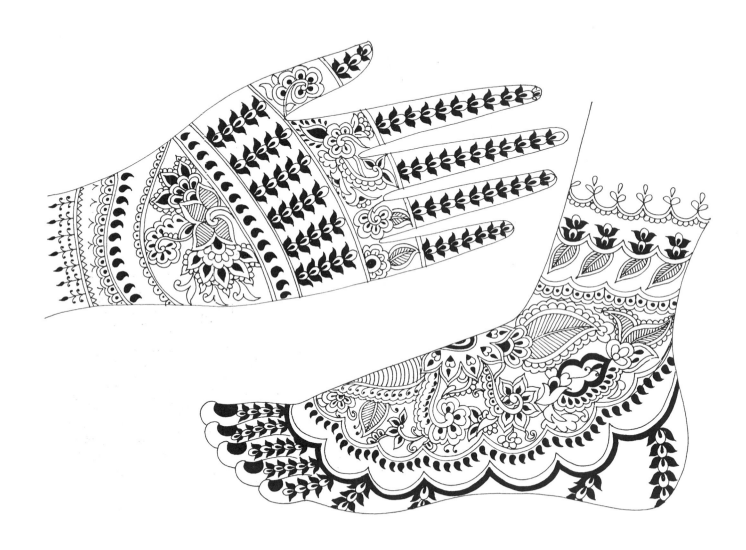

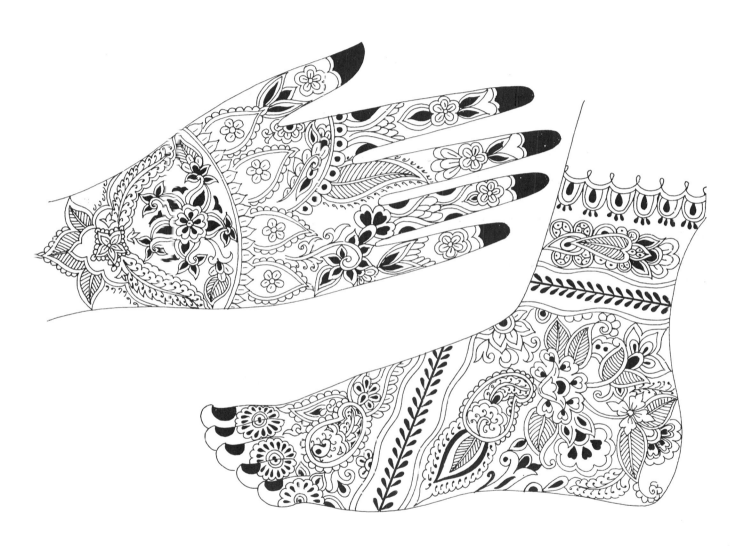

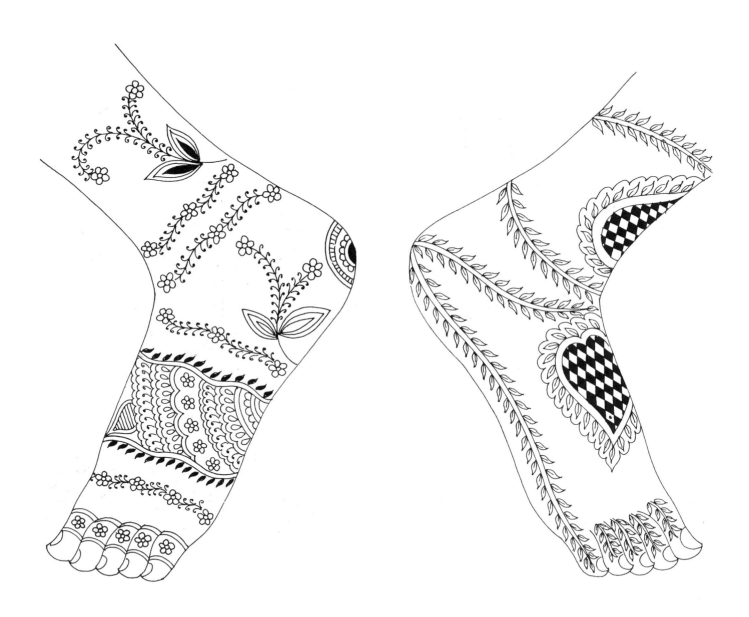

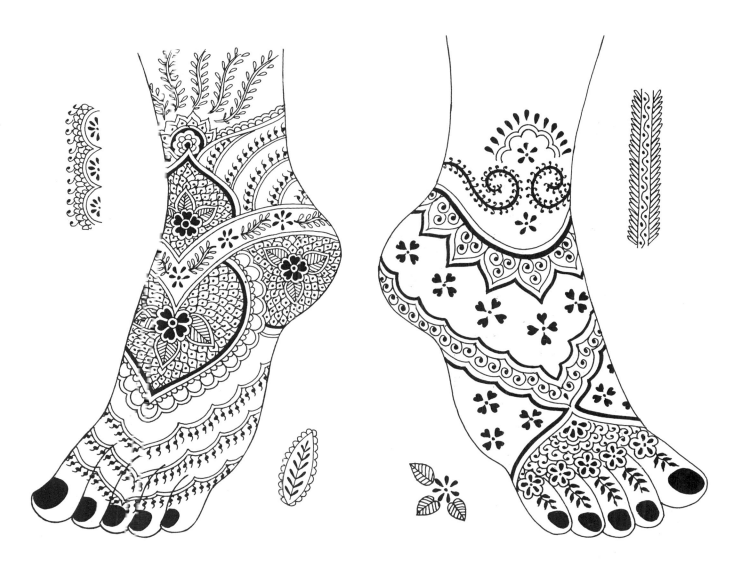

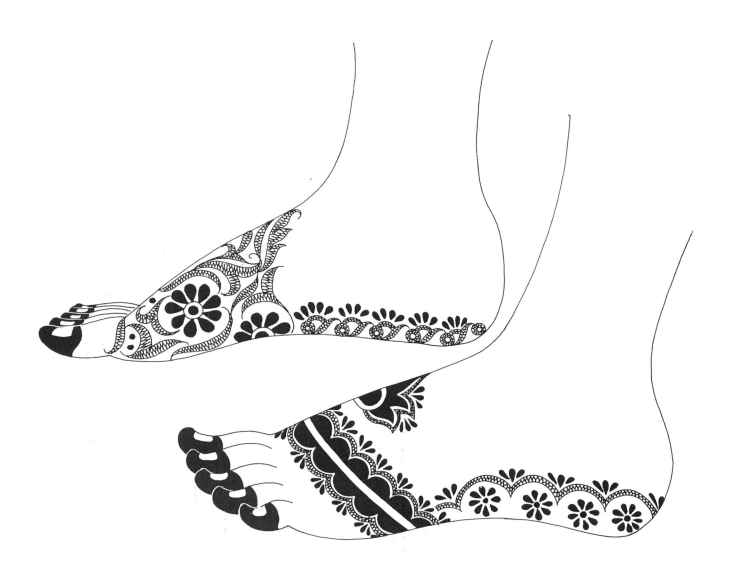

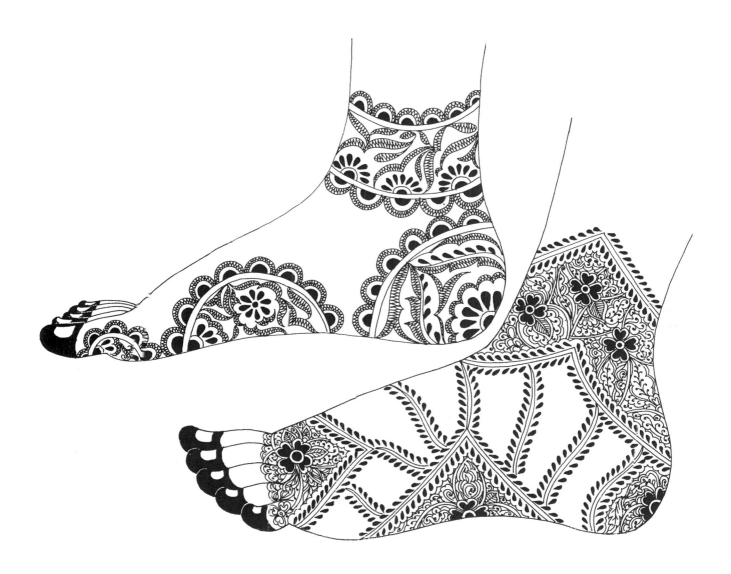

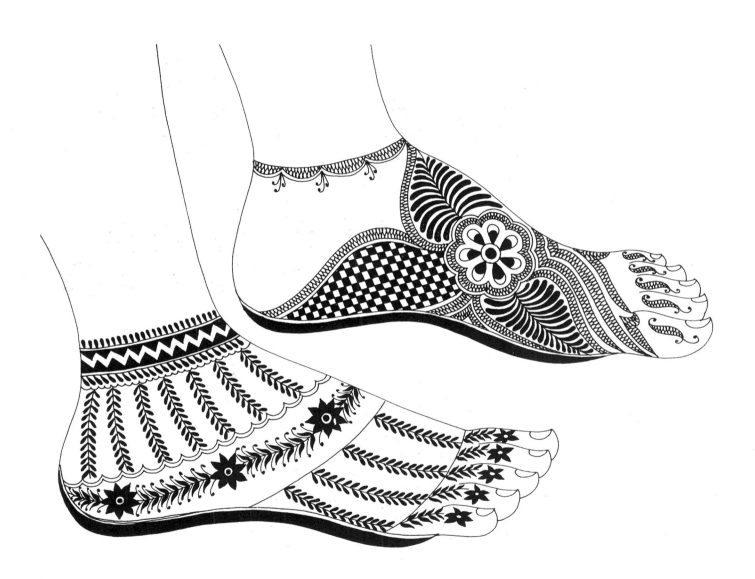

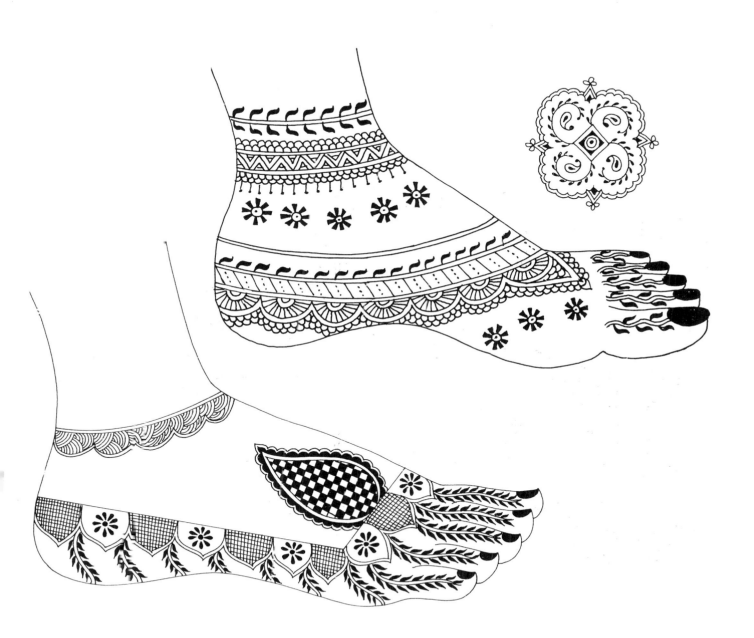

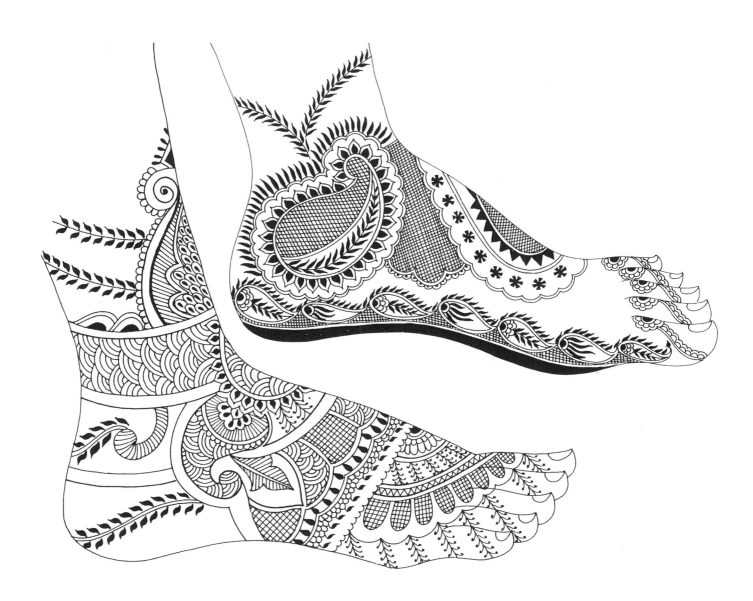

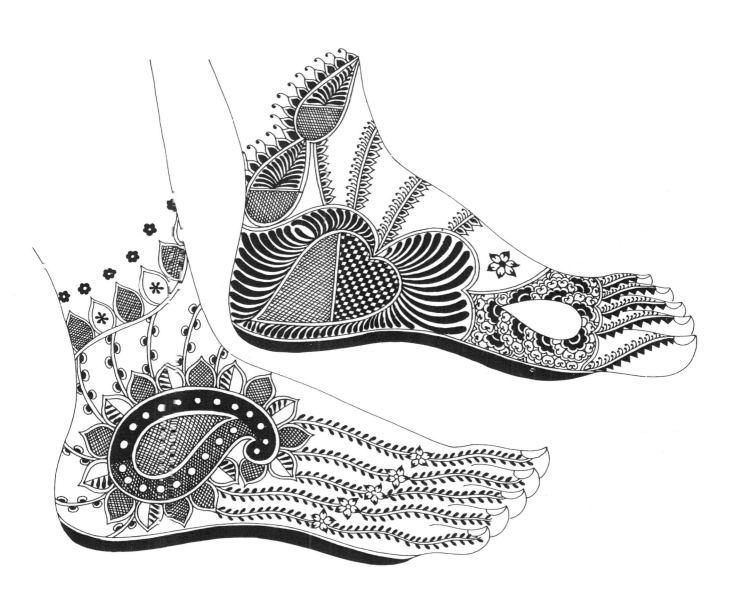

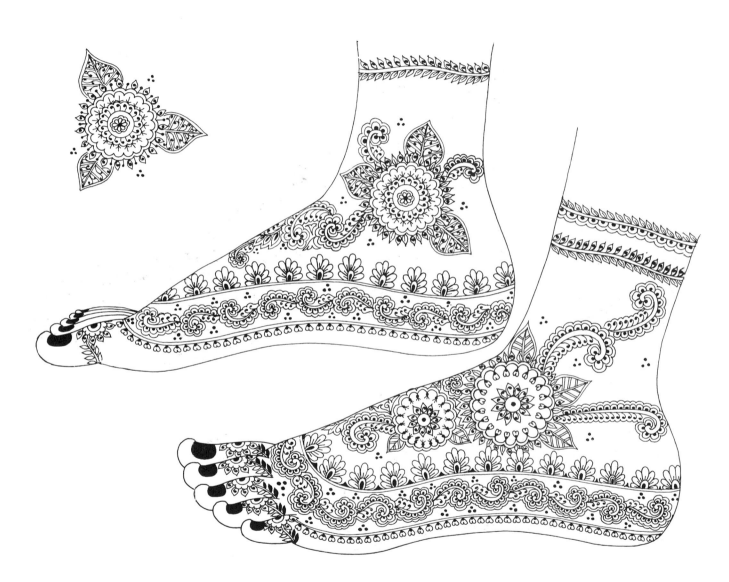

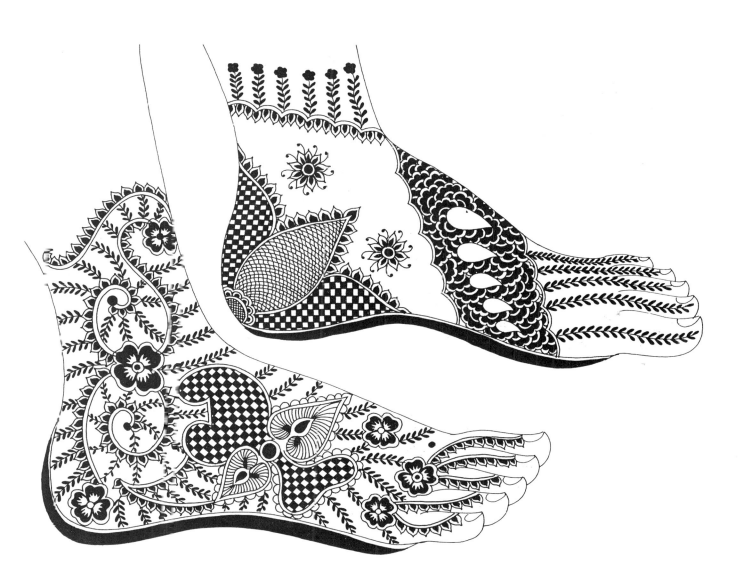

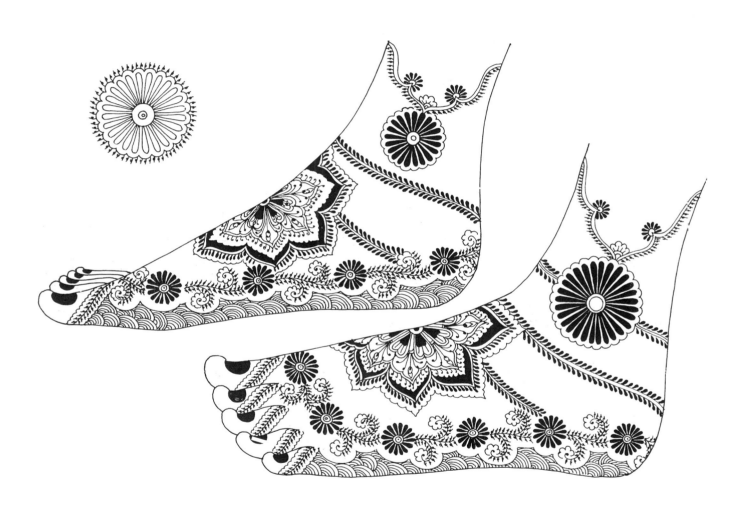

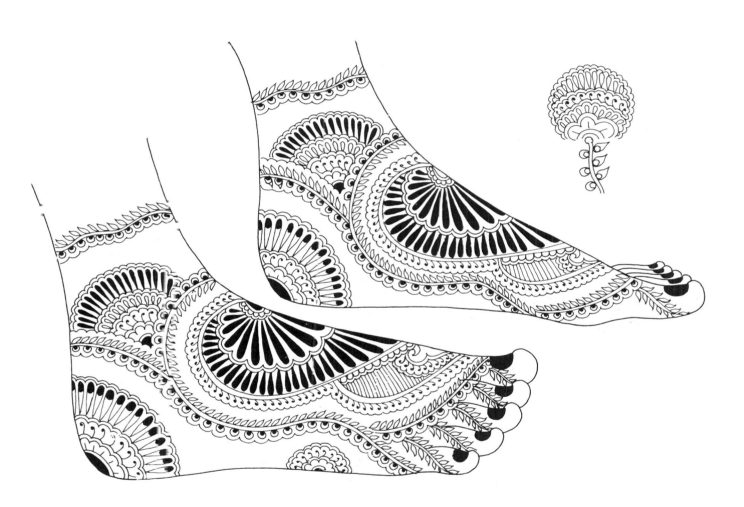

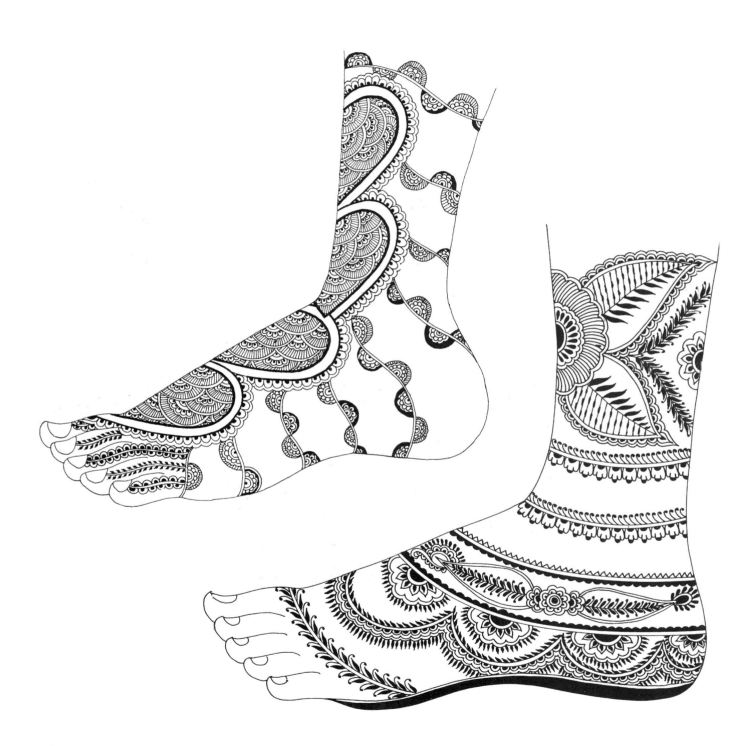

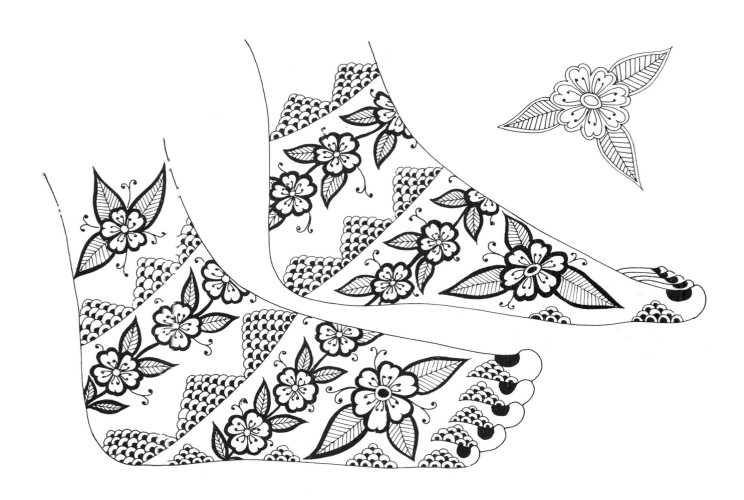

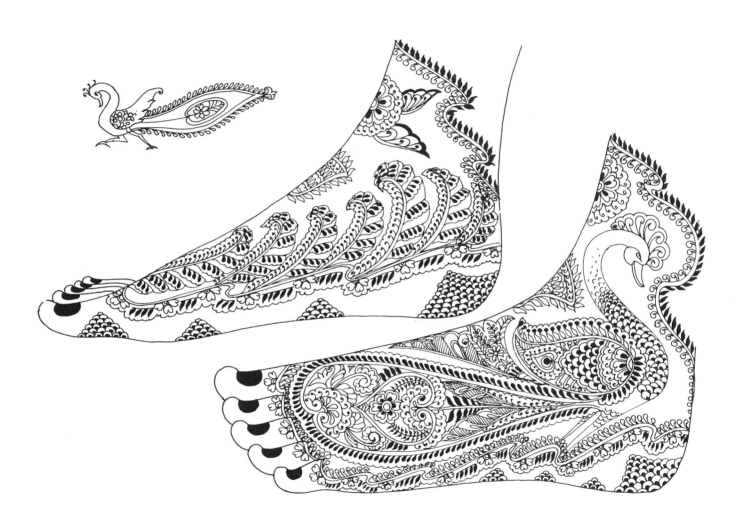

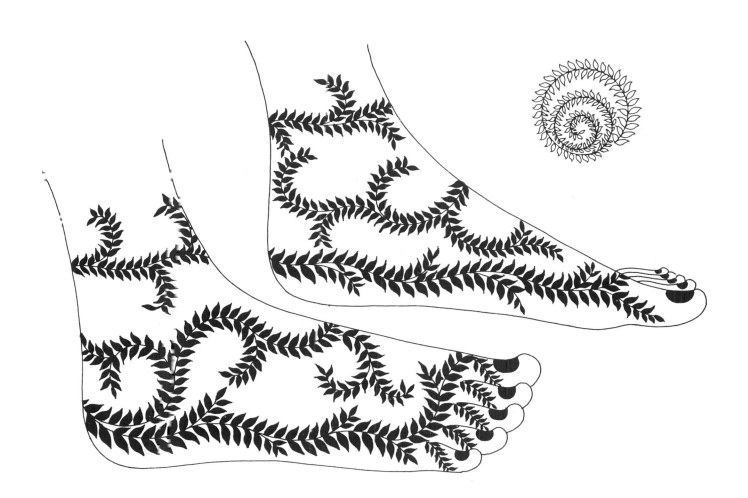

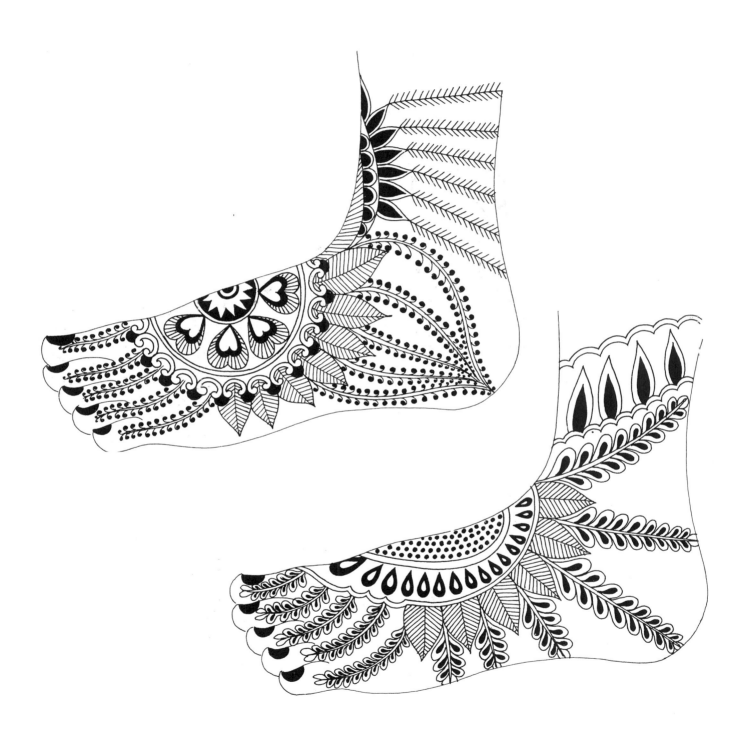

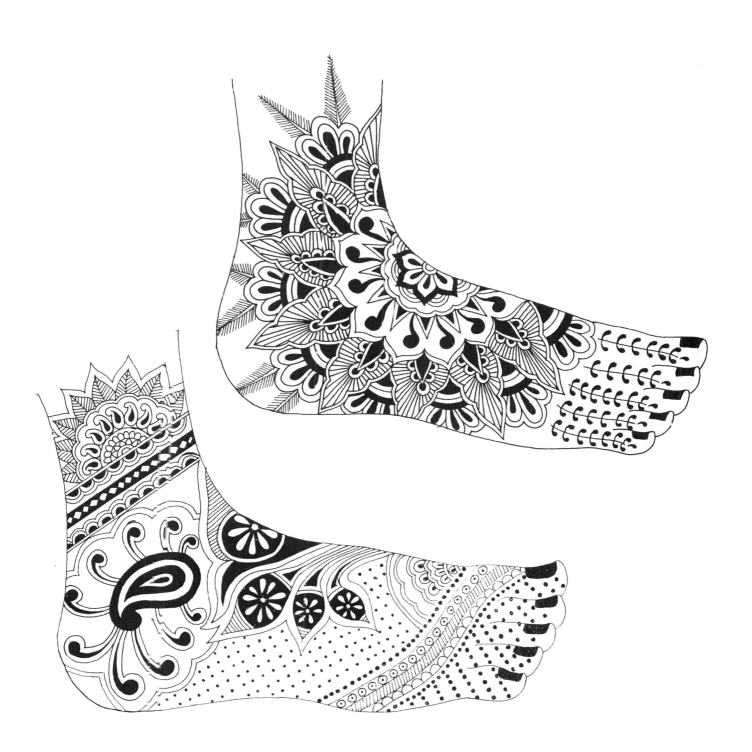

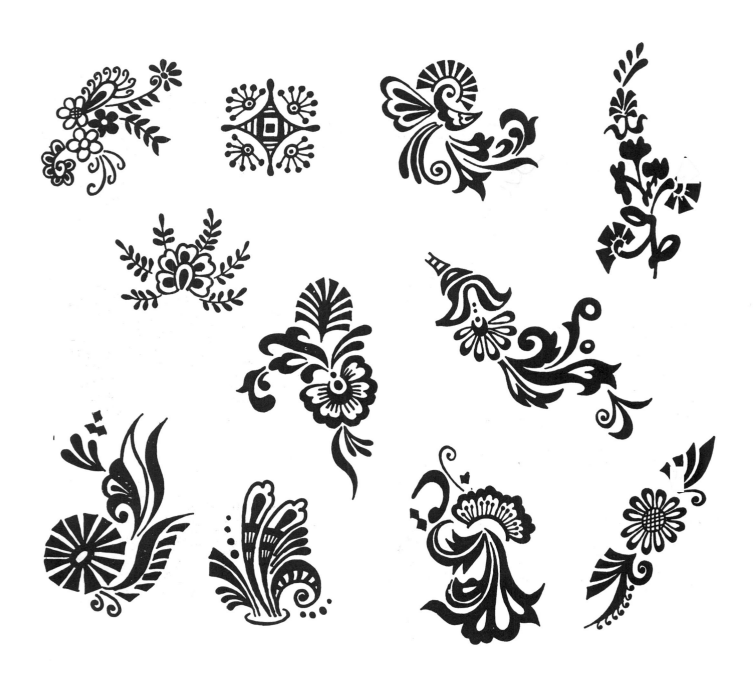

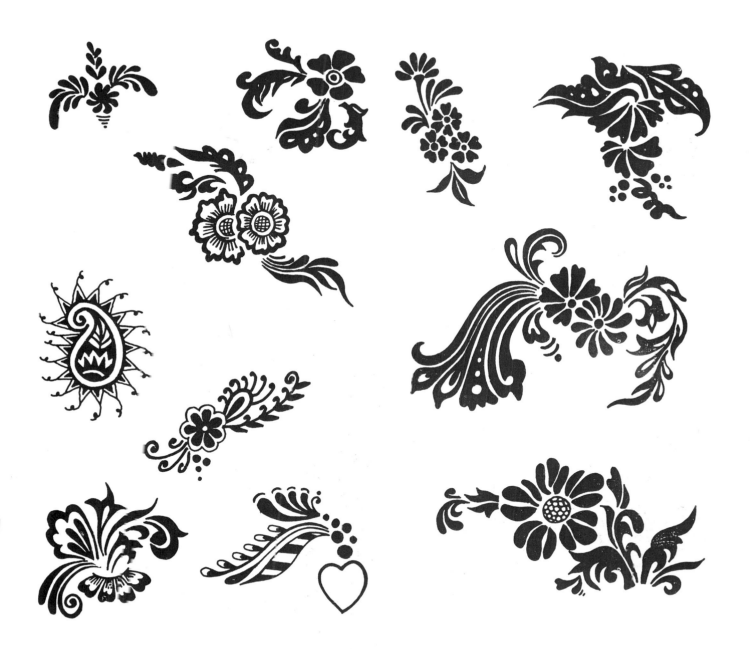

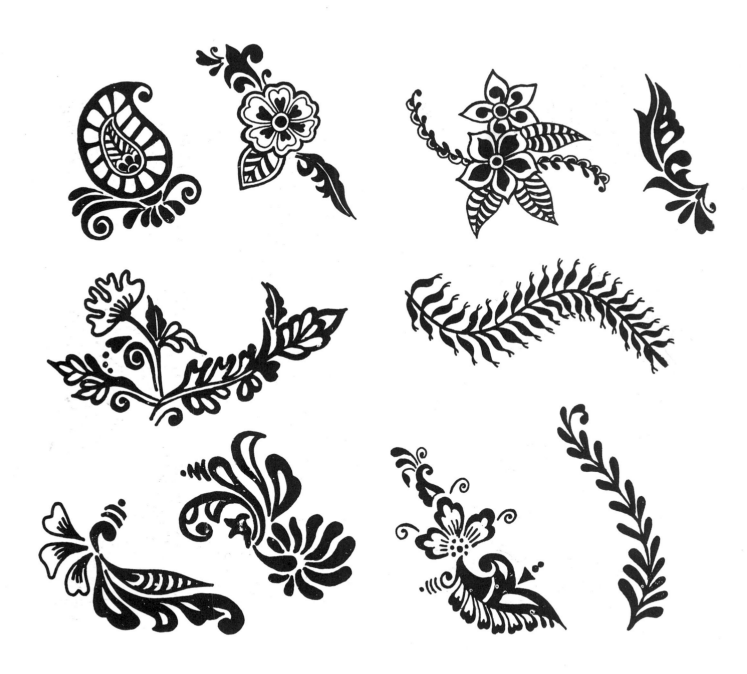

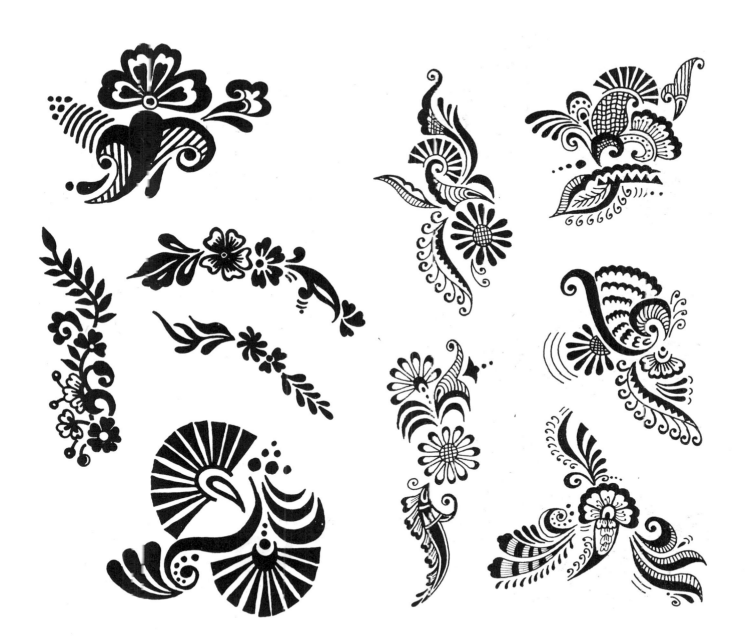

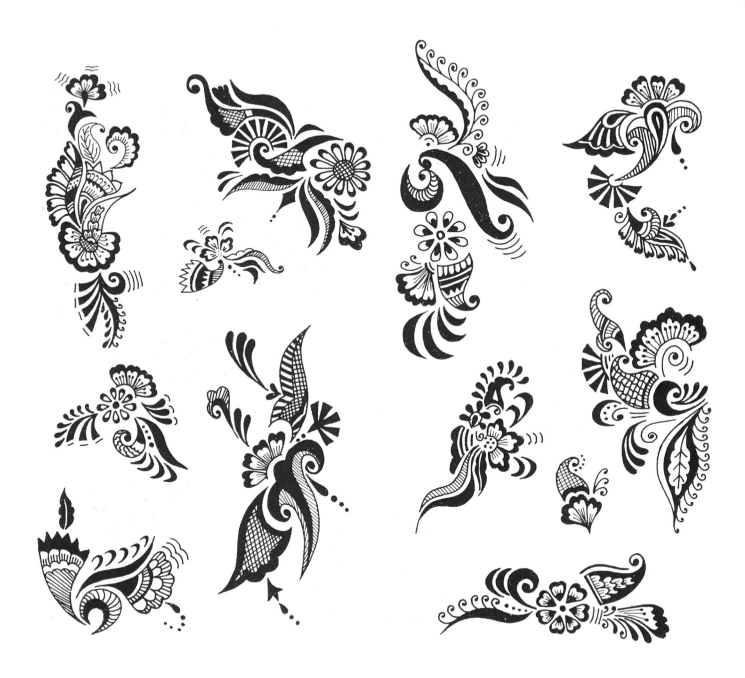

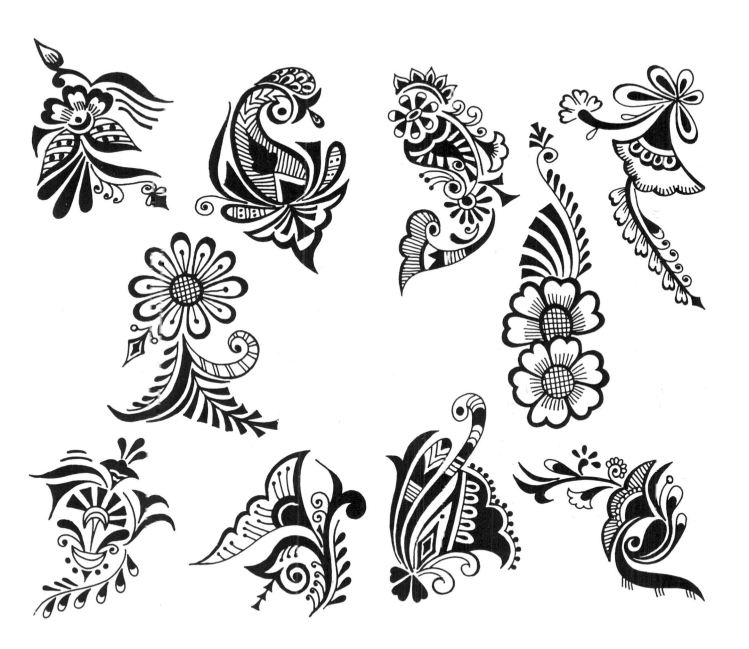

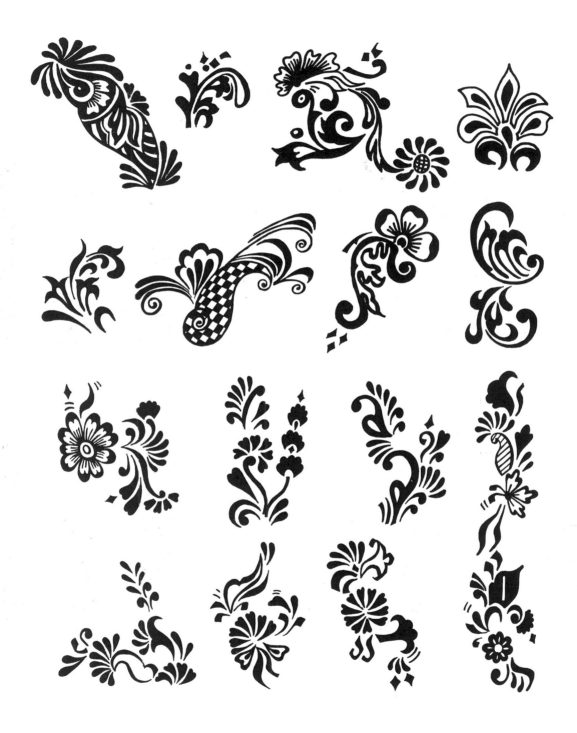

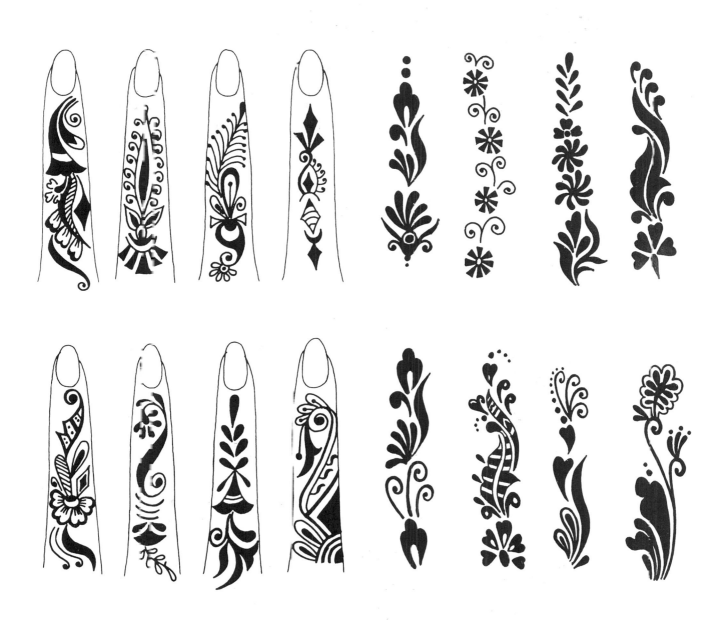

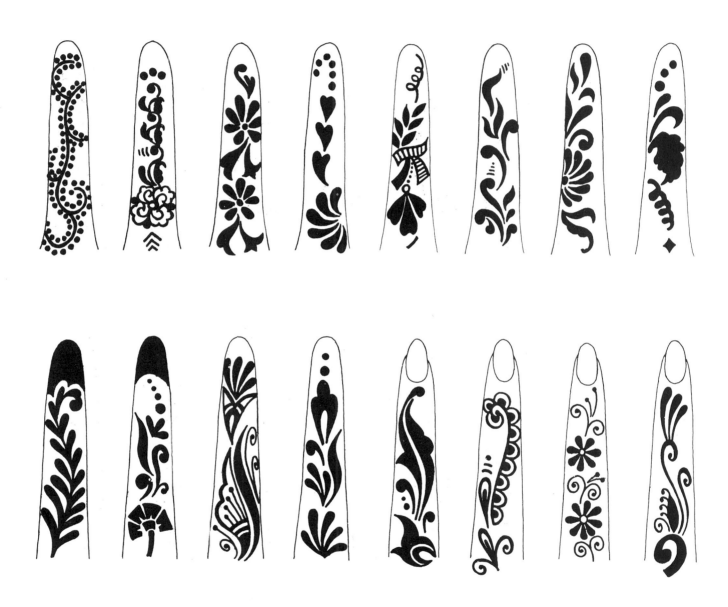

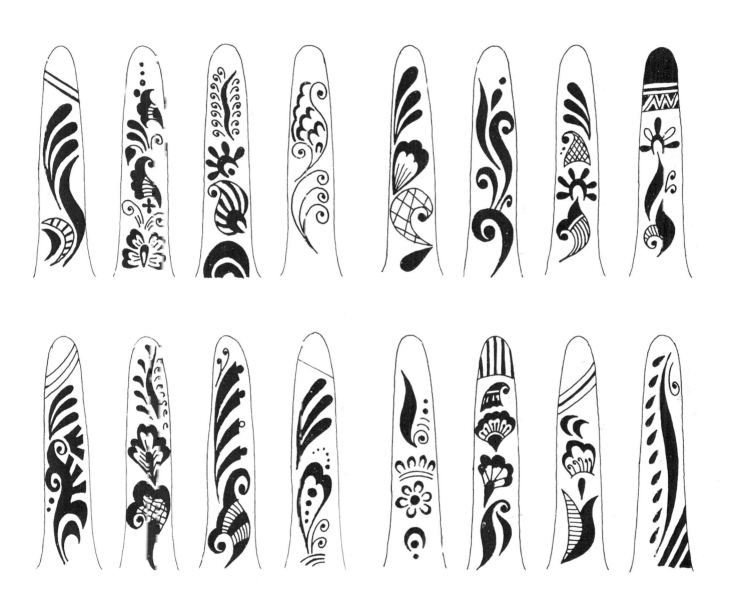

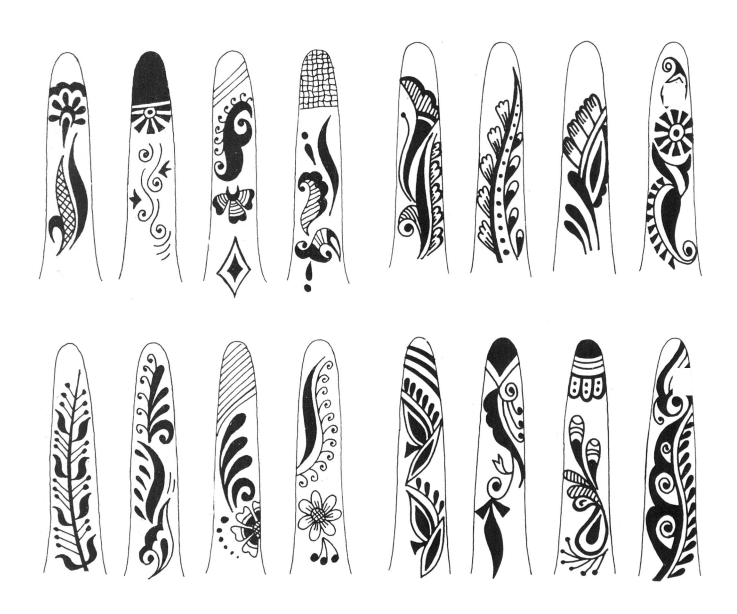

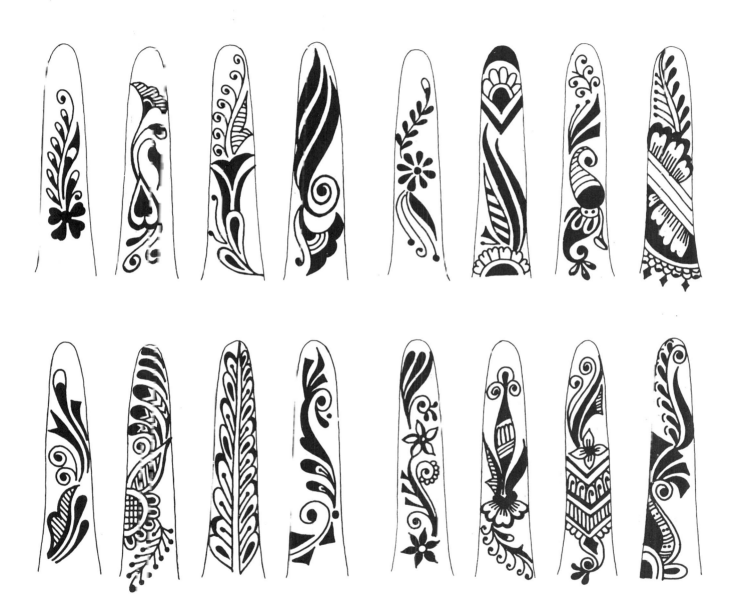

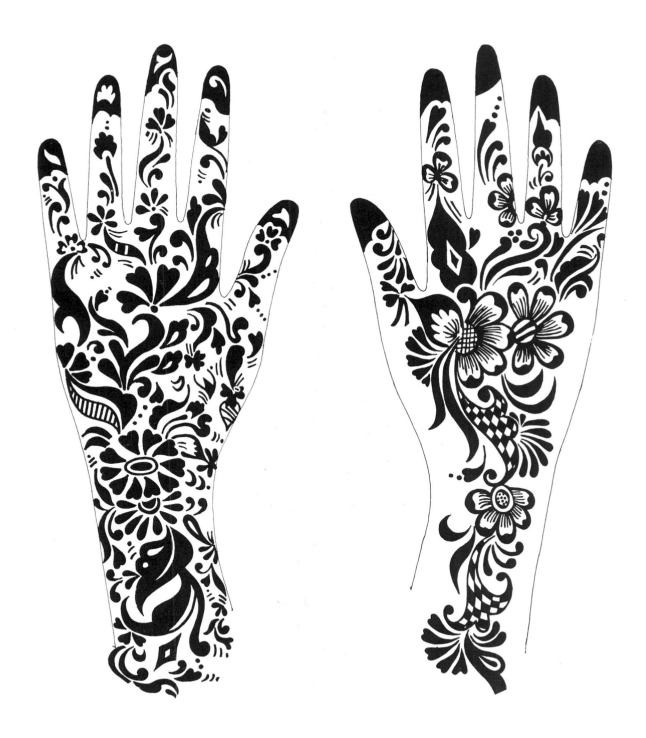

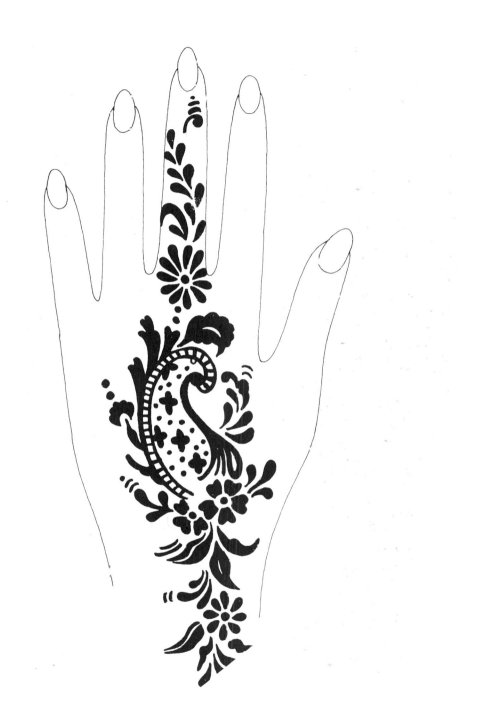

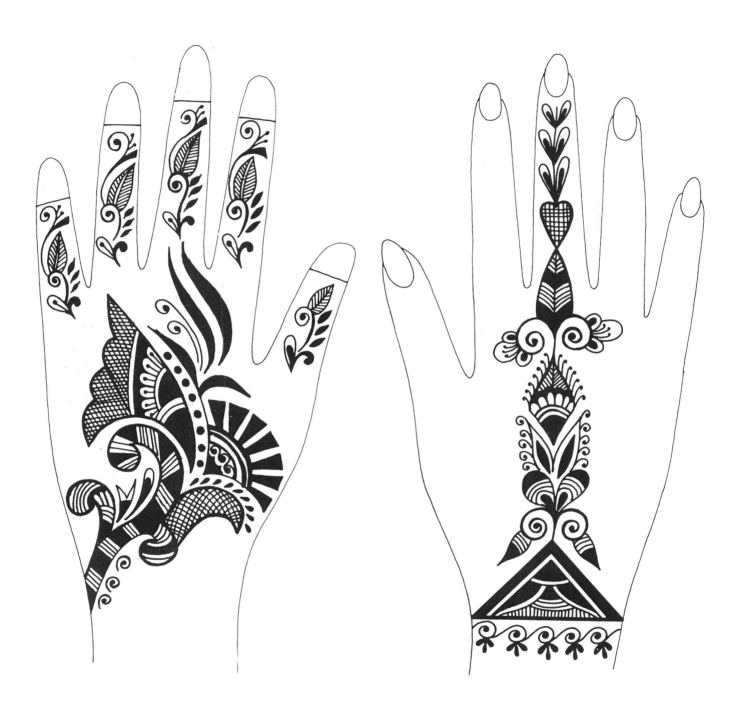

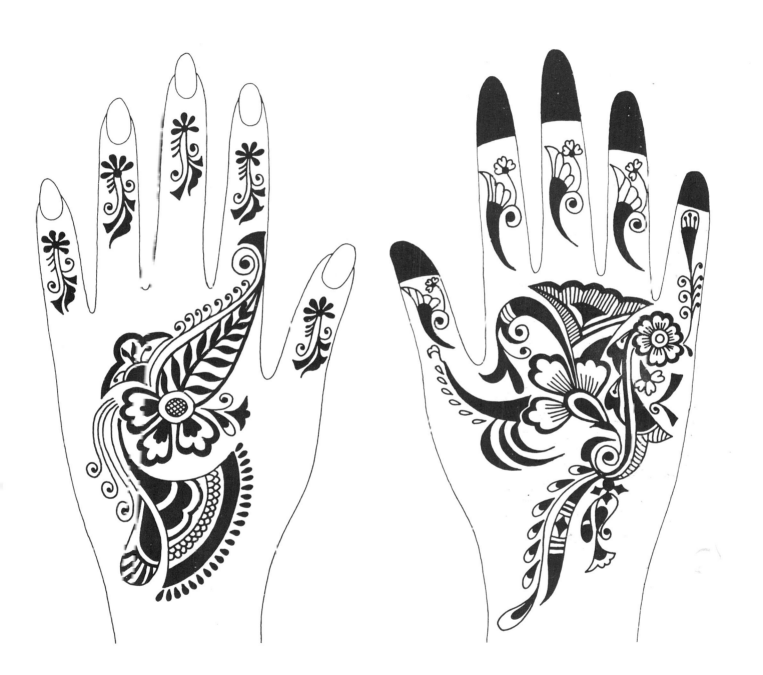

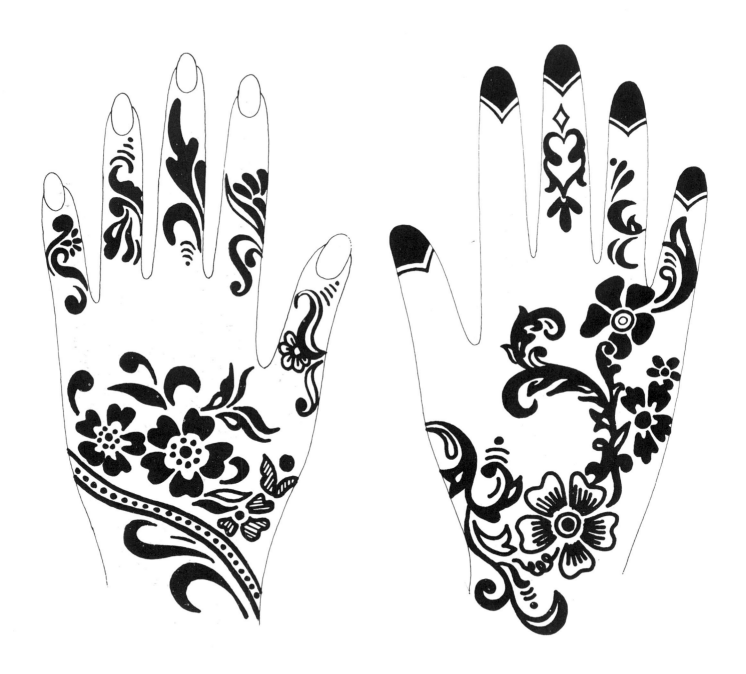

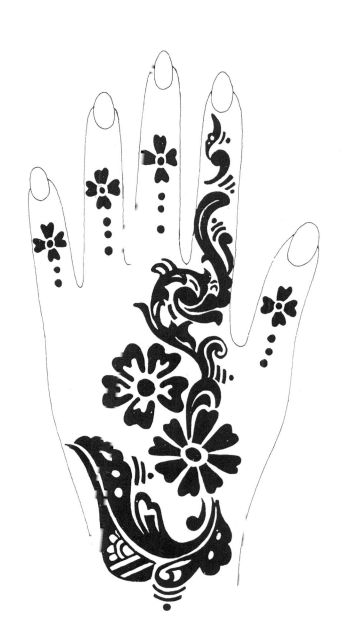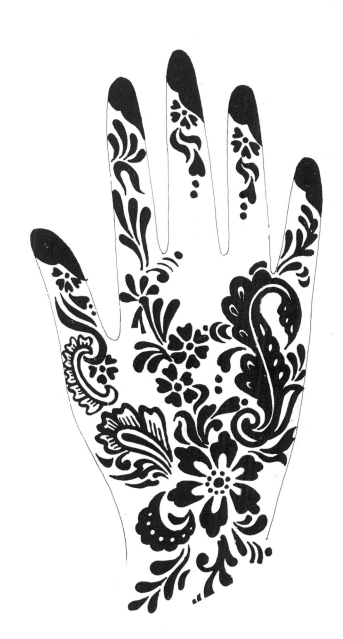

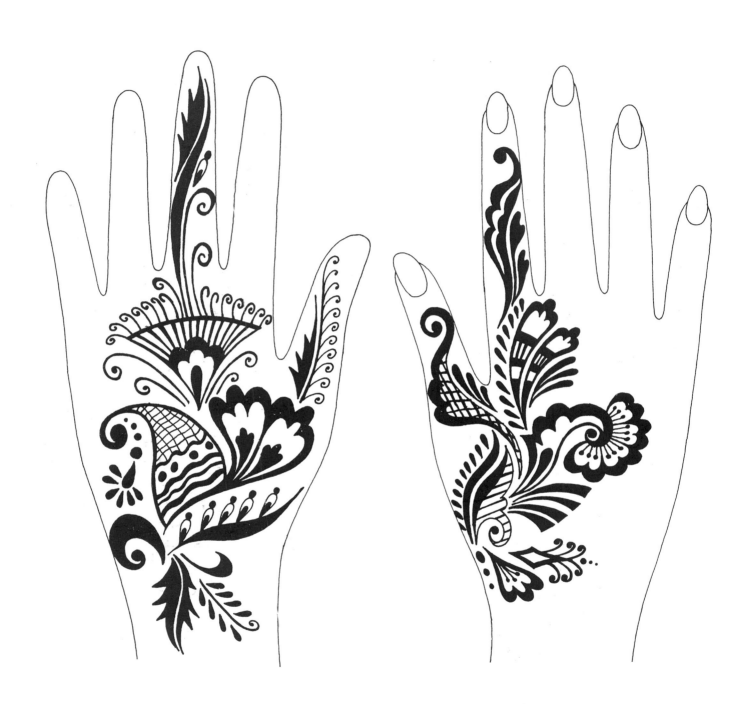

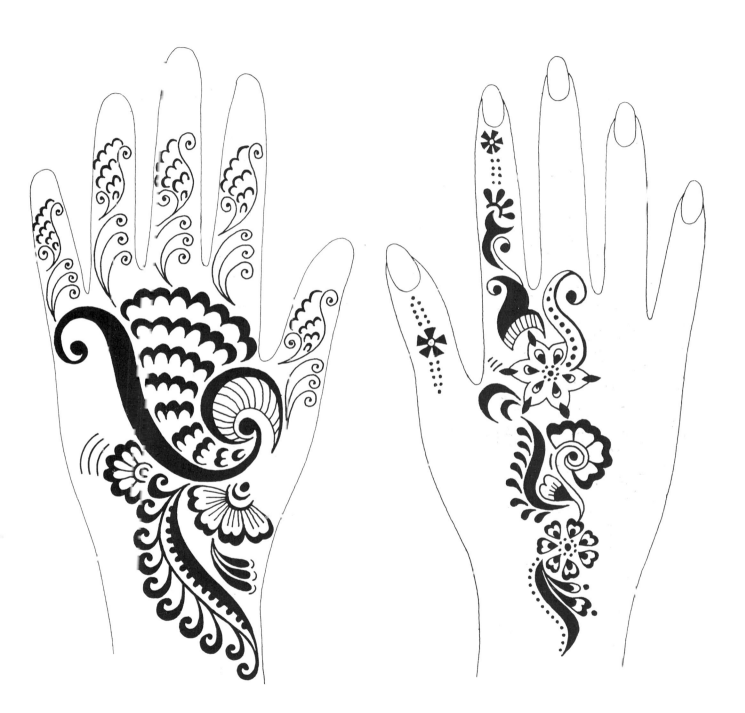

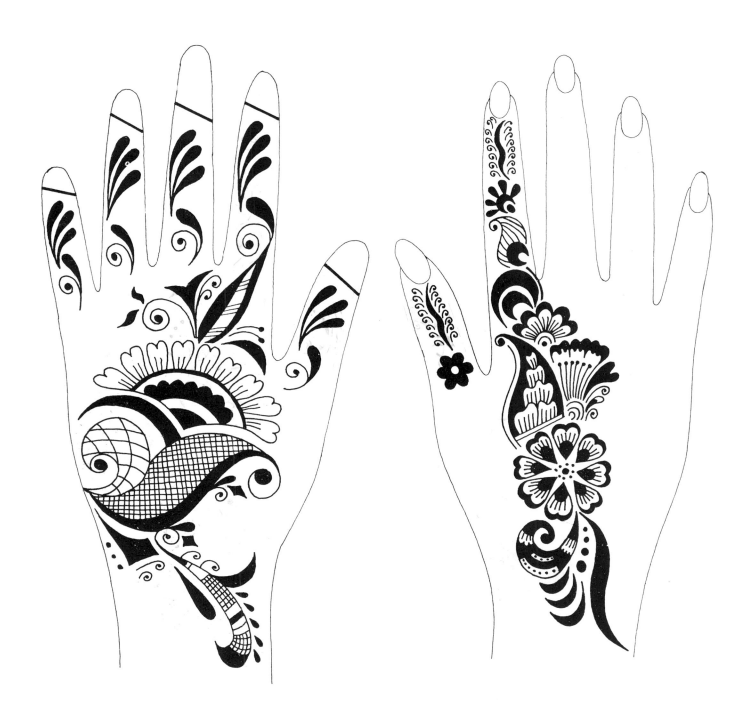

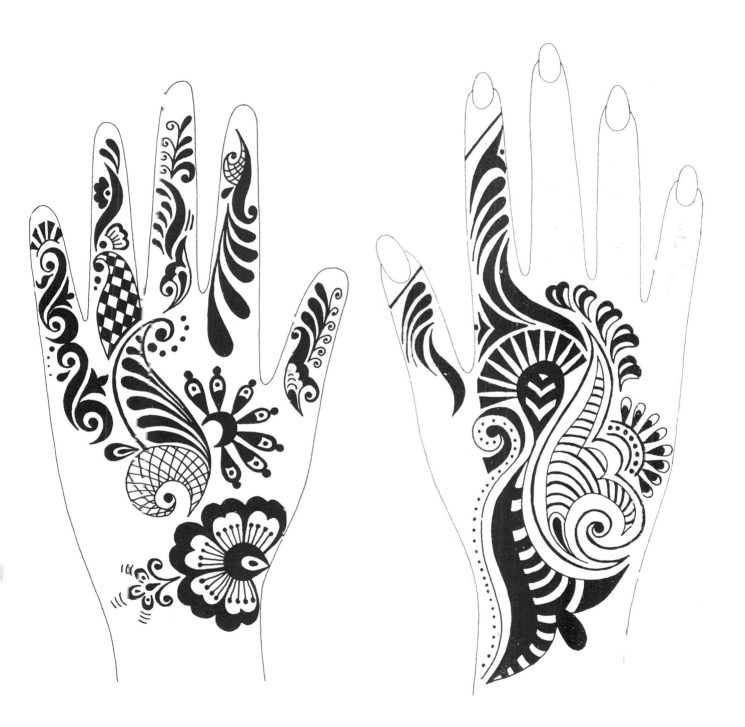

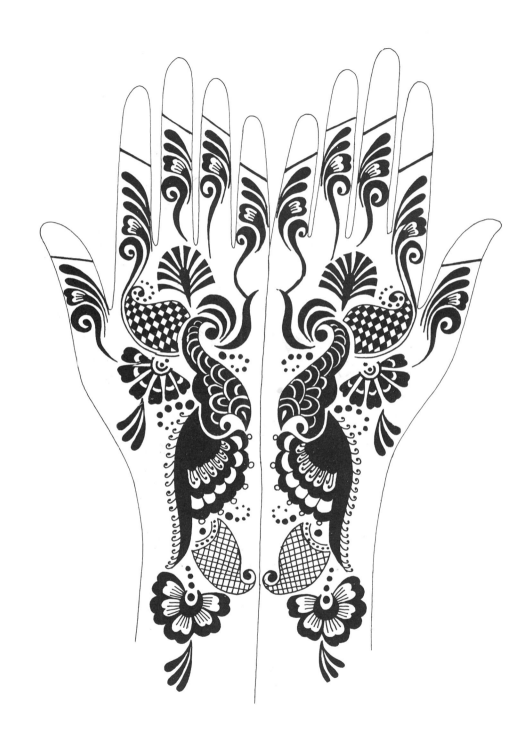

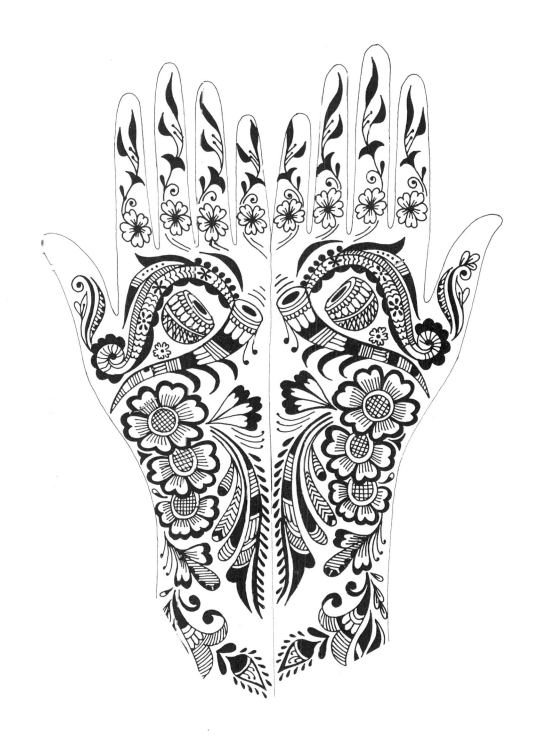

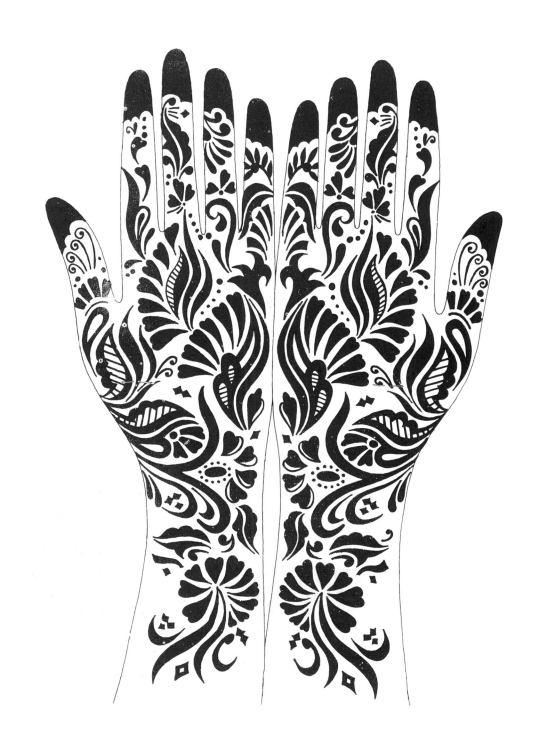

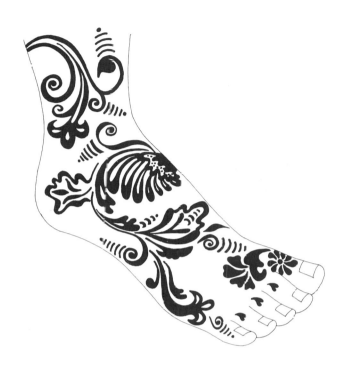

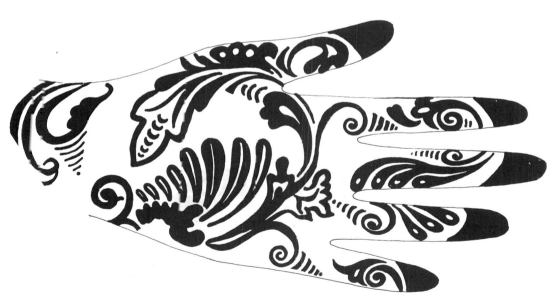

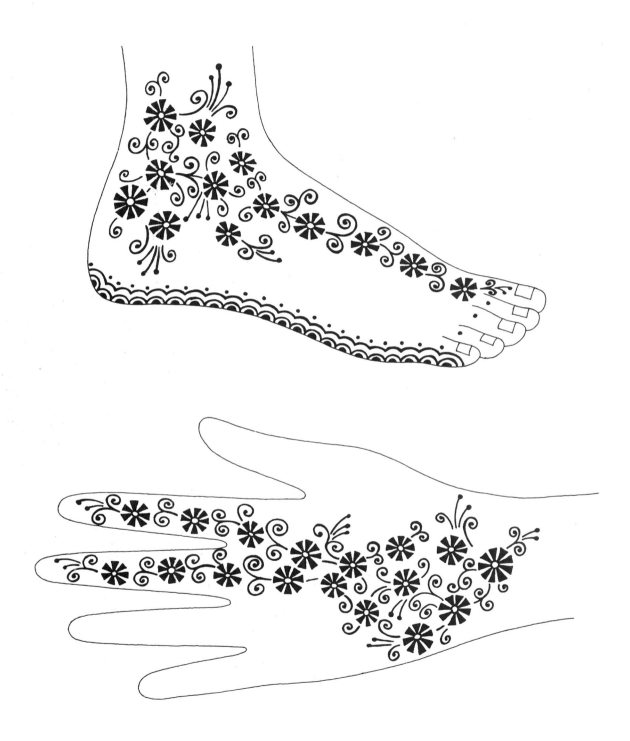

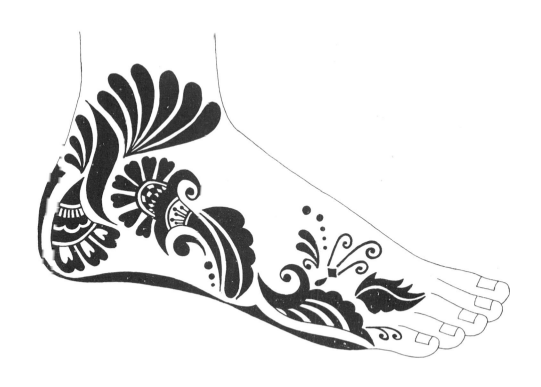

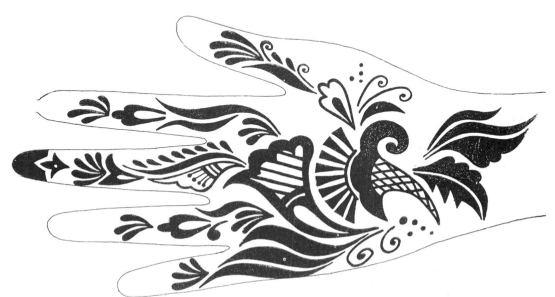

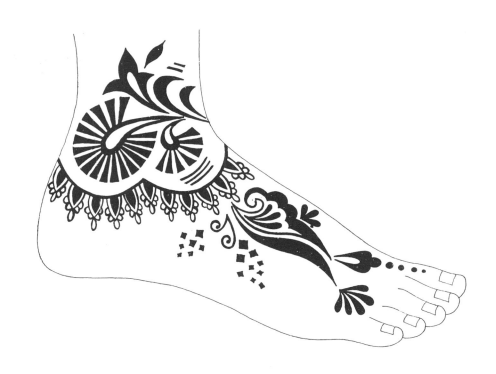

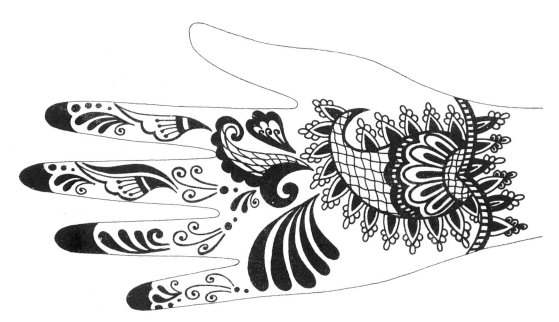

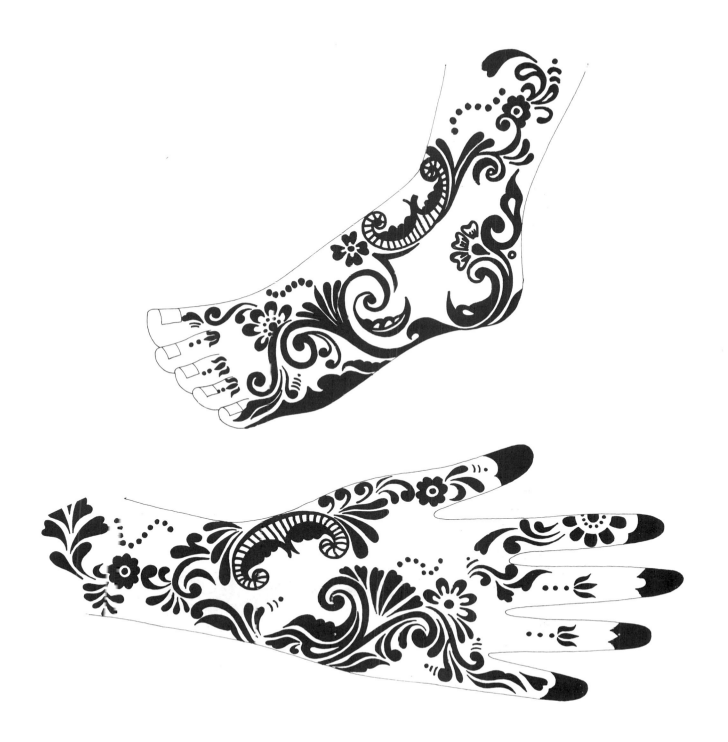

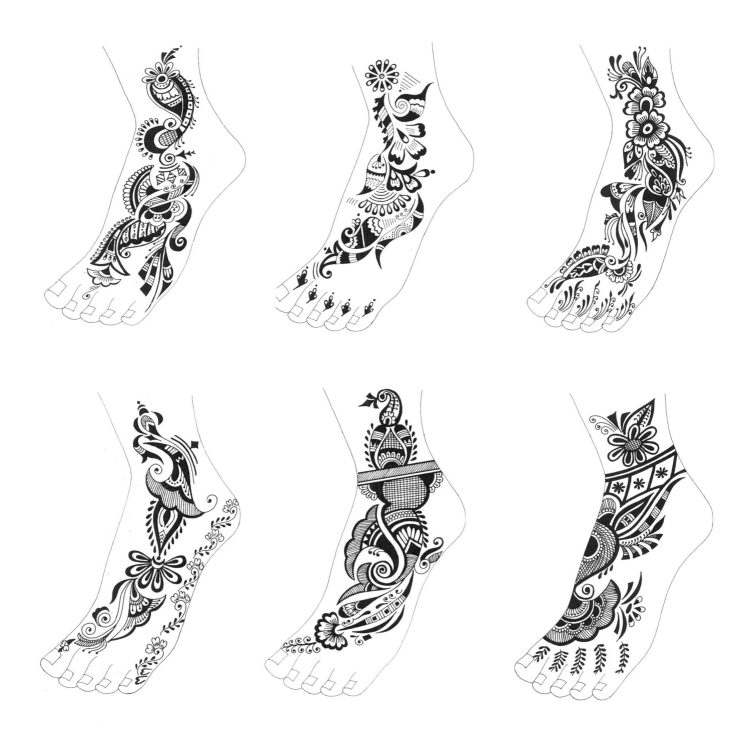

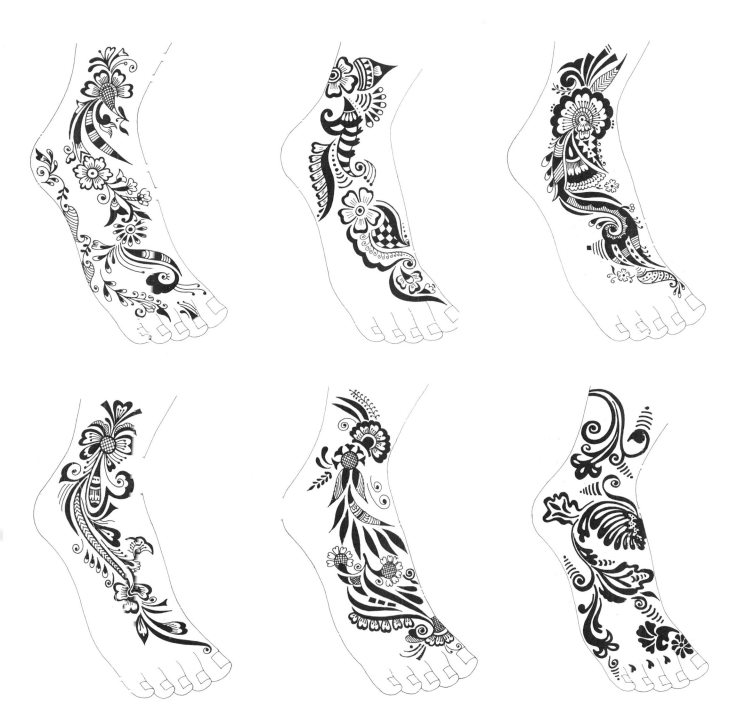

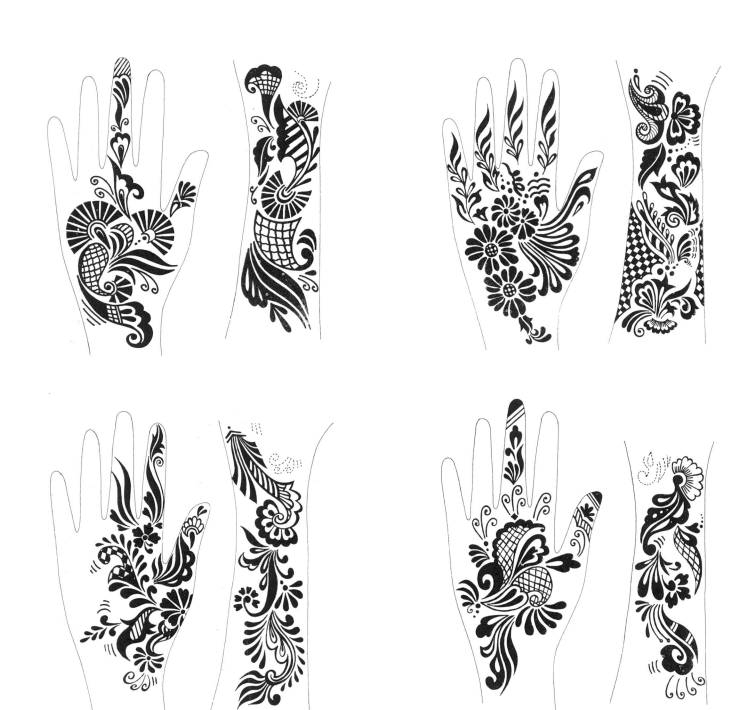

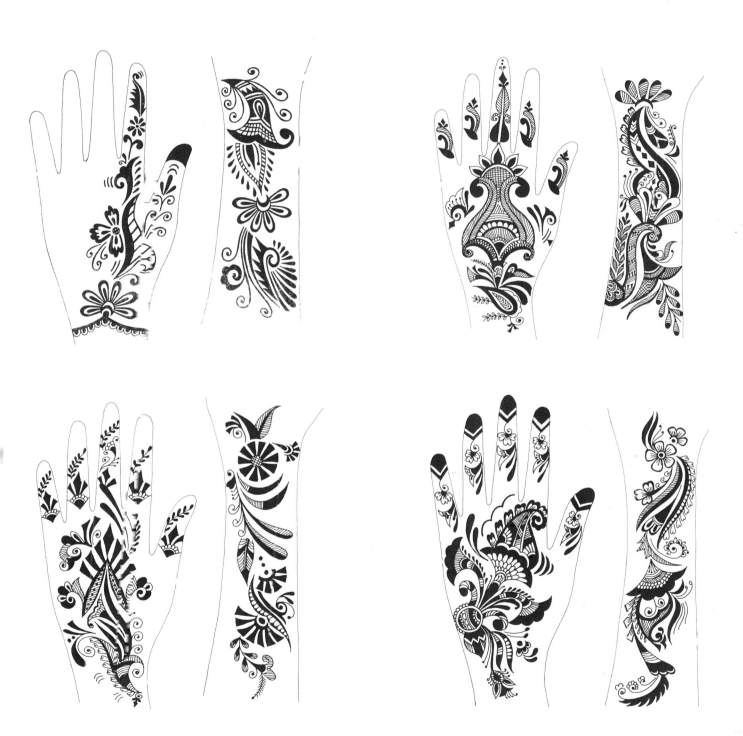

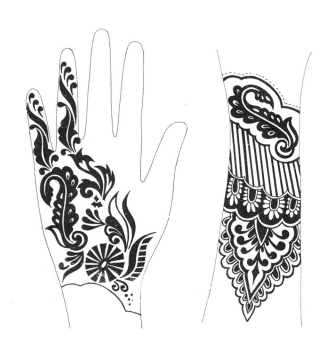

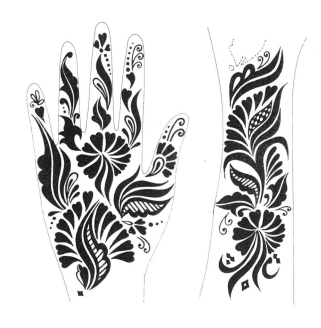

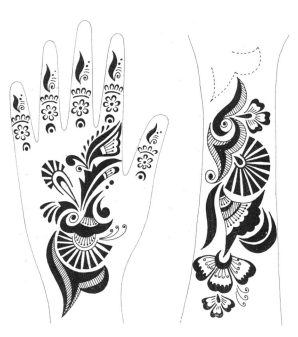

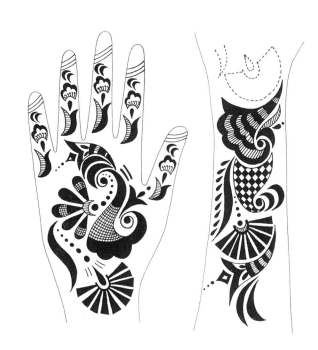

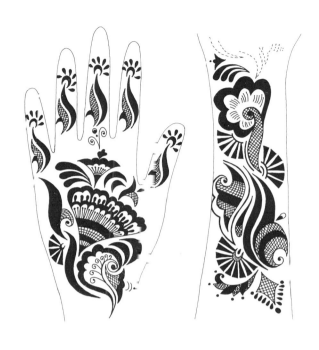

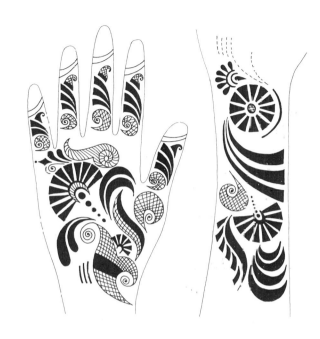

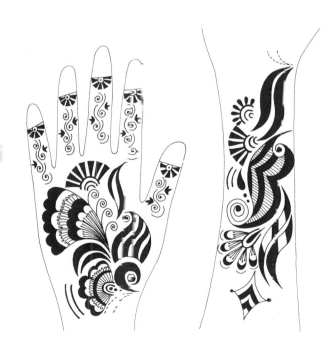

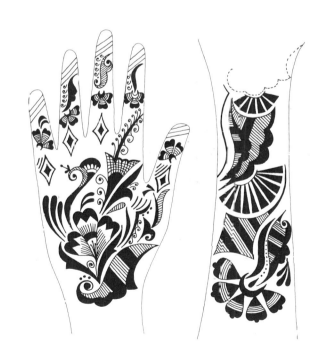

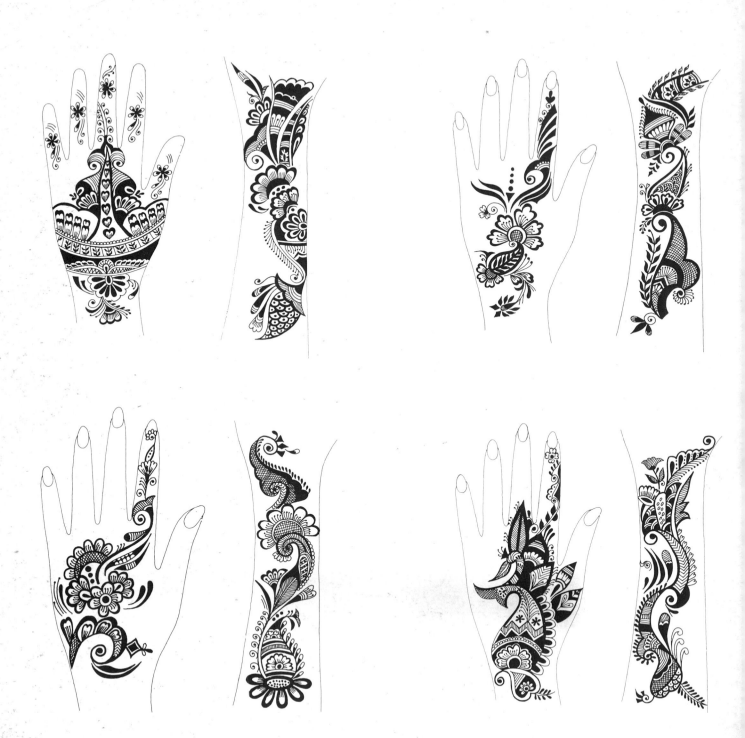

Traditionelle Henna-Designs

Motifs traditionnels au henné

Diseños tradicionales con henna

Disegni tradizionali all'henné

ヘンナの伝統デザイン

Traditionelle Henna-Designs

Lawsonia inermis, hina und *mehndi* – das sind die lateinischen, arabischen beziehungsweise indischen Namen einer recht großen Pflanze mit weißen Blüten, die in Nordafrika, dem Mittleren Osten, Indien und Südostasien wächst. Der Pflanze werden etliche Eigenschaften zugeschrieben, so zum Beispiel heilende Wirkung bei Hautkrankheiten, Kopfschmerzen und Halsentzündungen. Auf der Haut wirken die Blätter kühlend, und sie werden seit langem als Zutat für Parfümessenzen und Salben verwendet. Am bekanntesten dürfte allerdings die Anwendung dieser Pflanze als Grundstoff für einen natürlichen, rötlich-braunen Farbstoff sein. Seit Jahrhunderten wird er als Farbstoff für Baumwolle, Wolle und Seide benutzt und ist immer noch als Haartönung und Farbe zum Verzieren des Körpers, vor allem der Hände und Füße, sehr beliebt. Heute ist diese Pflanze unter ihrer arabischen Bezeichnung *Henna* am bekanntesten.

Man weiß nicht mit Sicherheit, wann und wo Henna zuerst zur Verzierung der Haut gebraucht wurde, doch es gibt zahlreiche Anhaltspunkte dafür, daß der Brauch eine sehr lange Tradition hat. In Ägypten fand man Spuren von Henna an 5000 Jahre alten Mumien, und in Indien stieß man auf Höhlenmalereien, die eine Prinzessin mit Hennabemalung an Händen und Füßen zeigen. Der Prophet Mohammed soll seinen Bart mit Henna gefärbt haben. Der bekanntesten Theorie zufolge stammt die Bemalung mit Hennamustern aus Ägypten; von dort aus verbreitete sich der Brauch sowohl westwärts bis nach Marokko als auch ostwärts über den Mittleren Osten, Indien und Südostasien.

Im allgemeinen werden Körperverzierungen aus Henna zu festlichen Anlässen wie religiösen Zeremonien, Festen und vor allem Hochzeiten aufgetragen. In allen Kulturen, in denen die Hennabemalung bekannt ist, verziert man meist die Hände und die Füße. Zu Hochzeiten werden die Zeichnungen jedoch oft auch auf Arme und Beine aufgemalt. Zu islamischen, jüdisch-sephardischen und hinduistischen Hochzeiten erhalten die Bräute und manchmal auch der Bräutigam Bemalungen, die Glück bringen sollen. In einigen Gegenden glaubt man, daß das frischverheiratete Paar umso glücklicher sein wird, je tiefer der Farbton des Henna ist.

Die verwendeten Muster variieren von Kultur zu Kultur sehr stark. So sind nordafrikanische Hennamuster entsprechend der allgemeinen Tradition der islamischen Ornamentik, die das Abbilden von Menschen und Tieren verbietet, meist geometrisch oder bestehen aus stark stilisierten Blumen. Auch im Mittleren

Osten herrscht komplexe florale Ornamentik vor. In einigen Teilen Arabiens dagegen werden große Flächen auf Händen und Füßen ganz ohne Ausführen eigentlicher Zeichnungen mit Henna eingefärbt. Indische Muster haben meist ein zentrales Sujet, das gewöhnlich in Quadraten, Rechtecken oder Kreisen ausgeführt ist und dann mit einer Unzahl kleinerer Zeichnungen umgeben wird, die Hände und Unterarme sowie Füße und Fußknöchel vollständig bedecken.

Die Motive entstammen der gesamten, umfassenden Bildsprache Indiens: Blumenmotive im Mogulstil, Paisleymuster, komplizierte Rankenmuster, Stern-, Reben-, Spiral-, Blatt- und Karomuster, Wassertropfen, Wellenmotive etc. Oft sind diese Muster so dicht, daß sie wie Spitzenhandschuhe wirken.

Neben den kleinen, sich wiederholenden Mustern kommen häufig größere, figürlichere Motive wie Lotusblumen, unreife Mangos, Fächer, Elefanten, Schmetterlinge, Fische, Papageien, Pfauen, Süßspeisen und traditionelle Musikinstrumente zur Anwendung. Es wurden auch Muster passend zu indischem Schmuck geschaffen, oder man empfand den Schmuck in den Mustern nach; angeblich kamen sogar Armbanduhren in den Zeichnungen vor.

Die Finger werden mit speziellen linearen Motiven bedeckt (S. 50-57, 179-183) und die Fingerspitzen manchmal in Henna getaucht, so daß auch die Fingernägel mitgefärbt werden. Um das Handgelenk und um die Knöchel und Fußsohlen werden Saummotive angebracht (S. 58-59).

Muster, die auf die linke und rechte Hand gezeichnet werden, ergänzen sich manchmal so, daß beide Hände zusammen ein Gesamtmuster ergeben (S. 24-25). In einigen Fällen sind die Muster symmetrisch angelegt und bilden zusammen einen Vogel oder ein Herz (S. 119-125), zuweilen werden auch unterschiedliche Muster an der linken und rechten Hand verwendet (S. 14 rechts). Teils zeichnet man bestimmte Muster auf die Hände und dazu passende Muster auf die Füße (S. 140-153, 197-201).

Besondere Muster finden bei Hochzeitszeremonien Anwendung. Zu den traditionellen Symbolen zählen die Sänfte, in der die Braut vom Haus der Eltern zum Haus ihrer Schwiegereltern getragen wird (S. 48, 132), Krüge mit heiligem Wasser für die Trauzeremonie S 12-13, 133), Bilder von Braut und Bräutigam (S. 49, 134-139), der Pfau als Symbol der Liebe, oder die Swastika als Symbol künftigen Wohlergehens. Obwohl meist nur die Hände der Braut mit Henna verziert werden, erhalten in einigen Regionen von Bangladesh und Kaschmir auch die Hände des Bräutigams Verzierungen mit Motiven, die Männern vorbehalten sind.

Anwendung von Henna

Traditionell wird Henna ohne jedes Hilfsmittel aufgetragen. Man nimmt etwas Hennapaste zwischen Daumen und Zeigefinger und formt dann durch mehrmaliges Hin- und Herrollen zwischen Daumen und Zeigefinger einen feinen Strang aus Paste. Mit diesem Strang wird die Zeichnung auf die Haut gemalt. Diese Methode erfordert viel Erfahrung. Ein andere traditionelle Methode ist das Auftragen von Henna mit einem Stöckchen. Am praktischsten zum Aufbringen von Hennazeichnungen ist allerdings das Arbeiten mit einem kleinen Spritzbeutel (s. Beschreibung auf Seite 230-231).

Eine ganz andere Methode zur Anwendung von Henna ist, die Zeichnungen mit einer Paste aus Zucker und Zitronensaft aufzumalen. Diese Paste läßt man zunächst trocknen und bestreicht dann die gesamte Oberfläche der Hand mit Hennapaste. Nachdem man Zitronen- und Hennapaste entfernt hat, bleibt eine weiße Zeichnung auf rotem Hintergrund zurück.

Es gibt unterschiedliche Rezepte zur Herstellung von Hennapaste. Deshalb folgt an dieser Stelle nur eine allgemeine Beschreibung.

1

Zunächst wird das Hennapulver gesiebt. Das Pulver muß sehr fein und völlig frei von Zweigen oder Klumpen sein. Nun gibt man ein heißes Gemisch aus starkem, schwarzen Tee oder Kaffee, Zitronensaft (zwei Eßlöffel pro Tasse Kaffee bzw. Tee) und Senföl zu dem gesiebten Henna. Sobald die Paste eine schlammige Beschaffenheit erreicht, läßt man sie mindestens eine Stunde lang abkühlen. Falls die Mischung zu trocken wird, fügt man noch etwas Tee-Zitronen-Öl-Gemisch hinzu. Nach 48 Stunden hat die Paste den optimalen Zustand erreicht.

2

Vor dem Auftragen des Henna wird die Haut mit Rosenwasser oder Senföl abgewaschen. Die Hennapaste wird mit einem Stöckchen, einer Spritze ohne Nadel oder einem kleinen, eistütenförmigen Spritzbeutel aufgetragen. Vergewissern Sie sich, daß das verwendete Hilfsmittel nicht die Haut berührt, sondern daß nur ein dünner Strang Hennapaste auf die Haut fällt.

3

Nach Fertigstellen der Bemalung sollte diese mindestens vier bis fünf Stunden, am besten über Nacht, einziehen. Beschädigungen müssen sorgfältig vermieden werden; wenn nötig, deckt man die Bemalung mit Wattebäuschen ab. Damit das aufgetragene Henna nicht rissig wird und abfällt, befeuchtet man es von Zeit zu Zeit mit einer Zucker-Zitronensaft-Lösung. Dadurch erhält das Henna außerdem einen dunkleren Farbton.

4

Wenn die Hennapaste dunkelrot geworden ist, reibt man die Haut mit Senföl ein, kratzt das Henna ab, wäscht die Haut mit Wasser und reibt die Haut nochmals mit Öl ein.

Damit die Farbe nachdunkeln kann, darf die Hennazeichnung danach zwölf Stunden lang nicht naß werden. Je seltener die Haut gewaschen wird, desto länger hält die Bemalung; Seife sollte man nicht benutzen. Je nach Beanspruchung bleibt das aufgetragene Motiv zwischen zwei und vier Wochen lang schön.

Nehmen Sie kein Henna, das zum Haarefärben gedacht ist. Diese Art von Henna ist nicht stark genug, um die Haut zu färben.
Achten Sie außerdem genau darauf, daß das verwendete Hennapulver nicht zu alt ist, da es mit der Zeit an Farbkraft verliert. Die gemahlenen Hennablätter sollten hellgrün aussehen.

Anstelle von Senföl lassen sich auch andere Pflanzenöle wie Eukalyptusöl, Lavendelöl, Nelkenöl oder Olivenöl verwenden.

Motifs traditionnels au henné

Lawsonia inermis, *hina*, et *mehndi* sont les noms respectivement employés en latin, arabe et hindi pour une plante aux fleurs blanches qui pousse en Afrique du Nord, au Moyen Orient, en Inde et en Asie du sud-est. De nombreuses vertus sont attribuées à cette plante, comme par exemple ses pouvoirs thérapeutiques contre les maladies de la peau, les ecchymoses, la teigne, les migraines et les maux de gorge. Les feuilles ont un effet rafraîchissant sur la peau et ont été utilisés depuis très longtemps comme ingrédient pour des parfums et des pommades. Cependant, l'usage le plus probablement connu pour cette plante reste comme la source d'une teinture naturelle brun-rougeâtre. Cette plante a en effet été employée comme matière colorante depuis des siècles pour le coton, la laine et la soie entre autres, et continue d'être très populaire comme teinture pour les cheveux et en tant que colorant pour l'embellissement du corps, la plupart du temps sur les mains et les pieds Cette plante est de nos jours plus couramment connue sous son nom arabe: *henna*.

D'où et de quand remonte l'utilisation du henné comme colorant pour la décoration du corps n'est pas connu avec certitude, mais il existe de nombreux signes qui tendent à prouver que c'est une pratique très ancienne. Ainsi, des traces de henné ont été découvertes sur des momies datant de cinq milles ans en Egypte, et des peintures rupestres représentant une princesse aux mains et aux pieds décorés de motifs au henné ont été trouvées en Inde. Il est dit que même le prophète Mahomet utilisait de l'henné pour se teindre sa barbe. La théorie la plus courante veut que l'usage du henné comme motif décoratif prend sa source en Egypte d'où la pratique s'est répandue pour finalement atteindre le Maroc à l'ouest et le Moyen Orient, l'Inde et l'Asie du sud-est à l'est.

Ces motifs décoratifs au henné sont généralement appliqués sur le corps pour de grandes occasions, plus notablement pour des mariages mais également lors de cérémonies religieuses et lors de festivals.

Toutes les cultures qui pratiquent la peinture à l'henné l'utilisent principalement pour décorer les pieds et les mains. Cependant, pour les mariages, ces motifs décoratifs peuvent être appliqués aux bras et aux jambes pareillement. Lors de mariages islamiques, hindous ou de juifs séfarades, la future mariée (mais également le futur marié parfois) porte des motifs qui sont supposés lui porter chance. Dans certaines régions, on estime que plus la teinte de l'henné est profonde, plus les jeunes mariés auront un marriage heureux.

Les types de motifs appliqués varient considérablement suivant les cultures. Ainsi, les motifs au henné en Afrique du Nord tendent à être géométriques ou alors composés de fleurs extrêmement stylisées, en accord avec l'ornementation traditionnelle islamique qui interdit la représentation de personnes et d'animaux. Il en est de même au Moyen Orient où des compositions florales très élaborées sont prédominantes. Par contre, dans certaines régions d'Arabie, les pieds et les mains sont en grande partie colorés de henné sans pour autant représenter de véritables designs.

Pour leur part, les motifs indiens représentent généralement un thème principal, dessiné habituellement à l'intérieur d'un carré, d'un rectangle ou d'un cercle, qui est lui-même entouré d'une myriade de designs plus petits, le tout recouvrant en totalité les mains et les avant-bras ainsi que les pieds et les chevilles.

Les motifs proviennent de l'ensemble du riche vocabulaire décoratif indien tel que les fleurs mogholes, les dessins cachemire, de complexes motifs en vrille, des étoiles, des vignes, des spirales, des feuilles, des jeux de dames, des gouttes d'eau, des vagues, etc. Très souvent, tous ces motifs forment des dessins si minutieux qu'ils donnent l'impression d'être de véritables gants en dentelle. En dehors de ces petits motifs répétitifs des designs plus grands et figuratifs sont fréquemment utilisés: des lotus blancs, des mangues, des éventails, des éléphants, des papillons, des poissons, des perroquets, des paons, des bonbons et des instruments de musique traditionnels. Des motifs ont également été dessinés pour imiter ou être assortis aux bijoux indiens, et il est supposé que même les montres ont été comprises parmi les designs.

Quand aux doigts, ils sont recouverts de motifs linéaires particuliers (p. 50-7, 179-83) et les bouts des doigts sont parfois trempés dans le henné, teintant ainsi les ongles par la même occasion. Des motifs limitrophes (p.58-9) sont appliqués autour des poignets et autour des chevilles et de la plante des pieds.

Les motifs qui sont dessinés sur la main gauche et la main droite sont parfois complémentaires, formant ainsi un seul dessin lorsque les mains sont jointes (p. 24-5). Dans certains cas, les motifs se reflètent formant ainsi un oiseau ou un coeur (p. 119-25) ou, dans d'autres cas, plusieurs dessins peuvent être représentés sur la main gauche et la main droite (p. 14 à droite). D'autres exemples sont aussi donnés où les motifs de la main sont assortis avec les motifs des pieds (p. 140-53, 197-201).

Des motifs plus spécifiques sont utilisés pour les mariages. Ils représentent en général des symboles traditionnels tels la chaise à porteur dans laquelle la jeune mariée est transportée de sa maison vers la maison de ses beaux-parents (p. 48,

132), une cruche contenant de l'eau bénite utilisée pour les mariages (p. 12-3, 133), des portraits du marié et de la mariée (p. 49, 134-9), le paon (symbole de l'amour), ou le svastika (symbole du bien-être dans le futur). Bien que la plupart du temps, seules les mains de la mariée soient décorées de henné, il arrive parfois dans certaines régions du Bangladesh et du Cachemire que les mains du marié soient décorés de motifs spécialement reservés pour les hommes.

Appliquer le henné

La méthode traditionnelle pour appliquer le henné consiste à n'utiliser aucun outil. La pâte se prend entre le pouce et l'index et en malaxant la pâte entre ces deux doigts, on forme un fil de henné. C'est ensuite avec ce fil que le motif peut être dessiné sur la peau. Cette méthode demande beaucoup d'expérience. Une autre méthode traditionnelle consiste à appliquer la pâte à henné avec un petit bâton. Cependant, l'utilisation d'un cône est le moyen le plus pratique pour appliquer le motif (voir la description en page 230-1).
Les recettes pour une bonne pâte à henné varient beaucoup. C'est pour cette raison qu'une seule description générale nous est donné ci-dessous.

1

Tamiser la poudre à henné. La poudre doit être fine et ne surtout pas contenir de petites brindilles ou de grumeaux. Ajouter ensuite à la pâte tamisée: un chaud mélange de thé noir ou de café corsé, du jus de citron (deux cuillerées pour une tasse de café ou de thé) et de l'huile de moutarde. Quand la pâte devient boueuse, la laisser reposer une bonne heure. Si le mélange devient trop sec, rajouter un peu de la mixture thé/citron/huile. Il faut ensuite attendre 48 heures pour que la pâte atteigne une qualité optimale.

2

Bien nettoyer la peau avant d'appliquer le motif au mehndi en la lavant avec de l'eau de rose et de l'huile de moutarde. Appliquer ensuite la pâte à henné avec un petit bâton, ou bien une seringue sans aiguille, ou alors avec l'aide d'un petit cône. S'assurer que l'objet utilisé ne soit pas en contact avec la peau mais que seul un fil de la pâte à henné s'étale doucement sur la peau.

3.

Une fois que le motif est terminé, le laisser reposer au moins 4 ou 5 heures et de préférence pendant la nuit. Faire attention de ne pas l'abîmer et si nécessaire, le recouvrir avec des boules de coton. Afin d'éviter que le motif au henné ne se fendille ou ne se désunisse, il est préférable de l'humecter de temps en temps avec du jus de citron et du sucre. Cela aide également l'henné à obtenir à une couleur plus prononcée.

4.

Quand la pâte à henné a atteint un ton rouge foncé, frotter la peau avec de l'huile de moutarde, et enlever ensuite le henné en grattant, puis rincer avec de l'eau et frotter à nouveau la peau avec de l'huile. Afin que la couleur s'imprègne profondément, ne pas mouiller le motif au henné pendant 12 heures par la suite. Pour préserver le design, il est ensuite conseillé de nettoyer la peau aussi peu que possible et surtout d'éviter d'utiliser du savon. Le design appliqué devrait ensuite rester en bonne condition de deux à quatre semaines suivant l'usage qu'il en ait fait.

Ne pas employer le henné qui est censé être utilisé pour se teindre les cheveux. Ce type de henné n'est pas assez fort pour teindre la peau. En outre, s'assurer que la poudre de henné utilisée n'est pas trop ancienne car elle perd rapidement de sa force. Les feuilles de henné se ramassent à même le sol et doivent être d'une couleur vert vif.

Au lieu de l'huile de moutarde, il est possible d'utiliser d'autres types d'huiles végétales, comme par exemple l'eucalyptus, la lavande, de l'essence de girofle ou de l'huile d'olive.

Diseños tradicionales con henna

Lawsonia inermis, *hina* y *mehndi* son el nombre latino, árabe e hindi de una planta considerablemente grande de flores blancas que crece en el norte de África, Oriente Próximo, India y el sudeste asiático. Se le atribuyen diversas propiedades como, por ejemplo, poderes medicinales contra ciertas enfermedades de la piel, contusiones, la tiña, la cefalea y el dolor de garganta. Las hojas de esta planta tienen un efecto refrescante sobre la piel y se han usado durante mucho tiempo como ingrediente en la fabricación de aceites perfumados y pomadas. Sin embargo, sus aplicaciones más conocidas son, probablemente, las que derivan de su potencial como fuente de un tinte natural de color marrón rojizo. Durante siglos, éste se ha utilizado para teñir algodón, lana y seda, y continúa siendo muy popular como tinte de pelo y como colorante para decoraciones corporales, principalmente en las manos y los pies. Hoy en día, esta planta es más conocida por su nombre árabe: *henna*.

No se sabe a ciencia cierta cuándo y dónde se origina el uso de la henna en la decoración de la piel, pero hay indicios más que suficientes sobre la antigüedad de esta práctica. En Egipto se han encontrado rastros de henna en momias de hace cinco mil años y en India se han descubierto pinturas rupestres que representan una princesa con diseños de henna en las manos y los pies. Dicen que el profeta Mahoma se teñía la barba con esta sustancia. La teoría más aceptada es que los diseños de henna son originarios de Egipto, desde donde se extendieron hacia el oeste, hasta Marruecos, y hacia el este, Oriente Próximo, India y el sudeste asiático.

En general, las decoraciones corporales de henna se realizan en ocasiones festivas tales como ceremonias religiosas, fiestas y, sobre todo, bodas. En todas las culturas que conocen la pintura hecha con henna, la decoración se centra principalmente en las manos y los pies. No obstante, en las bodas los diseños pueden aplicarse también en los brazos y las piernas. En las ceremonias nupciales islámicas, judías sefardíes e hindúes, las novias y a veces los novios se hacen diseños que se consideran portadores de buena fortuna. En algunos lugares se cree que cuanto más fuerte sea el color de la henna, más feliz será la nueva pareja.

Los diseños que se realizan varían mucho de una cultura a otra. Así, al igual que la ornamentación islámica, que excluye la representación de personas y animales, los diseños de henna norteafricanos suelen ser geométricos o estar compuestos de flo-

es muy estilizadas. En Oriente Próximo también prevalecen las composiciones florales. No obstante, en algunas partes de Arabia, amplias zonas de las manos y los pies se colorean con henna sin elaborar ningún diseño.

Los diseños hindúes suelen tener un tema central, normalmente dibujado en el interior de un cuadrado, un rectángulo o un círculo, que es rodeado después por una miríada de dibujos más pequeños, cubriendo completamente las manos y la parte inferior del brazo, los pies y los tobillos.

Los motivos se extraen de la totalidad del vasto vocabulario decorativo hindú: flores mongoles, cachemiras, complicados diseños de zarcillos, estrellas, vides, espirales, hojas, damas, gotas de agua y olas, etc. A menudo forman diseños tan detallados que parecen guantes de encaje.

Además de estos pequeños dibujos repetitivos, también se usan con frecuencia motivos más grandes y figurativos, tales como flores de loto, mangos, abanicos, elefantes, mariposas, peces, loros, pavos reales, dulces e instrumentos musicales tradicionales. Asimismo se han hecho dibujos que combinan o imitan las joyas hindúes; dicen que incluso se han incluido relojes en los diseños.

Los dedos de las manos se cubren con motivos lineales especiales (pág. 50-57, 179-183) y las yemas pueden bañarse en henna, tiñendo también las uñas. En las muñecas y alrededor de los tobillos y las plantas de los pies se aplican motivos a modo de cenefas. Los diseños que se dibujan en la mano izquierda y la derecha son a veces complementarios, es decir, ambas manos forman un motivo (pág. 24-25). En algunos casos éstos crean la imagen de un pájaro o un corazón (pág. 119-125) y, en otros, se utilizan dibujos distintos en cada mano (pág. 14 derecha). También se incluyen ejem-plos de diseños para las manos que se combinan con diseños para los pies (pág. 140-153, 197-201).

Para las ceremonias nupciales se utilizan motivos específicos. Son símbolos tradicionales, como la silla de manos en la que una novia es transportada desde su casa hasta la casa de sus suegros (pág. 48, 132), el cántaro que contiene el agua sagrada utilizada en las bodas (pág. 12-13), imágenes de una novia y un novio (pág. 49, 134-139), el pavo real símbolo del amor o la esvástica símbolo de bienestar en el futuro. Aunque normalmente sólo se decoran con henna las manos de las novias, en algunas regiones de Bangladesh y Cachemira las manos de los novios se ornamentan con motivos reservados para los hombres.

Aplicación de la henna

El modo tradicional de aplicar henna es sin utensilios. Se pone un poco de pasta de henna entre el pulgar y el índice y se forma un hilo frotando un dedo contra el otro varias veces. Con este hilo se hace el dibujo sobre la piel. Este sistema requiere mucha experiencia. Otro método tradicional consiste en aplicar la henna con un bastoncillo. No obstante, la manera más práctica de aplicar un diseño de henna es usando un cono (véase descripción en las páginas 230-231). Una técnica completamente distinta para aplicar henna consiste en realizar los diseños con una pasta hecha de azúcar y jugo de lima. Ésta se deja secar antes de cubrir toda la superficie de la mano con pasta de henna. Tras retirar la pasta de lima y la de henna, queda un dibujo blanco sobre un fondo rojo.

Las recetas para hacer pasta de henna varían. Por esta razón, aquí sólo ofrecemos una descripción general.

1

Tamice el polvo de henna. Éste debe ser muy fino y no contener ninguna ramita o grumo. Añada una mezcla caliente de té o café negro fuerte, jugo de limón (dos cucharadas por taza de café o té) y aceite de mostaza a la henna tamizada. Cuando la pasta tenga la consistencia del barro, déjela enfriar por lo menos una hora. Si se seca demasiado, añada un poco más de la mezcla de té, limón y aceite.
La pasta adquiere la consistencia idónea transcurridas cuarenta y ocho horas.

2

Limpie la piel con agua de rosas o aceite de mostaza antes de realizar el diseño de henna. Aplique la pasta de henna con un bastoncillo, una jeringa sin aguja o un cono pequeño. Asegúrese de que la herramienta que usa no toca la piel y de que sólo un hilo de pasta de henna cae sobre ésta.

3.

Cuando el diseño esté acabado, deberá dejarse durante al menos cuatro o cinco horas, y preferiblemente durante toda la noche. Procure no estropearlo y, si es necesario, cúbralo con algodón. Para evitar que se agriete y caiga, debería hidratarse de vez en cuando con una solución de jugo de limón y azúcar. Así la henna también adquiere un color más intenso.

4.

Cuando la pasta de henna haya tomado un color rojo oscuro, frote la piel con aceite de mostaza, raspe la henna, lave la piel con agua y frótela de nuevo con aceite.

Para que el color se intensifique, no humedezca el diseño de henna durante las doce horas siguientes a la aplicación. Si desea conservar el dibujo, lávese la piel lo menos posible y evite el uso de jabón. Según su uso, el motivo aplicado permanecerá en buenas condiciones de dos a cuatro semanas.

No utilice la henna que se usa para teñir el pelo, pues no es lo bastante fuerte para colorear la piel. Además, asegúrese de que el polvo de henna que va a utilizar no sea demasiado viejo, ya que pierde fuerza. Las hojas de henna picadas deben tener un color verde claro.

En vez de aceite de mostaza también puede utilizar otros tipos de aceite vegetal, como el de eucalipto, lavanda, clavo u oliva.

Disegni tradizionali all'henné

Lawsonia inermis, hina e *mehndi* sono rispettivamente il nome latino, arabo e indi per una pianta di media grandezza dai fiori bianchi che cresce in Nord Africa, in Medio Oriente, in India e nel Sud Est Asiatico. A questa pianta sono attribuite molte proprietà medicinali, come ad esempio contro malattie della pelle, contusioni, tricotizia, mal di testa e mal di gola. Le sue foglie hanno un effetto rinfrescante sulla pelle e sono spesso usate come ingrediente in olii profumati e pomate. La sua applicazione piú nota è però probabilmente quella di tintura naturale di colore rosso-bruno. Per secoli questa pianta è stata impiegata per la tintura di cotone, lana e seta e continua ad essere molto popolare come tinta per capelli e come colore per decorazioni sul corpo, soprattutto su mani e piedi. Questa pianta è attualmente meglio conosciuta con il suo nome arabo, *henné*.

Non si hanno notizie certe su quando e da dove sia originato l'utilizzo dell'henné per decorazioni corporee ma è evidente che si tratta di una pratica molto antica. In Egitto ne sono state trovate tracce su mummie vecchie di cinquemila anni ed in India sono state scoperte pitture rupestri raffiguranti una principessa con disegni all'henné su mani e piedi. Si dice che il profeta Maometto avesse la barba tinta con l'henné. La teoria piú comune è che l'applicazione dei disegni con l'henné sia originaria dell'Egitto e che da lì l'uso si sia diffuso raggiungendo il Marocco ad ovest ed il Medio Oriente, l'India ed il Sud Est Asiatico ad est.

Generalmente le decorazioni sul corpo eseguite con l'henné vengono applicate in occasioni festive come le cerimonie religiose, le feste in genere e specialmente i matrimoni. In tutte le culture che conoscono i disegni all'henné, sono generalmente le mani ed i piedi ad essere decorati, tuttavia per i matrimoni possono essere applicati anche sulle braccia e sulle gambe. Nei matrimoni islamici, ebrei spagnoli ed indú le spose e a volte anche gli sposi sono decorati con disegni di buon auspicio. In alcuni luoghi è credenza che la maggiore profondità del colore dell'henné determini la maggiore felicità della nuova unione.

I disegni applicati variano molto da cultura a cultura. Ad esempio, in linea con i comuni ornamenti islamici dove si esclude la rappresentazione di persone e animali, i disegni all'henné del Nord Africa tendono ad essere geometrici o composti da fiori estremamente stilizzati. Anche in Medio Oriente prevalgono le intricate composizioni floreali. In qualche zona dell'Arabia, d'altra parte, ampie aree delle mani e dei piedi sono colorate con henné senza uso di veri disegni. I disegni indiani ten-

cono ad avere un tema centrale solitamente disegnato all'interno di un rettangolo, un quadrato o un cerchio a loro volta circondati da una miriade di minuscoli disegni che coprono completamente le mani, i polsi, i piedi e le caviglie. I motivi sono presi da tutto il vasto vocabolario ornamentale indiano: fiori Moghul, decori Paisley, complicati viticci, stelle, rampicanti, spirali, foglie, quadretti, gocce d'acqua, onde ecc.. Molto spesso questi disegni molto dettagliati danno l'impressione di guanti merlettati. Oltre a questi piccoli disegni ripetitivi vengono spesso usati anche motivi e figure piú grandi come ad esempio: fiori di loto, manghi acerbi, ventagli, elefanti, farfalle, pesci, pappagalli, pavoni, caramelle e strumenti musicali tradizionali. Altri disegni invece vengono eseguiti come imitazione di gioielli indiani. Addirittura gli orologi sembrano essere inclusi in questa tipologia di disegni.

Le dita sono ricoperte con speciali motivi lineari (pagine 50-7, 179-83) e le punte delle dita possono essere immerse nell'henné, anche le unghie sono colorate. Motivi orlati (pagine 58-9) sono applicati intorno ai polsi, alle caviglie e sotto la pianta dei piedi. Disegni dipinti sulle mani destra e sinistra a volte possono essere complementari nel senso che entrambe le mani formano un'unica immagine (pagine 24-5). In qualche caso i disegni possono specchiarsi a formare un uccello o un cuore o , in altri casi, diversi disegni possono essere usati sulla mano destra e sinistra (pagine 119-25 e pagina 14 (a destra)). Vengono dati anche esempi di disegni per le mani che accompagnano disegni per i piedi (pagine 140-53, 197-201).

Per le cerimonie nuziali vengono utilizzati disegni specifici e possono essere simboli tradizionali come la portantina dove la sposa è portata dalla sua casa alla casa del suo sposo (pagine 48 132), la brocca contenente l'acqua santa usata in cerimonie nuziali (pagine 12-3, 133), immagini della sposa e testimone (pagine 49, 134-9), il pavone , simbolo d'amore, o la svastica, simbolo di prosperità . Sebbene sia piú frequentemente solo la mano della sposa ad essere decorata con l'henné, in certe regioni del Bangladesh e del Kashmir anche le mani dello sposo sono decorate con motivi riservati agli uomini.

Applicazione del henné

Il metodo tradizionale di applicare il henné, metodo questo che richiede molta esperienza, consiste nel prendere un po' di pasta di henné tra l'indice ed il pollice e trasformarla in una stringa che viene poi applicata sulla pelle nella forma desiderata. Un altro procedimento tradizionale è applicare l'henné con un bastoncino. Tuttavia il sistema piú pratico per realizzare un disegno con l'henné è usare un cono (vedere descrizione a pagine 230-1).

Una tecnica completamente diversa per applicare il mehndi è di disegnare con un impasto di zucchero e succo di lime che viene lasciato asciugare per poi ricoprire l'intera superficie della mano con l'henné. Dopo aver rimosso la pasta di lime e l'henné apparirà un disegno bianco su sfondo rosso.

Le ricette per la preparazione dell'henné sono diverse. Per questa ragione ne viene data qui solo una descrizione generale.

1

Setacciare la polvere di henné che dovrà essere molto fine e non contenere ramoscelli o grumi. Aggiungere una miscela calda di tè nero forte o caffé, succo di limone (due cucchiai pieni per una tazza di té o caffé) e olio di senape. Quando la pasta raggiunge una consistenza fangosa lasciar raffreddare almeno un'ora. Se l'impasto è troppo secco aggiungere ancora un po' di té/limone/olio. Dopo quarantotto ore l'impasto é pronto.

2

Prima di applicare in mehndi pulire la pelle con acqua di rose o con olio di senape. Applicare l'henné con un piccolo bastoncino, una siringa senza ago o un piccolo cono. Assicurarsi che lo strumento usato non venga a contatto con la pelle; far cadere cioé solo un filo di henné.

3

Quando il disegno é completato lasciar trascorrere quattro o cinque ore, preferibilmente una intera notte. Attenzione a non danneggiarlo e se necessario coprirlo con batuffoli di cotone. Per prevenire rotture o cedimenti del disegno inumidirlo di tanto in tanto con una soluzione di succo di limone e zucchero. Questo aiuterà anche a rendere il colore dell'henné piú profondo.

4

Quando l'henné é diventato rosso scuro frizionare la pelle con olio di senape, rimuovere l'henné, lavare con acqua e frizionare la pelle nuovamente con olio.

Perché il colore divenga più profondo evitare di bagnare il disegno per dodici ore. Per preservare il disegno bagnare la pelle il meno possibile ed evitare l'uso di sapone. A seconda della tecnica usata il motivo applicato resterà in buone condizione per due-quattro settimane.

Non usare henné per capelli in quanto questi non è abbastanza potente per tingere la pelle. Accertarsi inoltre che l'henné usato non sia troppo vecchio perché avrà perso efficacia. La terra di foglie di henné dovrebbe essere di colore verde brillante.

L'olio di senape può essere sostituto con altri olii vegetali come eucalipto, lavanda, chiodo di garofano e olio d'oliva.

ヘンナの伝統デザイン

ラテン名は Lawsonia inermis、アラビア語では hina、ヒンディー語では mehndi と呼ばれ、北アフリカ、中東、インド、東南アジアに自生するかなり大きな植物。白い花をつける。皮膚病、打ち身、白癬、頭痛、咽喉の痛みに対する薬効など、いくつかの特性を有する。葉には肌を冷却する効果があり、香油や軟膏の原料として古くから使われた。しかし、おそらくもっともよく知られているのは、赤褐色の天然染料としてこの植物を使うことだろう。幾世紀にもわたり、木綿、羊毛、絹の染料として使用されてきた。現在でもヘアダイとして、また主として手足に施すボディ・デコレーションの顔料として、広く使われている。今ではアラビア語名である「ヘンナ」がこの植物の代表的な名称となっている。

肌を飾るというヘンナの用途がいつどこで始まったかは定かでないが、これが非常に古くから行われてきたことにはさまざまの根拠がある。エジプトでは5,000年前のミイラにヘンナが使われていた痕跡があるし、インドの洞窟画には手足にヘンナの模様を施した王女が描かれている。預言者マホメットもその顎鬚をヘンナで染めていたといわれる。一般的にいわれているのは、ヘンナで模様を描く風習はエジプト起源で、そこから西に広まり、やがてモロッコまで伝わった。東に向かっては、中東、インド、東南アジアへと伝播した。概して、ヘンナによるボディ・ペインティングは、宗教儀式、祭り、特に婚礼などに際して多く用いられる。いずれの文化圏でも、ヘンナのボディ・ペインティングは主として手と足に描かれるが、婚礼の時には腕や脚にも施されることがある。イスラム、セファルディ（スペイン、ポルトガル、北アフリカ系ユダヤ人）、ヒンドゥなどの結婚式では、花嫁が、そしてときには花婿も、幸運を保持するデザインを身につける。所によっては、ヘンナの色が深ければ深いほど、新婚の二人の行く末は幸せになると信じられている。

ペインティングのデザインは、文化圏によって大きく異なる。イスラム装飾では全体として人や動物の姿は使わないというルールがあるため、これに沿って、北アフリカのヘンナ・ペインティングのデザインは、幾何学的なものや、高度に様式化された花で構成されることが多い。中東でも複雑精緻な花模様が主流になっている。一方で、アラビア各地には、手と足の大部分にヘンナの色を施すだけでデザインは使わないところもある。

こうした小さなパターンの繰り返しに加えて、蓮の花、未熟なマンゴー、扇、象、蝶、魚、鸚鵡、孔雀、菓子、伝統楽器など、表章的な大型のモチーフもよく使われる。ペインティングのパターンはまた、インド風の装身具に合わせたり似せたりして描かれることもあり、そんなデザインには腕時計まで入っているといわれる。

指の部分は、特殊な線状モチーフ（50〜57頁、179〜183頁）で覆われる。指先はヘンナに浸けて、爪まで着色することもある。手首や足首の周囲、足裏には、ボーダー・モチーフ（58〜59頁）が描かれる。
左右の手に描かれるデザインが補い合って、両手でひとつのデザインを形成することもある（24〜25頁）。鳥や心臓を象った左右対称のデザイン（119〜125頁）もあれば、左右の手に異なるパターンが使われることもある（14頁右）。また、手と足にマッチするデザインを使った例も紹介した（140〜153頁、197〜201頁）。

婚礼の際には決まったデザインが使われる。こうした伝統的なシンボルとして、花嫁を実家から婚家へと運ぶ輿（48頁、132頁）、婚礼に使われる聖水の入った水差し（12〜13頁、133頁）、花嫁・花婿の姿（49頁、134〜139頁）、愛のシンボルである孔雀、将来の幸福のシンボルである卍などがある。たいてい、ヘンナで飾られるのは花嫁の手であるが、バングラデシュとカシミールの地方によっては、男性用のモチーフが花婿の手に施される。

ヘンナによるペインティング

準備

ヘアダイ用のヘンナは、肌を染めるには弱すぎるため、使うことはできない。また古くなると着色力が弱まるため、使用するヘンナ・パウダーがあまり古くないことを確認する。ヘンナの葉の粉末は、鮮やかな緑色をしている。

伝統的なインド式の着色法では、道具はまったく使用しない。親指と人差し指の間にペーストを付け、指を数回付けたり離したりしてペーストを糸状にし、この糸で肌の上にデザインを描く。この方法はかなりの経験を要する。もうひとつの伝統的な方法として、スティックを使うものがある。だが、最も実践的なのは、円錐形のコーンを用いることだろう (230-231).
インドで行われるまったく別のテクニックは、砂糖とライム果汁で作ったペーストでデザインを描くものである。このペーストのデザインを乾かしてから、手の表面全体をヘンナ・ペーストで覆う。その後ライム・ペーストとヘンナ・ペーストを除くと、赤い地に白いデザインが残る。

1
ヘンナ・ペーストの製法はさまざまであるため、ここではごく一般的な方法を紹介する。

ヘンナ粉末をふるいにかける。粉末は細かくなければならず、枝や塊が混じっていてはならない。濃い紅茶かコーヒー、レモン汁（カップ1杯の紅茶またはコーヒーに対して2匙）、マスタードオイルの熱い混合液をふるったヘンナに注ぐ。泥のようなペーストになったら、最低1時間放置してさます。ペーストが乾き過ぎるようなら、上記の混合液を少し加える。
ペーストは48時間後に最上の状態になる。

2
ヘンナ・ペインティングを施す前に、ローズウォーターまたはマスタードオイルで皮膚を拭く。
細いスティック、針のない注射器、小さな円錐形コーン（図を参照）などを用いて、ヘンナ・ペーストでデザインを描く。これらの道具が皮膚にまったく触れないように注意すること。ヘンナ・ペーストが糸状になって肌に落ちていくのが正しい。

3

デザインを描き終えたら、少なくとも4〜5時間、理想的には一晩そのままにしておく。デザインを損なわないように注意し、必要なら脱脂綿を当てておく。ヘンナのデザインのひび割れや剥離を防ぐには、レモン汁と砂糖の溶液でときどき湿らせるとよい。これによって、ヘンナの色も深まる。

4

ヘンナ・ペーストの色が暗赤色になったら、皮膚にマスタードオイルを擦り込み、ヘンナをこすり落とす。水で洗って、再びオイルを擦り込む。
色を深めるためには、この後12時間はヘンナ・デザインを濡らさないようにする。長持ちさせるために、なるべくその部分を洗わないようにし、石鹸の使用は避ける。描いたモチーフにもよるが、条件が良ければ、2週間から4週間ぐらい維持できる。

注：マスタードオイルに代えて、ユーカリ油、ラベンダー油、クローブ油、オリーブ油などの植物オイルを使うこともできる。

Schneiden Sie ein Rechteck von ungefähr 15 x 20 cm aus einer stabilen Plastiktüte aus. Rollen Sie es in Eistütenform zusammen und kleben Sie die Kanten mit Klebeband zu. Der Spritzbeutel braucht jetzt nur noch mit Henna gefüllt zu werden und ist dann einsatzbereit.

A l'aide d'un sac plastique résistant, découper un rectangle d'approximativement 15 par 20 cm. Le modeler ensuite en forme de cône, et fermer les jointures avec du scotch. Remplir enfin le cône avec de la pâte à henné et il est ainsi prêt à l'emploi.

Corte un rectángulo de aproximadamente 15 x 20 cm de una bolsa de plástico resistente. Déle forma de cono y cierre las junturas con cinta adhesiva. Llene el cono con pasta de henna y ya está listo para ser utilizado.

Da una robusta borsa di plastica tagliare un rettangolo di circa 15 x 20 cm. Formare un cono e chiudere il tutto con nastro adesivo. Riempire il cono con l'impasto di henné e procedere con l'applicazione.

丈夫なビニール袋から、約15 × 20 cmの長方形を切り抜く。これを円錐形にして、継ぎ目をテープで留める。これにヘンナ・ペーストを入れて使用する。